DESIGNING ONLINE IDENTITIES

CONTENTS

INTRODUCTION

We are a brand-conscious people. The cars we drive, the food we eat, even our most mundane purchases like soap and toilet paper are clearly branded. But what comes to mind when we speak of the elements of branding? Most immediately, we think of packaging—labels, bags, boxes, and the logos printed, stamped, or otherwise emblazoned upon them. But packaging alone does not define a brand entirely.

It's difficult to imagine packaging a Web site for presentation as a branded commodity. Yet this is what we must do as brand-aware Web builders and designers. In my previous book, *Great Web Architecture*, I discussed designers who, like architects, are building custom-crafted solutions to particular sets of problems. This custom-crafting is the most appealing aspect of the work for many of us. Each site requires a strongly stated, coherent identity, and it is this identity that becomes the site's brand. And for users, the browsing public whose attentions we most desire, the brand becomes the thing that is most recognizable about a site.

There are several aspects of a brand that must be considered when establishing a site. The process of branding a site is in many ways similar to designing a corporate identity. But where a corporate identity considers only the visual manifestation of the image to be projected, Web site branding must also take the site's entire contents into consideration. This includes the content itself, the words and images displayed, and also the way in which all of these are presented.

This takes us back to the idea of packaging, because for a Web site, the content represents the product, and the package becomes synonymous with the brand. And just as a product designer works to achieve the right look and feel—for instance, a product has not only a Sony label, but also a Sony-designed look—we must achieve the same intangible rightness for every site we place on a server for broadcast to the entire Web.

One of the most obvious lessons of graphic design as used in advertising and marketing is that what is left unsaid can be as important as what is said. This lesson is especially applicable to Web design, which depends on establishing positive and easily recognizable identities, rather than becoming another anonymous URL in the seemingly boundless landscape of the ceaselessly expanding World Wide Web.

Designing Online Identities examines Web sites—great sites that contain useful information, are worth revisiting, and promote the site brand in attractive, memorable, and innovative ways. In the first half of this book, I identify and examine the elements of Web branding. Starting with logos and the treatment of standard corporate and brand identifiers on pages and sites, I then discuss the use of traditional graphic design elements, such as layout, color, and typography, to define image. You will see how branded navigation can affect the clarity and ease-of-use of a site and learn how elements such as text and dynamic content can be used to project a range of qualities such as sophistication and friendliness.

In the second half we'll explore the use of branding elements to create sites of different types—the application of branding theory in real Web situations. We learn that what is right for a big brand may not be appropriate for a boutique brand; that information-oriented sites have very different branding concerns from e-commerce sites. In short, Web branding is as much a matter of customization as Web architecture is. And just as you must consider the interaction of elements like site structure and navigation, you must be aware of the power of branding to establish the architectural elements of a site.

This book does not attempt to recommend any right way to design or incorporate branding into a design. Instead, it tries to show the breadth of possibilities available to the creative brander. The emphasis is on the use of dynamic tools and techniques, and the only way to decide what will work is to understand what image you're trying to project before you start designing. Know your client, know your audience, and know what's possible with the technology available. These are the real secrets to great Web sites.

If you watched Super Bowl XXXIV, you also saw the first dot-com bowl—what a great way to begin the millennium. Could there be anything homier or more American than the family gathered together on a cold winter evening to watch the finest advertising agencies fight it out on national television? It's great entertainment, perhaps the finest television has to offer, and it's all about branding—an ostentatiously expensive battle for your attention. (For an in-depth definition of branding, please see the Introduction.)

This fine, old tradition was pioneered by Apple's memorable 1984 commercial, introducing the Macintosh. Those were the days when computer companies came and went as quickly as Internet start-ups do today, when Big Blue was the evil Big Brother, and Microsoft appeared like a white knight in shining armor. Images may tarnish, but brands endure, even in the emerging medium of the World Wide Web, but it has become a brand-crowded world.

With so many enduring brands, how is a dot-com to establish its own identity? Ad agencies know how to burn millions creating brand recognition in the old broadcast box, but they don't necessarily understand how to transfer such branding to the new broadband boxes of the Internet.

Can you get a well-branded site for $2.2 million dollars, the average cost of thirty seconds of fame during Super Bowl XXXIV? For this exploration of great Web branding, sites are examined as if they were products that might be purchased off a shelf. Is a box of Cracker Jacks so different from a Web site for Cracker Jacks? Yes, but some of the same elements of image and information must be present in both. There may even be a prize in every box!

[1] BRAND RECOGNITION
VISUAL IDENTITY

The fact is, the NFL itself and the Super Bowl in particular are great brands—pinnacles of brand name recognition. But they seem to have forgotten they have a great brand when it comes to branding their Web site or even a single Web page, www.nfl.com.

FOOTBALL OR BEER, WHICH SELLS BETTER?

The page is clearly about football, but where's the NFL.com brand? It's there, in a strange, almost undetectable graphic arrangement with the NFL shield. But the designers of this page aren't emphasizing its importance. And perhaps the NFL.com brand isn't important to the NFL hierarchy or, more significantly, to its fans. After all, this page is not about dot-coms or the Branding Bowl; it's really about football. On the other hand, there is money to be made here. There are sponsors willing to pay for banner ads, and there's a wealth of carefully branded NFL souvenirs available.

Vying for attention with the NFL.com brand is the Super Bowl XXXIV logo, which links to SuperBowl.com. This home page is somewhat better; the Super Bowl XXXIV logo is big and prominent, and almost everything on the page says Super Bowl.

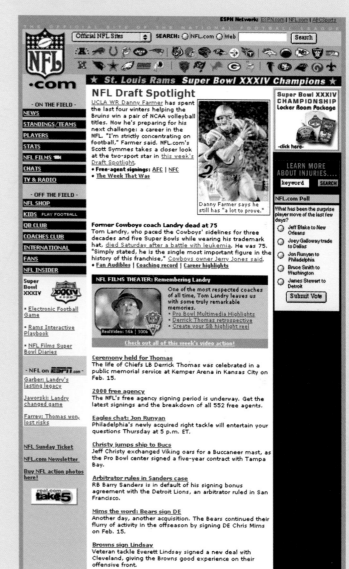

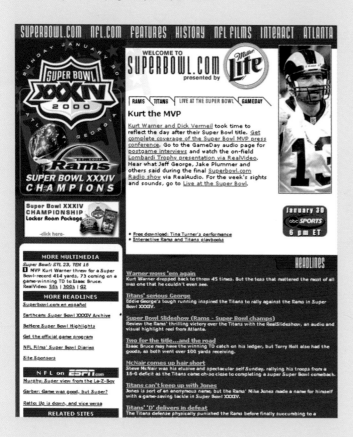

(LEFT) 'Whose page is this anyway,' episode 2. Here's a Miller Lite logo next to Super Bowl MVP, St. Louis Rams–recycled quarterback, Kurt Warner, and a more discreet ABC Sports logo just under his picture. And there's ESPN, always lurking at the edges. You could say that these are like the usual banner ads and they don't really detract, but the role of advertising is clearly more important to the NFL than it is to most Web sites.

(RIGHT) Brand unrecognition: Is this the NFL's home page or ESPN's? There are lots of logos here, and the NFL's is biggest. But there are also some odd logo pairings at the bottom; the NFL plays catch with Motorola next to an ESPN Internet Ventures logo that seems to dominate the NFL logo.

LOOKING FOR CROSS-BRANDING SYNERGY

There's an obviously intentional link between the NFL and ESPN, the American sports broadcasting network. In fact, it looks as if ESPN is making these pages for the NFL and, indeed, it is through its ESPN Internet Ventures (EIV) subsidiary.

There's no mention of EIV on the ESPN home page, yet another Internet entity, GO.com, (now defunct) had inserted its own banner at the top of the page. Let's follow this confusion of brands to the GO.com page, a once popular portal where the news brand was ABC and the sports brand was ESPN.

Aside from a well-positioned and strongly defined identity, GO's box was pretty bland and gave the contents a somewhat monotonous flavor without any sugar coating or nutlike crunch.

Back at the gridiron, fans probably don't care that the NFL is recklessly ignoring its own brands on the Web. But if the NFL isn't careful, it's possible it'll end up being a small brand in a very large media conglomerate. Okay, Mouseketeers, are you ready for the first Disney Bowl?

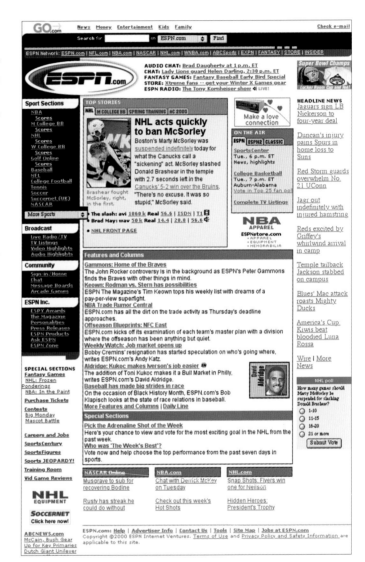

(ABOVE) The ESPN site shares some of the same design aesthetic with the NFL site. Notice especially the ESPN logo, which links to all of the ESPN Internet Ventures (EIV) sports-related Web sites, including NFL.com and SuperBowl.com.

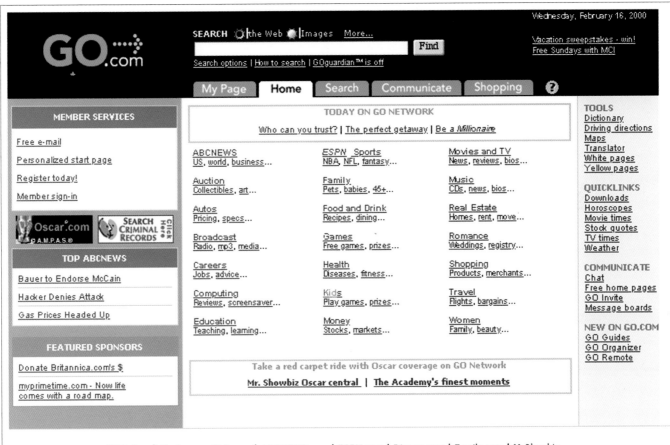

MAKING A WEB MONSTER

Enough of the laissez-faire approach to Web branding. Monster.com has created high-impact ads for two Super Bowls. One could argue that this is a poor name choice for this company. What do monsters have to do with the job market? Nothing, and herein lies one of the basic challenges of branding.

Monster is an easy name to remember; it's easy to type into a browser. However, not all monster associations are positive. (Big Daddy's "little no-neck monsters"—his grandchildren—in Tennessee Williams's *Cat on a Hot Tin Roof* come to mind.) Through clever advertising and Web design, monster.com draws the association between monsters we love, monsters we hate, and the monster we live with every working day—our job.

Immediately, monster.com's home page establishes two linked identities: the monster.com logotype (which is the part of the logo without the monster's eye) and the humorously grotesque monster figures.

THE EYES HAVE IT

For instance, the swirling dragon's eye logo matches the slightly open, broadly stroked *o* in monster. Even the color of the period (Barney purple) in monster.com seems to have been carefully selected to be a monstrous color. And almost as an afterthought, monster.com has tied in the key slogan with the logotype: Work. Life. Possibilities. It's as if the whole composition were saying: get a new job, get a life, realize the possibilities, escape the no-neck monsters.

At the same time that the site establishes the monster imagery, the text and links are all very career-oriented: work, life, and possibilities. But take a closer look at the subtle eye imagery monster.com is putting to work. The eyes of the model used for monster.com's Super Bowl ad are soulful, curious, wide-open eyes, while the monster's eyes are just scary. There's a powerful tension in this design imagery.

This is a meticulously constructed home page that reflects a concerted effort not only to build the brand, but also to create a useful hierarchy of information and to establish a navigational scheme. There are three vertical divisions, as if we were looking at the front and two side panels of a box. The left panel contains nonhierarchical links, and the right panel serves as a sidebar. The primary site hierarchy, the contents of the site listed in order of importance, fills the middle panel.

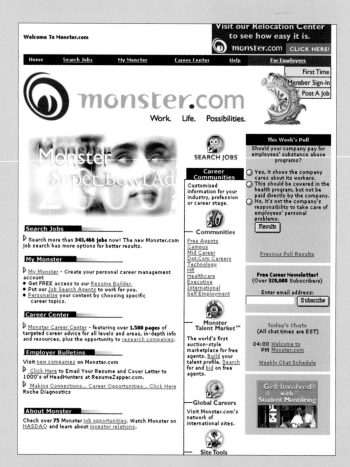

(ABOVE) Monster.com's home page establishes two identities. The first is light, but very businesslike; the other is amusing and fun. The visual connection between the two is made through the eyeballs.

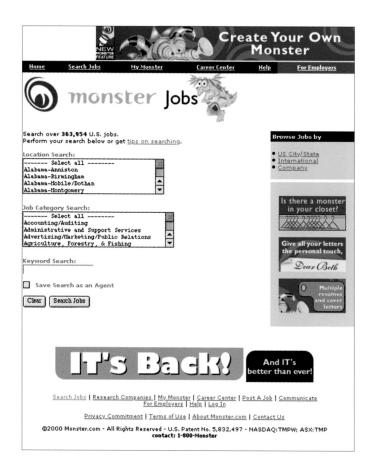

RETAINING CONSISTENCY OVER DISPARATE DIVISIONS

Each major section of the site is listed in site map style with a title and subsections shown. Each section has a different monster character with exaggeratedly distinctive eyeballs. In effect, each section is branded with its own distinctive monster eye—"Look here!" "Examine this!" they seem to be saying. The links on the home page feature the eyeballs as imagery along with the linking text—Search Jobs, Communities, Monster Talent Market, Global Careers, and Site Tools—all in the same monstrous purple as the logo.

The importance of the Search Jobs category, the number one reason for viewers to visit this site, is emphasized by its position at the top of the column. Note that there are no subcategories under the Search Jobs link and that the other hierarchical links are contained within a box labeled Career Communities. Hierarchically, the monster-eyeball links are equal, but logically they are not.

At left is monster.com's Jobs page, the entry to the master jobs list, the database upon which the success of monster.com depends. Note how the Jobs monster is graphically tacked onto the end of the monster.com logo where .com used to be. Functionally, this page is straightforward. Pick from a list of locations, a list of job categories, and/or type in a keyword to narrow the search.

When you strip out the extraneous images, it becomes apparent that you can also browse the job listings without searching. Browsing capability was there all along, but its placement made the box of browsing links look like another banner ad. This page presents a cautionary tale of overbranding, because even though most of the banner ads present links to other areas of monster.com, they draw attention away from the function of this page.

This layout, surrounded by branding banners, is standard across the monster.com site, and in most areas where there is more page content, it is better integrated into the total package.

(ABOVE) Monster.com's Jobs page is so simple that the advertising around the sides overwhelms it. Most of the spots link to pages within the monster.com site, but they still overwhelm this particular layout.

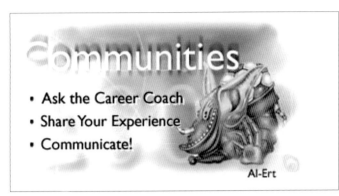

Communities

* Ask the Career Coach
* Share Your Experience
* Communicate!

Al-Ert

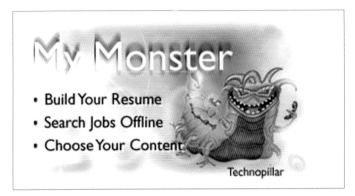

My Monster

* Build Your Resume
* Search Jobs Offline
* Choose Your Content

Technopillar

Monster Talent Market℠

* Market Your Talent
* Search LIVE Auctions!
* Register Now!

Skeeter

Search Jobs

* Create Search Agents
* Jobs Added Daily
* Search NOW!

Swoop

Global Careers

* Find Work Abroad
* Get a Job in the US
* Talk to the Experts

Trumpasaurus

(THIS PAGE) Al-Ert, Skeeter, Trumpasaurus, Technopillar, and Swoop each represent a different brand monster or hierarchical section within the monster.com site.

NAVIGATING THROUGH DEEP HIERARCHIES

In monster.com's case, the packaging is a multilevel, multibranded affair. For instance, on the home page, every link represents brand central. As discussed previously, each of the first-level links is represented by a different brand of monster. The featured brand changes with each visit to the home page.

Following the Al-Ert brand to the Communities link brings up a secondary home page. Tabbed headings on the page represent the same hierarchical level, and a list of links further down the hierarchy follows each tab. At any point there's a choice two levels deep.

As you follow the hierarchy down, it's evident that the site is very deep. For instance, the forum pages are five levels down in the Communities division. Not all the monster-branded sections are so complex or run as deep. For instance, there is always a Search Jobs link that goes straight to the Jobs selection page. Monster.com's page-branding scheme works for both deep and broad sections. It's obvious that the designers had fun with it. It's not so rigid that it becomes dull, and most importantly, it sets monster.com apart from all the other job sites on the Web. It makes the brand.

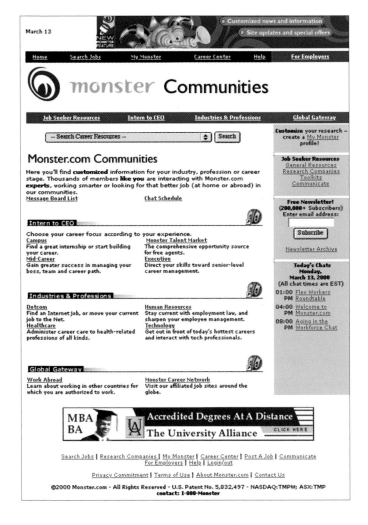

(ABOVE) The Communities page, a secondary home page for the site, contains a secondary, horizontal navigation bar in Barney purple.

ADDING "E" FOR SUCCESS: DISCUSSING E★TRADE'S SITE

E*trade, the online brokerage and financial information Web site, worked harder than anyone (even Budweiser) to make the Super Bowl a coming-out party to remember. Not only did it take out ads in every quarter, but it beat out all our favorite beverage vendors for the right to name the halftime show after itself.

The E*trade home page, www.etrade.com, has the flavor of a portal, with news items and a regularly updated stock ticker. But providing a portal is not the objective here. This is pure business or, perhaps, a business club.

BRANDING IS EVERYWHERE

You do your research, follow your favorite issues, perhaps buy and sell securities, without ever speaking to a trusted (or suspect) human advisor. You can act on a tip you picked up at the office water cooler without fear of embarrassment.

While E*trade does away with the need for human contact, it does not let you forget with whom you are trading. Can you count the number of instances of E*trade on this page? Not only the logo, but also the E*trade IRA, E*trade Tax Center, E*trade Mail, E*trade Store, E*trade Visa, Power E*trade, E*trade International, and the E*trade Game are listed. You might say this is a brand-centric page. The only unbranded areas are the tabbed navigation bar across the top and the market watch chart, the two purely business-oriented features.

Regular visitors probably won't linger much over the home page, choosing instead one of the action areas from the tabbed links. So this initial look at E*trade is more important for first-time visitors or nonmembers. Not surprisingly, you must join E*trade to use most of its services. There's a discreet Free Membership link in the middle of the page and a small, yellow "Open an Account" button heading the list of links in the left-side navigation column. But our eye is first drawn to the offer of 25,000 frequent flyer miles. This is better than Cracker Jacks.

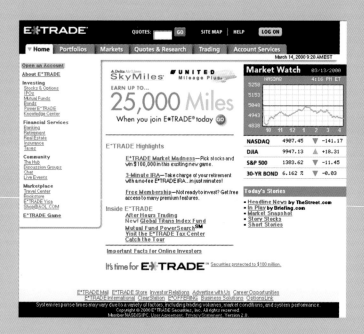

(ABOVE) E*trade's home page serves as a surrogate broker's office where you can check all kinds of information and learn about (or be sold) various financial products.

CONSISTENT DESIGN, STRONG NAVIGATION, AND EASE OF USE

Clicking the Markets tab opens this top-level divisional page. The page layout and navigational elements are identical to the home page. The E*trade logo, with its interlocking bull/bear arrows forming the asterisk, is at the upper left. The section tabs are unchanged, except that Markets is now highlighted, and the nonhierarchical links in the black horizontal bar across the top remain.

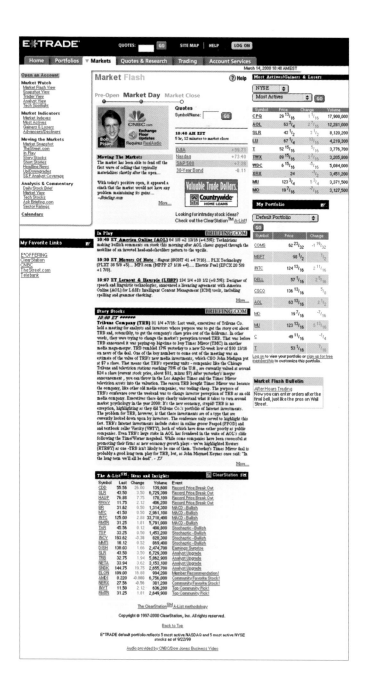

(ABOVE) Top-level divisional pages, like this one for Markets, contain similar branding elements to the home page. But the emphasis here is focused on information, while the home page is a starting point for further exploration.

THE DETAILS OF SIMPLICITY AND SOPHISTICATION

The branding and navigation bar at the top is implemented as a simple, two-row-by-one-column table. The links are image maps and the images themselves are all GIFs. There is a lone form field for entering stock symbols for current quotes. The tab bar itself is a single image created with one tab casting a shadow on the next, the text embossed on the tabs to give an impression of depth. The currently active tab is brought to the front, casting a shadow on both neighboring tabs, and it is filled white so that it blends in with the white background beneath, effectively becoming the tab for that page. A green down-pointing arrow helps highlight the tab and link it with the content beneath. This is basic stuff effectively executed to look sophisticated without being complicated.

The page, as defined by the area with the white background, is divided into three columns with sectional links on the left, textual content in the middle, and active quotes listed in tabular form on the right. All the content of the page is laid out in tables. Alternating gray and white bars are used for the stock tables, which are built from custom Common Gateway Interfaces (CGIs) that fill in the information when the page is loaded. Yellow table backgrounds create a yellow-pad effect for the textual content in the middle. The left-side navigation bar is separated from the other content by a drop shadow. Visually, the shadow ties the navigation bar to the navigational tabs, while separating it from the other content, even though all the elements exist structurally as separate tables.

All of this effort helps create the E*trade package, one of businesslike clarity and concision. It also enables each page to include a maximum amount of information without creating a chaos of topics and an overabundance of links. Furthermore, the consistent application of this layout scheme becomes familiar to the regular visitor, making it even easier to navigate to the different areas of the site. This is the members-only effect. Yes, it's great to be able to trade online and get a big discount while we're at it, but one of the benefits of membership and frequent use is that this quickly becomes a comfortable place to visit and, even more importantly, to linger.

(ABOVE AND OPPOSITE) Even these registration pages are consistent with a carefully branded site. The horizontal elements—black band on top for identification and nonhierarchical links within, white context area in the middle, and black bar with small, legal print across the bottom—are already familiar. There is the consistent use of the green and blue colors from the E*trade asterisk in the headline text.

MEMBERS ONLY, BUT NOT EXCLUSIVE

You have to join the E*trade clubhouse to find out what it's like to be a real insider. Clicking a link to any restricted area brings up the Log On window. You are still comfortably within the E*trade package, but you must choose to become a member (it's free) and/or open an account.

For anyone who has spent much time browsing the Web, this is a fairly typical sign-up page, but perhaps cleaner than most. It's also immediately evident that it has the E*trade look. Even with the page scrolled down so that no logo is showing, the familiar layout, navigational elements, and color scheme let you know that you are still within the clubhouse.

NO BROKERS, BUT STILL PERSONAL

The Quotes & Research Center contains more of the familiar club fare, but note that now the yellow Log On button in the upper-right corner of the page has become a blue Log Off button. Ah, the privileges of membership. You are now eligible for real-time quotes, and there's a list of other Exclusive Customer Features.

The designers of E*trade's site have managed to fit all kinds of information into their page template. This is the E*trade way and the E*trade look summed up in a large Web site that feels cozy. In fact, the databases used to provide information for this site are huge, complex, and constantly changing.

The effect of these simple personalizations is to make E*trade's way of doing business your way of doing business—your preferred trading method. It is not an idea that is exclusive to E*trade, but once you have a membership with one online trading partner, it's easier to remain loyal than to start all over with another. It's the Web version of brand loyalty.

(ABOVE) Link lists, blocks of text, and quote tables all look right at home within what amounts to the same E*trade space.

WHAT HAS EIGHTEEN WHEELS AND FLIES?

Making a return visit to Super Sunday was Volvo's idea of the typical truck driver in his luxurious Volvo eighteen-wheeler, completely equipped with onboard valet. "Your toothpick, sir?" Volvo is a familiar brand to us all, but volvo.com is not a car site. Instead, this is the site for the Volvo Group: trucks, buses, construction equipment, marine and industrial engines, and aero products (things that fly). It clearly says so right across the color-coded, horizontal navigation bar. There's an external link to Volvo Cars, but you can forget about station wagons at this industrially oriented site.

IDENTITY CRISIS, BRANDING SOLUTION

Now that Volvo Cars is a wholly owned subsidiary of Ford, the Volvo Group has a bit of a branding problem. If Volvo isn't cars, what is it? The text of this entry page points out that the Volvo Group, owners of the www.volvo.com domain, is "intensively focused on transport solutions for commercial use." Does this sound like horseless carriages? No, it is the high end of big things that move.

The elements of the Volvo site are all strongly established on the entry page, which essentially becomes Volvo's Web package. Upon entering the Volvo domain, you are immediately transported into the package. What would be the home page is left behind for a new window. It opens to fill whatever size display you're browsing on with a dark-blue background, the package box, and a longish, white rectangle in the middle—its content.

The immediately recognizable Volvo logo is present in the upper left corner, the place where most logos go. But it is part of the surrounding blue box and is not prominent. Instead, the content space emphasizes volvo.com, along with five bold images: truck, bus, payloader, airplane, and the Volvo Penta logo. The background color of each division image matches the corresponding link color of the horizontal navigation bar above. These five images themselves are rollovers with explanatory messages and links to the division pages, which continue the color scheme established by the entry page.

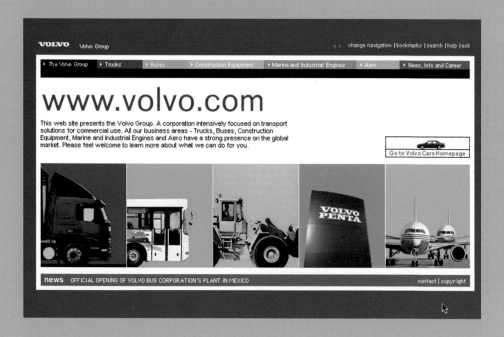

(ABOVE) The OpenWindow JavaScript used to launch this window also turns off standard scrolling and browser commands. The effect is somewhat TV-like, concentrating your attention on this single display space.

DIVIDE AND SUBBRAND

This color scheme also shows how Volvo has clearly divided its site into five divisions, but has not left out important links to nondivisional elements: news, info, career, contact, and copyright information. While these features are nonhierarchical, it's important for browsers to be able to access them from the top level of the site. Grouping them in the red links makes them accessible without giving them more importance than the corporate entities that make up the Volvo Group and thus detracting from the brands presented here.

Even though the contents of Volvo's Web package don't take up much room on the page, a lot has been crammed into this space. For instance, the headings of the navigation bar are not just simple links. Clicking a heading opens a drop-down menu of links that provide direct access to the hierarchical sections within each division. Clicking once anywhere within the navigation area activates rollover access to the drop-down menus and links. Clicking a second time executes the highlighted link or turns off the rollovers.

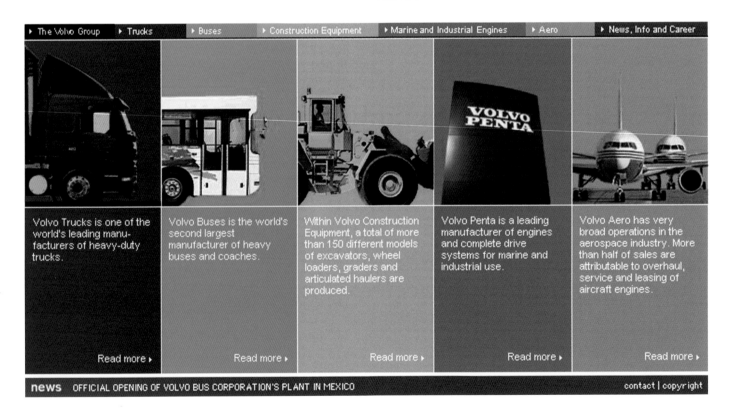

(ABOVE) This composite screen shot shows the navigation bar, the five images, their rollovers, and the red news bar from the bottom of the page. This makes the use of color to brand each division within Volvo more obvious.

User-interface experts can argue over the advisability of forcing the user to click an extra time instead of using direct rollovers to drop the menus. I prefer the direct rollover, but as long as the implementation is consistent, as it is here, either system is fine.

This is a dense page, yet we are not overwhelmed by the number of links or the amount of information. The rectilinear layout (some might call it boxy) establishes a strong framework upon which all the pages of this site are based. Even the color scheme for the site is evident from the start. This spare, unfussy arrangement imparts the kind of elegance that is one of the hallmarks of Swedish design in general, and Volvo in particular.

▸ The Volvo Group	▸ Trucks	▸ Buses	▸ Construction Equipment	▸ Marine and Industrial Engines	▸ Aero	▸ News, Info and Career
Home	Home	Home	Home	Home	Home	Home
Business Overvie	Customer Off	Corporate Inf	Product Range	Business Information	Business Inf	Press Releases
CEO	Volvo Trucks	Press Center	Dealer Locator	Importers/ Dealers	Military Engin	Image Bank
Board	Our Core Valu	Product Rang	Business Information	Marine Commercial	Commercial E	Calendar
Management	Markets	Used Buses	History	Marine Leisure	Engine Servi	Publications
Core Values	Business Part	Sales Contact	Media Services	Industrial	Space Propu	Career
Shareholder & Inv	Used Trucks	Public Transp	Career	Parts and Accessories	Land & Marin	Contact
Research & Technology		After Sales S	M3 Magazine	Press Center	Volvo Aero Turbines (UK) Ltd	
Volvo in Sponsoring		Contact Us	Contact Us	Human Resources	Aviation Support Services	
Volvo Information Technology				Core Values	Vehicle Components	
Other Volvo Companies				Contact Us	Research & Development	
History & Museum					Product key	

(ABOVE) Here's a composite image showing all the drop-down menus on Volvo's home page. Notice how each division has its own home page, as does the news heading.

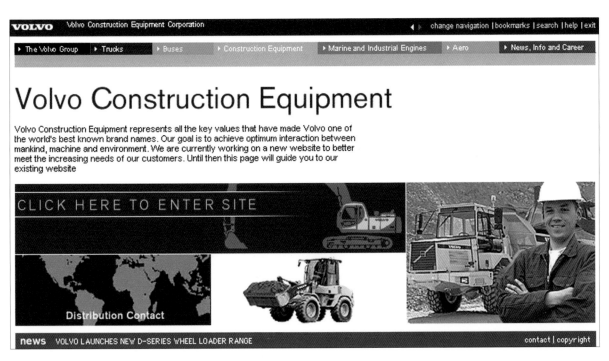

(THIS SPREAD AND FOLLOWING SPREAD) Each division page is distinct, yet there's a harmonious order to them all. The truck site corresponds with the bus site, which corresponds with the heavy-equipment site, and so forth.

The fact is, it's a beautifully engineered site. So beautifully, that barely anything needs to change when you enter one of Volvo's divisions. And yet it's clear at all times exactly where you are. The portal frame changes, as does the color of the highlight under the navigation bar. More subtly, the subheading following the Volvo logo at the top also changes for each division.

The collage of images on each division home page provides non-hierarchical links to more current, important, or popular items. Rolling over an image pops up a caption for the connected link, although there's at least one animated GIF on the Construction Equipment page. The particular images and the number of links can be changed to suit the division or to reflect recent events. It's boxy, but not rigid.

The site could do much more, but many of the links leave the order-liness of this nearly hermetically sealed package to individual division sites, which are generally quite ordinary in their use of navigation, imagery, and in establishing the Volvo brand at the high end of a blue-collar world. This opens the question of who's actually using this site. It probably wasn't built for teamsters. No, this equipment may be built to get dirty, but it's being purchased by a very white-collar crowd: The same crowd that feels safe waiting in the school pick-up line in one of those very boxy, but beautifully engineered Swedish station wagons from Volvo.

VOLVO | Volvo Aero Corporation | ◄ ► change navigation | bookmarks | search | help | exit

▸ The Volvo Group | ▸ Trucks | ▸ Buses | ▸ Construction Equipment | ▸ Marine and Industrial Engines | ▸ Aero | ▸ News, Info and Career

Volvo Aero Corporation

Volvo Aero, a wholly owned subsidiary of AB Volvo, develops and manufactures components for aircraft and rocket engines with a high technology content as a partner to the world's leading manufacturers in this segment. In its service operations, the company offers a broad range of products, including sale of spare parts for aircraft engines and aircraft, sale and leasing of aircraft engines and aircraft, and overhaul and repair of aircraft engines.

news VOLVO TRUCKS' DELIVERIES JANUARY-FEBRUARY 2000 | contact | copyright

What's in a name? Everything, if it's followed by .com. Would a rose smell as sweet if it were from rose.com (a seemingly defunct ISP), or roses.com (a florist)? Of course, innumerable rose dealers exist online. You can find cut roses (flowers.com), rose plants (rosarium.com), rose forums (roses.about.com), and endless information about roses (roses.org). But only one rose.com exists, and as a Web site, it stinks.

Okay, so the scratch 'n sniff transfer protocol has yet to be perfected, but a site can convey a lot of information simply from its look. The look can set the tone or mood as effectively as text copy or any single image.

Domain names are an important aspect of Web sites, but as explained in Chapter 1 about monster.com, plenty of room is left for imagination. And perhaps too much emphasis exists on domain names. Names, as well as tag lines, words used for buttons, and the tone of textual content, create perceptual associations for browsers. This nonvisual identity of a site in some ways is the most important aspect of branding, because it's completely portable.

For example, the monster.com site uses a lot of visual imagery, most notably with its monsters and color schemes. But the site's tag line, "Work. Life. Possibilities," has a succinctness and ring of truth to it that no monster, no matter how inventive, can match. Sites in this chapter were selected for their nonobvious use of branding elements and not for their "coolness." In fact, these sites achieve their strong sense of brand almost in spite of themselves.

[2] IMAGE PERCEPTION
NONVISUAL IDENTITY

CELTIC BREW—THE SECRETS OF OBFUSCATION ∎ 031

Tazo, the tea packager, was recently purchased by the biggest brand in the Northwest that's not yet a monopoly, Starbucks. Tazo makes a high-quality product that is sold largely on the basis of pretense—Tazo, "The Reincarnation of Tea." Even the name, chosen to sound mystical in an Eastern, spiritual sort of way, is complete fiction. It's all made up. And yet even supposedly sophisticated types buy the stuff. Fortunately, the joke is a clever one, and you can drink the tea, which is good, and chuckle inwardly at the joke.

Teaologists, tea scholars, and tea shamen have all contributed to the self-described tea universe that is tazo.com. What's going on here? When you enter the Tazo universe at www.tazo.com, you must wait through a long pause while the Flash movie loads. The use of Flash is a high-tech solution with a decidedly archaic-looking result.

THE TEA LEAVES ARE CLOUDY; THE EFFECT IS NOT

This site revels in sophisticated phoniness. About the only real object on this entry page is the Tazo logo, and it's reproduced in such a way as to look like an old grave rubbing. The site is like a magician's sleight-of-hand trick. This page, the first loaded, is labeled number three. A definition of Tazo, complete with correct pronunciation and dated 4786 B.C. is at the bottom. The symbols on the page look like characters from an ancient alphabet with odd reference numbers. The whole presentation looks genuine, and for a split second you might believe that Tazo is not just a modern-day fabrication. But then the joke becomes obvious and you play along, believing whatever the tea leaves tell you.

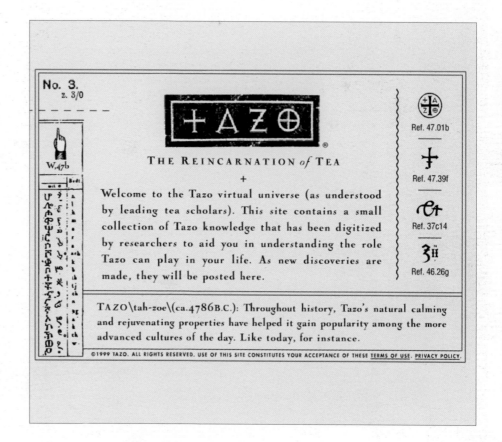

(ABOVE) It looks like something as mysterious and ancient as the *Book of Kells* with fuzzy reproductions of what might be ancient Christian imagery and an odd blend of Saxon and far Eastern typography. But this home page is really an elaborate hoax.

POKING FUN WITH SERIOUS DESIGN

The elements may be mystical, but graphically, this composition is very modern. The simple ruled box centered on the page, the incongruous dashed line that breaks the border, and even the reverse logotype are all popular design elements. But here they are used in unconventional ways, which is part of what makes this page interesting.

When you unwrap this package, you can see what's inside this brand. It turns out that the links all lead to the same series of four frames within this Flash animation. These pages all bear the marks of the Tazo Universe—slightly blurry imagery, unrecognizable foreign characters, and a reverential tone that is completely tongue-in-cheek. Even the color scheme has the musty quality of a medieval cathedral, and yet, it's very contemporary.

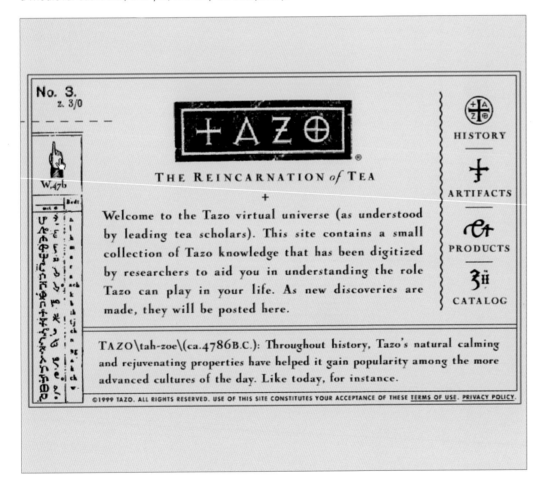

(ABOVE) The bogus reference numbers on the right side are actually rollover links, making the right column a sort of navigation bar. The upward-pointing hand on the left, though not a rollover, is a nonhierarchical link. This screen shot shows all the rollovers and the nonhierarchical links in their activated state.

NO TREASURE UNDER THE MOSS

What's strangely missing from Tazo's Web package is any real information. What are the products, how do you get them, or even why Tazo? The first two questions are answered by links to Starbuck's site, a temple of Web commerce, and by a link to a catalog request form. Surprisingly, this place is not one from which you can find out anything about tea.

Tazo isn't selling anything but karma, which, in a way, is the answer to the third question. In the search for brands that have meaning beyond a patented "flow-thru" tea bag, Tazo presents itself with twenty-first century sophistication. Tazo makes you feel comfortable, hip, smart, or some other form of modern contentment, which makes people happy to be a part of the Tazo fantasy.

Obviously, Tazo's site will change, and most likely it will sell its wares online someday. But doing so should be easy for it because its Web persona is already well established.

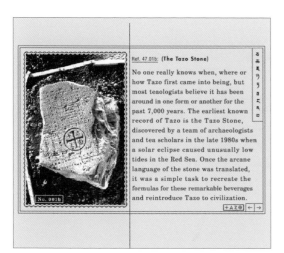

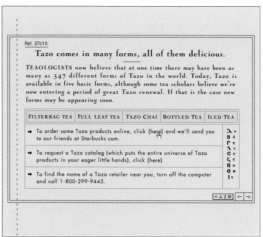

(ABOVE) At the bottom of each frame are navigational elements that let you move forward, back, or return to the Tazo entry page. Because the site uses Flash, the pages have already loaded and you can move about very quickly.

SEEKING CLARITY FROM SUBTLETIES

The Metro Furniture Company has been in the contract furniture business for over ninety years, with a history it is obviously proud of. But this history doesn't really fit with its image as a furniture supplier to the offices of Silicon Valley—thus the motto, "A 94-year-old start-up company," which shows up near the top level of its Web site on the About Metro page at www.metrofurniture.com/about.htm. Tradition is a nice thing, especially since it means that the brand is already well established. But the branding on this site is all about the things that go on around the simple circular Metro logo.

DESIGN BASICS: COLOR, TYPOGRAPHY, AND LAYOUT

What is it about the Metro home page that so clearly bespeaks sophisticated design? First, this home page is created to look like a duotone photograph, a processing trick used to enhance contrast. In a full-color medium, such as the Web, tricks like this one aren't necessary, but they create an effect that is quite striking. The two colors used here, a sort of Italian pasta of paglia e fieno (grass and straw), is distinctively eye-catching—an unusual combination on the Web. The navigation bar across the top uses the pale grass color as background with a contrasting deeper green for the textual links and the Metro logo (in the upper-left corner where we most expect to see it).

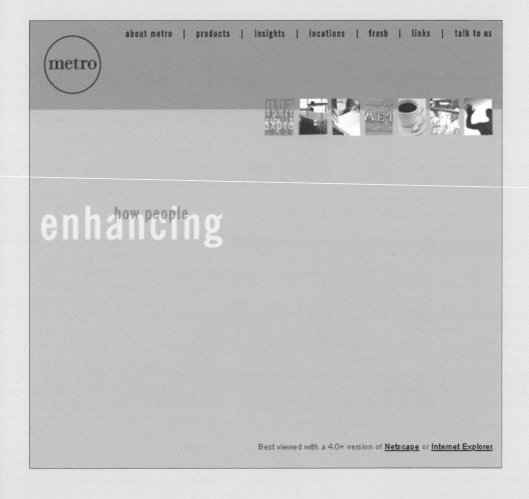

(ABOVE) Metro's home page isn't technically flashy. There is a simple animated GIF and some nicely implemented rollovers, but the most basic things—color, typography, and layout—make this page succeed. These intangibles have as much to do with establishing the Metro brand as the meticulously designed products.

The animated GIF, which contains the message for the site, plays within the straw-colored field that fills most of the page. The message is never visible all at once. You have to read the words as they fade from one to the next, changing size, color, and position. It's a device that engages, making you feel as if you are a part of the site. Thus you become convinced that Metro's furniture is "enhancing how people express and experience their space."

HARMONIOUS BRAND ELEMENTS USED HIERARCHICALLY

All the elements of this home page match the company's logo in simplicity, elegance, and sophistication. The sparse but pithy text, the striking duotone color scheme, the basic graphic layout, and even the clever but direct navigation bar give us a very strong feel for this brand. Imagining that the furniture has the same close attention to detail and attractive, high-quality design is easy.

(ABOVE) For the elegant navigation bar, the seven links are spelled out across the top of the page and with seven duotone thumbnail images to match. Roll over a link or image and the image darkens and tilts slightly while the matching text link is highlighted white, and a menu of second-level hierarchical links drops down.

Take a look at the brand page for the Detour line (left). The navigational scheme and graphic layout remain the same, but color pictures and new background colors exist. Also included is an additional logo for Detour along with its tag line, "Seek alternative routes." The logos also serve as links back to the brand home pages—the Metro logo to the site home page and each furniture line logo back to its section page.

Metro achieves an appropriate level of detail on this page without losing any of the feeling established on the home page. At this level in the hierarchy, ample text explains the product line and gives the specifications for the pictured room. It all fits. Compare this page to product packaging where the box shows an exciting, action-packed wonder toy, but inside is only a cheap, plastic, do-nothing toy. Metro's site is substantial and, at least from the photos, so is the furniture.

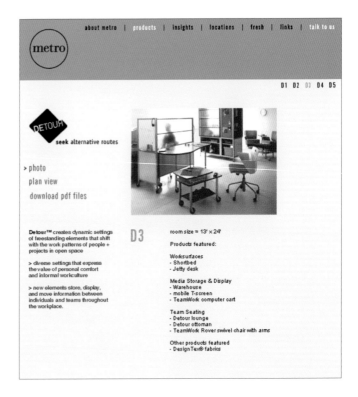

(LEFT) The two-tone background divides these product pages so that the top color stripe contains all that is Metro Furniture, whereas the larger space underneath contains the product line, the brand within the brand.

(RIGHT) The images of display rooms are labeled D1–D5, and you can either click the label or the image to see it explained or enlarged.

IF YOU HAVE TO ASK, YOU CAN'T AFFORD IT

Nowhere does this site state that the products are high-priced furniture for a high-priced crowd. Of course, this image isn't what Metro is selling. On the other hand, the site also doesn't state that these products are on the high-design end of the often-mundane office furniture market. However, it doesn't have to. Everything says it without actually stating it. You know without being told that everyone will be impressed if you have an office full of Metro furniture. Now if you could only find the right people to sit in those elegant chairs, you would have a complete office package.

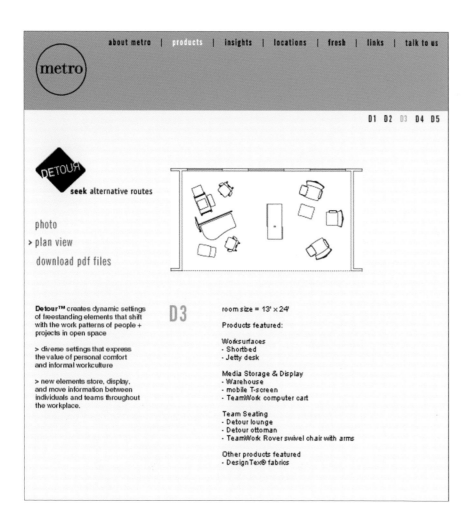

(ABOVE) The informational page is clearly identified with its label, and you can also see the sample room in plan view.

THE SAID AND THE UNSAID

Gmund has been hand-making paper in Bavaria, in the town of Gmund, since the days when Goethe was still pushing a pen. You would think that Gmund would have a lot to say about itself with such a long history, but this site is almost taciturn in its lack of detail. This lack is not necessarily a bad thing, and in this case, it contributes to the site's elegance and spare, old-world quality.

DESIGN CONFLICT: OLD AND NEW, PAPER AND WEB

But what you see here are two different forces at work for two very different kinds of brand identity. First is the old Gmund, with its Bavarian crest and limited supply of very special papers known only to designer cognoscenti. This Gmund has little need for widespread marketing. And then there's the new Gmund, as represented by gmund.com, sleek, chic, and ready for business on the Internet. None of this is stated, but it is inherent in the design of the tidy little package that is Gmund's home page at www.gmund.com.

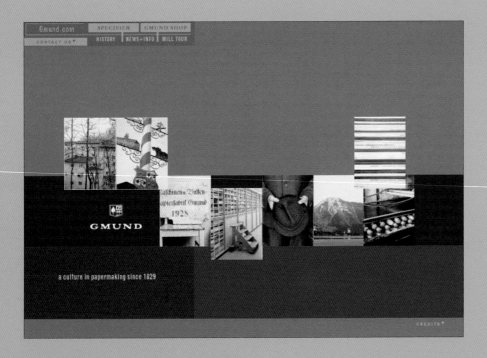

(TOP) Gmund's crest with the old logo is near the middle of the page set against a black band. You can see the almost stark, black-and-white images of the old world on a nearly neutral-colored background. But you can also see a quiet, animated GIF, "a culture in paper-making since 1829," fading in and out in German, English, and French. And in the upper left-hand corner, the place where logos go, is the freshly minted Gmund.com label in a shade of orange that is nearly bright. There's creative tension here.

(BOTTOM) The site brand, Gmund.com, anchors the navigational element, an understated box that nearly hides the intricate workings of this site. There is the box itself, neatly divided into sections, with eight JavaScript rollovers and the home button, which in this instance is orange, a decidedly modern color, to indicate that it represents the active page.

The old Gmund is present in the design aesthetic, while the new Gmund is represented by everything that is Web technology. For instance, the rollovers in the navigation box work two ways (similar to how the Metro Furniture site discussed earlier in this chapter implements them). Roll over any of the images or any of the buttons in the navigation box. This action activates replacement images for both images. The button text becomes highlighted in orange, and the images are highlighted with an orange outline and additional boxes of text.

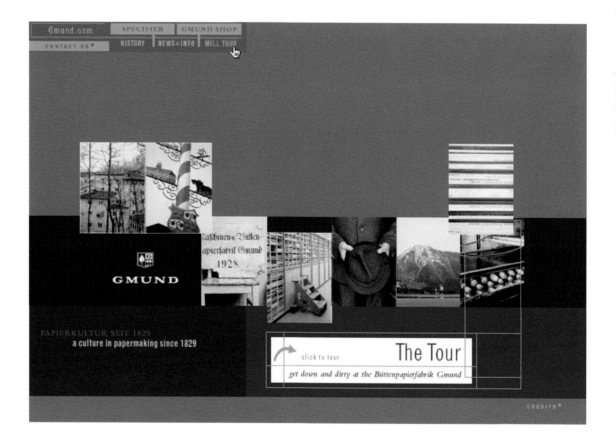

(ABOVE) Rolling over the Mill Tour link invites you to "click to tour."

SELF-GUIDED TOUR AND SELF-SERVICE SHOPPING

You'll find no fancy Flash animation for Gmund's Walking Tour. You must guide yourself through by pointing to each image and seeing what pops up. You have to admire the old farmhouse that serves as Gmund's headquarters, as well as the ancient papermaking equipment. These images really make you want to see what the paper is like.

The specifier page has more of the same. How much variation exists in the papers themselves and in the way they're identified for branding purposes is really quite remarkable. Yet Gmund is able to feature them all with a distinctly consistent treatment. The brand logos are such a tour de force of labeling styles that you might think they would compete for attention. Instead, the straightforward unassuming presentation makes them all seem quite desirable.

The specifier has additional links into the hierarchy of the site's shop. The shop is the only area of the site with any hierarchical depth to it. This site doesn't need as much depth, because so much information is packed into each page. But the shop is different. In a way, it is the personification of the new Gmund, Gmund.com.

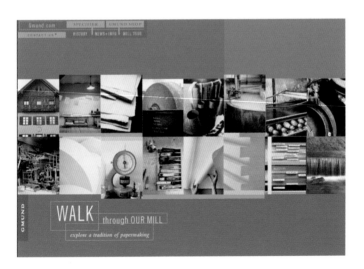

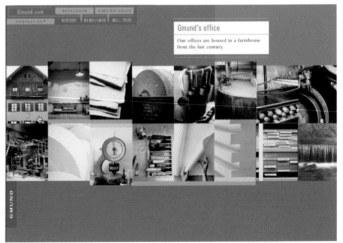

(LEFT) This tour page uses all the same elements found on the home page: the navigation box, the muted background colors (which happen to match some of Gmund's paper colors), the Gmund logo (here without the crest), and an array of diverse images.

(RIGHT) These rollovers don't actually link to anything; they are an end in themselves.

OLD-WORLD ELEGANCE IN A NEW WORLD MEDIUM

What's important here is the overriding elegance of the layout, the attractive presentation of the items, and the fact that everything looks special. The descriptions are straightforward and succinct. If we were actually ordering something here, we would know what we were getting, and we would know, without ever having touched a sheet of this company's paper, that it's all of the highest quality. In Europe in the early 1800s, good taste was considered the epitome of fashion. This site is all about the projection of good taste without the need to proclaim it loudly.

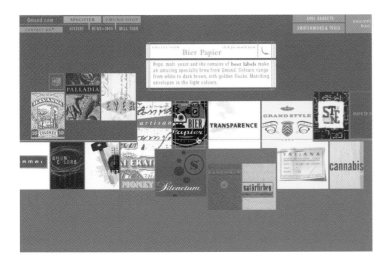

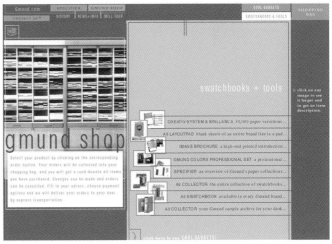

(LEFT) The background colors of this specifier page are a little different, the Gmund crest replaces the logo, and each line of paper is given a brand. Roll over the brand identity to read a brief description.

(RIGHT) In addition to swatch books, Gmund's neatly organized shop is full of cool gadgets and tools. Every item in the shop has textual explanation as does the ordering sequence, so one doesn't have to be an experienced user to navigate with ease.

DESIGNING ONLINE IDENTITIES (CHAPTER 2: IMAGE PERCEPTION)

WHEN A BRAND IS NOT THE BRAND

What kind of brand is Turbonium? Simple—it's a bogus brand, a brand for the unbrandconscious, a way to brand the VW Turbo Beetle without branding it. It's a way to make the right people—and you know who you are—feel even better about liking the retro, yet very contemporary, reincarnation of Volkswagen's Beetle. It's a car site for people who don't necessarily like cars.

The Turbonium site, www.turbonium.com, shares some of the studiously subtle nonbrand features of the Metro and Gmund sites, but doesn't go as far as Tazo into the land of make-believe. If a site could smile, this one would, yet it manages to do so while carrying a full load of factual data—all the gory specification details that are the usual baggage of car sites. In this site, even the mundane becomes fun. Volkswagen may be the people's car but there's nothing hoi polloi about this site.

Scientists have discovered a new element

skip

FUN WITH ALCHEMY

At the end of the introductory Flash animation, a mild-mannered image is presented in the form of an excerpt from a fictitious periodic table of elements. Trb, Turbonium, is the middle element, flanked by St, Stuff, and Tv, Television. The page is clearly marked with the VW logo and Drivers Wanted slogan in the bottom right corner, and a light gray Volkswagen of America copyright is in the opposite corner. But this page bears the Turbonium brand, a powerful combination of positive energy and product positioning.

Turbonium would not exist, as a brand or an element, without the Web. It is not something you can own or buy; it exists solely to promote the turbocharged VW Beetle to a turbocharged Web-browsing audience. So how do you make a brand out of something that isn't there? Be bold.

and they are calling it Turbonium.

skip

(THIS SPREAD) You enter the world of Turbonium through a Flash animation. Then the animation lingers for several seconds over a glistening image of a bottle green Turbo Beetle and then delivers the punch line. The sophisticated sense of humor is immediately apparent.

MOVEMENT AND SOUND, PLUS AN ANIMATED EXPERIENCE

For starters, the home page serves solely as the primary navigational tool. (The designers of this site are creating an HTML pun by using chemical elements as navigational elements.) Each element represents a hierarchical link, and each level is contained within a different Flash animation. Click the Turbonium square. The music starts again, the green Beetle zooms on to the screen for a few seconds, and then a new table of elemental rollover links is revealed, Eng, Engine; Fea, Features; Spe, Specs; Opt, Options; Saf, Safety; and Cst, Cost.

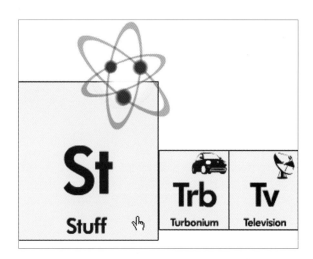

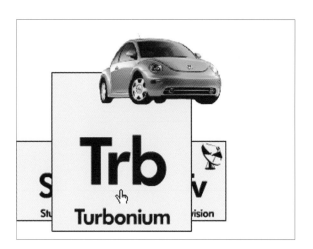

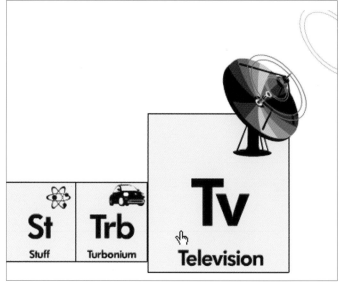

(THIS PAGE) Roll over a button and it isn't just highlighted, it makes noise and practically pops off the page.

Nothing on this site happens in a static way. Even a look at the engine's features becomes something of a game. "Warning: Entering Secure Area. Authorized Research Personnel Only," reads the dire message. A security clearance sequence follows, and then you must choose to enter the Research Area. It's pure gamesmanship, but by requiring you to make a choice, you become part of the game.

After passing the entry sequence, every section page has a nifty navigation tool in the lower-left corner. The page gives no hint as to how the tool works, but it's clear that something will happen when the cursor passes over it. And indeed, the hexagonal element comes to life when touched. The center arrow serves as back button, and the dots around the perimeter of the circle link to the three main hierarchical divisions, to the home page, or to the nonhierarchical pages for dealer information.

SURPRISES AROUND EVERY CORNER

Unexpectedly original schemes make all the sections of this site more interesting. It's the Turbonium way. This kind of amusement keeps one looking at the site, and almost without realizing it, becoming Turbonium-charged oneself.

An interesting note is that even though a VW logo, with a link back to the corporate site, appears on most pages, the Beetle name is barely mentioned at all. This is because the site is selling Turbonium, which is somewhat like hot ice cream or sweat-free exercise—you may want them, but you can't have them. Yet why you're here is perfectly clear. Although the popularity of the Beetle begins with its retro charms, clearly this car would not be selling nearly so well if it didn't appeal to sophisticated tastes.

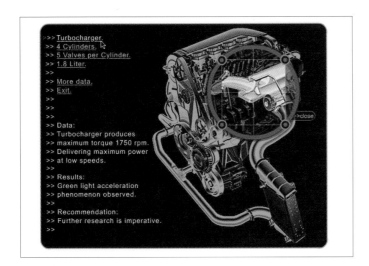

(LEFT) Click a feature. A mechanical voice announces the selection, a section of the engine becomes highlighted, and some humorously written text appears.

(RIGHT) The options link shows a color specifier. Choose any interior and exterior color to see what they look like together. Use the animated navigation tool in the bottom corner to navigate through the twists and turns of this very amusing site.

Logos, corporate identity systems, branding—they've all had to be adapted to fit with new media, which has been both a challenge and a windfall for designers. In many respects, the Web is merely the latest expansion of the media universe, and so, for the unimaginative, it becomes a straightforward process to digitize existing materials and plug them into Web pages. But creative Web branders know that much can be gained by expanding the presentation of brand identities to suit the particularities of the Web.

Look at it another way. You can put a logo on a Web page, but not all logos serve well in this new context. Some are too static, others too detailed, and others too old-fashioned; any number of problems crop up. There are effective methods of translating a corporate image to the Web or expanding a brand in ways that aren't possible in other media. This chapter explores one such expansion, branded navigation.

For instance, the nonsequential aspect of Web sites necessitates careful attention to navigational schemes. The creation of a navigational plan is generally considered a usability issue, not an issue for marketing people—especially those concerned with branding. Yet navigation is one of the most important aspects of site design, the foundation of a site's architecture, and is therefore a prime area for incorporating branding elements.

[3] NAVIGATIONAL CONTEXT
BRAND MAPPING

WWW.IO.COM (URL)
AGENCY (DESIGN FIRM)
MOTOROLA (CLIENT)

DESIGNING ONLINE IDENTITIES (CHAPTER 3: NAVIGATIONAL CONTEXT)

NAVIGATING IO.MOTOROLA.COM

■I 047

On one hand, it's just a site for cable modems, but on the other hand, it's Motorola's cable-Internet-access information center—a site touting the advantages of broadband connectivity to the Internet through cable access in general, and the virtues of Motorola's io brand of cable modems in particular, io.motorola.com. The site is also designed to accommodate expansion of the io line into other product areas. And, by the way, you can also buy the modems from the site.

The io brand (Motorola has chosen to keep both letters lowercase) is Motorola's entrée into home networking and telephone products. The designers are clearly building on the Motorola name, while at the same time creating a new brand category. Thus the use of the subdomain, io.motorola.com, and the design of the io logo, a simple, strong logotype symbol appended to the Motorola name. More importantly, the logo is put to extensive branding use on the io Web site.

NAVIGATIONAL IMAGERY

The introduction to the io site begins with a Flash animation. Like marching ants, a series of pulsing dots leads the viewer to the io words—imagination, information, communication, and transformation. Sound, constant motion, a clear message, and a carefully integrated io logo are woven into the introduction. What the viewer doesn't realize right away is that the glowing dots will be transformed into the chief image element for the site's navigation.

The main navigation bar loads in a frame above the introductory movie. It, too, is a Flash element. Here, the viewer sees an expansion of the dot motif—a series of larger, colored dots, each within concentric circles and arranged within a wireframe funnel, pointing to the Motorola name and the io logo. This Flash element provides the hierarchical links for the site.

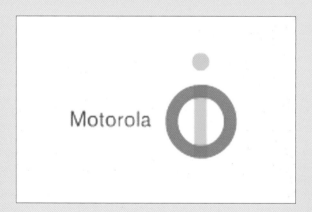

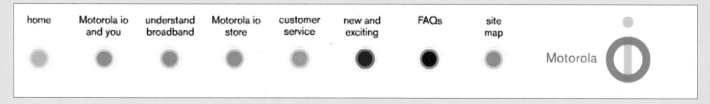

(RIGHT TOP) Is it a reference to computer input and output, to the binary 1's and 0's that make up a computer's memory, or to the on and off states of a computer's power switch? Motorola's io logo is intentionally ambiguous, but full of the right kinds of associations to conjure up positive connotations.

(BOTTOM) Graphically, the io navigation bar is probably too big; it occupies too much vertical space, especially for smaller screens. But it is an effective and attractive tool that doubles as a brand-strengthening element.

BRANDED LINKS

From a branding perspective, each dot represents the reduction of the io logo to its logical minimum, the circle. This means that each dot is an io-branded link. The dots and, therefore, the site sections, are identified by color and label. Therefore, instead of a generic home button, there is an io-home button, and so forth. This use of visual cues to establish the unstated helps strengthen the page visually, and as a result, the io-ness of each link is understood. Each linking element is further reinforced with a rollover and a surprising gonglike sound when clicked.

Most people browsing the Web recognize a horizontal navigation bar across the top of a page and understand that this top-level band of links is analogous to the top-level hierarchy of the site. The addition of multimedia effects adds to the perception that io is a high-quality, sophisticated brand. Visitors to the site can enjoy the mere fact that someone has taken the time to create an interesting and useful navigation bar. This navigational element is fun in a unique way that adds luster to the io brand.

The secondary navigational element down the right column of the page features nonhierarchical links. What's the difference between a hierarchical and nonhierarchical link? The top navigation bar corresponds directly to this basic, two-level hierarchy with six second-level divisions, each with a number of pages linked.

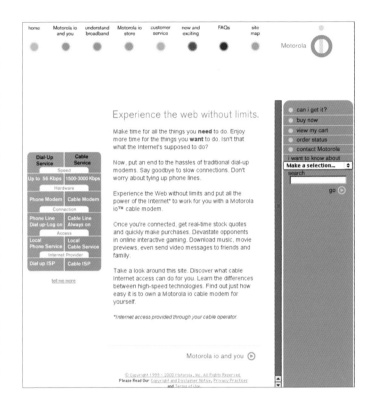

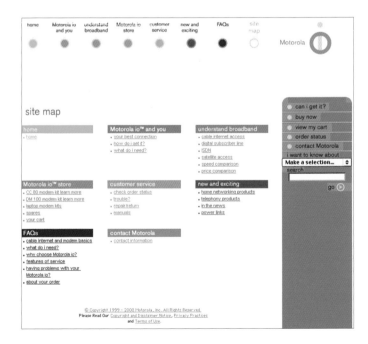

(ABOVE RIGHT) Putting the top navigation bar in a frame allows it to be implemented as a Flash animation while other frames are filled with standard HTML. In the case of io's home page, there are two additional frames: a wider content frame to the left and a second navigational element as a narrow column on the right.

(BOTTOM) This site map clearly shows the hierarchy of the site laid out as divisions and subdivisions.

NONHIERARCHICAL LINKING—STILL BRANDED

Io's side navigation bar is nonhierarchical, because it links to pages without regard for hierarchy. For instance, the first link, "can I get it?" bypasses the second hierarchical level altogether. Following the hierarchy to the same location requires a visit to the Motorola io and You page, where the text links to the same location. There are additional nonhierarchical links in a drop-down menu and a search field, the ultimate tool for nonhierarchical linking.

The yellow dots used in this navigational column glow within a concentric circle when selected. Is it a stretch to say that these links, too, are io branded? The buttons do represent an abstraction of the io logo, and in this way are associated with the brand. It's subtle but purposeful. Yellow dots, like the dot over the *i* in io, become a design theme for the site and its navigational elements. In this way, a branding element has been put to use and extended.

At the bottom of the Make a Selection pop-up menu is a link to Future products. It's not surprising, but it is revealing, and it means that this site, with its simple, two-level hierarchy, will need to expand to accommodate new products and perhaps new product areas. All the pieces are in place to facilitate this. Hierarchically, the Flash-based navigation with its drop-down expandability for divisional links provides a tool that's easily updated as the site grows. Programmatically, the side column with its drop-down selection menu and search field has plenty of room for more choices and can easily accommodate change.

Functionally, the navigation for the io site is well established, even as the content changes. Thematically, the brand-new io identity is ingrained into the site. But aesthetically, it's not a perfect site. The use of happy-people photographs as the main image element used to ornament the site is trite, and the frames feel unbalanced. However, the abstraction of the io logo to brand the site's navigation is clever and fresh. Other problems can be fixed as the site evolves around its strong navigational scheme.

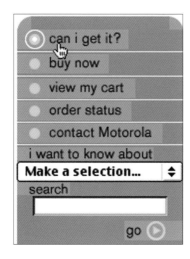

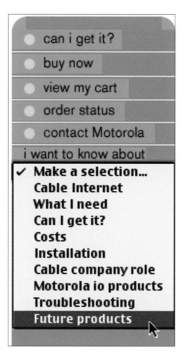

(LEFT) Io-branded links in the navigational column repeat the yellow-dot theme of marching ants used in the introduction sequence.

(RIGHT) This nonlink to future products is included in the navigation column as both a placeholder for future expansion and a teaser to customers interested in the io brand.

EXPLORING MODERN ART

The boldly understated Web site for the San Francisco Museum of Modern Art, SFMOMA, provides a strong contrast to the bold graphics and cutting-edge technology used by Motorola to establish its new io brand. Where io is flashy (both literally and figuratively), SFMOMA is cool and elegant in an almost blocky way. It's modern versus modernist, and modernist is looking awfully retro, and retro is looking seriously attractive these days. At least there are no smiley faces.

DECONSTRUCTING PAGE ELEMENTS

There are really only three elements here, though one, the navigation bar, is a complex element. First, there's the previously mentioned black-and-white drawing that serves as background. The second element is topical. This box, filled with a transparent GIF, is not a link but a nicely typeset title carefully positioned over the background. All of the typeset images here use the Futura typeface, Paul Renner's 1927 masterpiece, based on Bauhaus design principles of geometric proportion. It remains fresh and modern.

The navigation bar, the third element, is precisely positioned over the black bar that was added to the background. The navigational portion of this bar comprises nine basic text buttons of hierarchical links, divided into three groups of three by the sliced letters of MO and MA. The text of the buttons becomes highlighted when rolled over. There's also a nonhierarchical search feature discussed after the next paragraph.

(ABOVE) The SFMOMA splash page is anything but splashy. It is formal, geometric, and the epitome of clarity. The background is from a work by Sol LeWitt, whose art was being featured at the museum when this chapter was written. This sparse, almost technical, deconstructivist drawing sets the tone for the site

ACCOMMODATING CHANGE WHILE MAINTAINING THE BRAND

One of the beauties of this scheme is that the navigation is not so much branded as completely integrated into the brand. And even as exhibitions change, this basic brand element remains fairly consistent. Don't believe me? Here's the homage to Magritte version of SFMOMA's splash page.

The fact is, the navigation bar is on most of the pages of the site. This makes it as much a part of the site's brand as the SFMOMA logo. And the logo itself, the museum's initials inside a bold black box, fills the search field at the end of the navigation bar. Turning the logo into a search mechanism is the ultimate in branded navigation. It takes an extra step to perform a search. But the scheme is so clever and engaging that the extra step actually seems worth it. Additionally, this avoids the problem of designing around an ugly form field on every page. It's an aesthetically elegant solution to something that most designers don't even realize is a problem.

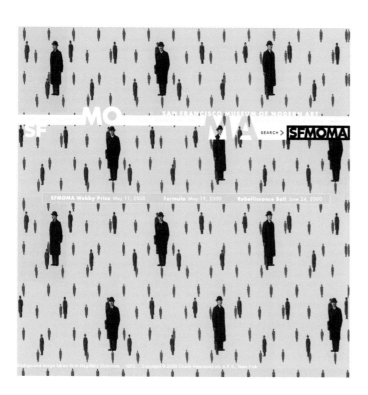

(TOP LEFT TO RIGHT) This logo block has been integrated into the navigational scheme as the site's search field. Click in the field, type in a word, and press the return key to make a nonhierarchical search of the entire site.

(BOTTOM) As featured exhibitions change, so does the background image of the home page. Ninety percent of this page looks different, but the brand is anchored in the instantly recognizable logo and strongly placed navigation bar, so the page is more familiar than not.

SUBBRANDING DIVISION WITHIN
A WELL-ESTABLISHED HOME BRAND

The organization of the SFMOMA site follows the three-by-three first-level hierarchy established in the navigation bar. Each of these three sections becomes a subbrand of three divisions each. The first page of the Visit division is topped with the same navigation/brand bar, but this time with a set of GIFs matched to the green background. The first three links are on a white background to show that this is the active group, while the other six links are backed by green. The Visit text is red to show that this is the active link. Other button links show red on rollover. The page is titled Visitor Information, and the page content—a nicely typeset column of text with useful information—is beneath the title.

A column to the right of the content is used as a sidebar and secondary navigational element. This is a standard page element for the three sections—Visit, Info, and Calendar—with green pages. At first it's not clear that an additional navigational element exists. The only clue is the red dot to the left of the box, indicating the active link. Following the protocol set by the top navigation bar, the text is in all caps (just like the logo), the active link is red, and the other links turn red on rollover.

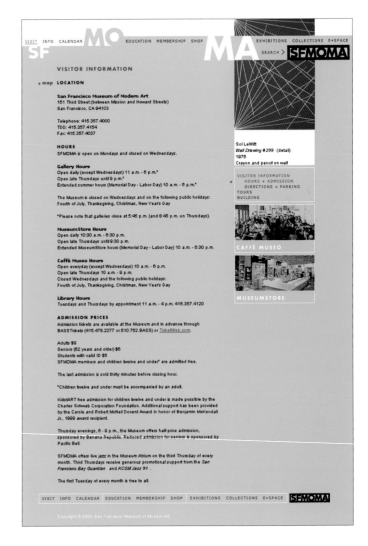

(**ABOVE**) Within the first three divisions of the site, Visit, Info, and Calendar, use similar layouts and are all set on green backgrounds.

ESTABLISHING A HIERARCHY WHILE PROVIDING NONHIERARCHICAL NAVIGATION

Actually, this site is skipping hierarchical levels and thus avoiding unnecessary pages. Instead of using a general tour page with three pages under it, viewers are taken directly to the first tour link, Docent Tours. You must click again to select Audio Tour or School Tour information. This scheme is applied consistently throughout the site's hierarchy, although the first link is often an overview page. This elimination of divisional or section home pages helps to lighten the site, keeping the hierarchy fairly broad and not very deep; this streamlines the navigation of the site and reduces the number of clicks to get to the informational pages.

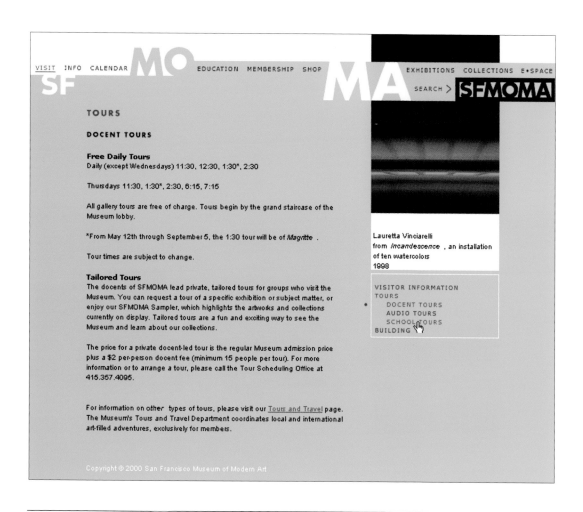

(ABOVE) As you proceed down in the hierarchy, the content of the pages changes and the images from the museum's collection change, but the navigation remains the same. On the Tours page, the second hierarchical level is shown simply by indenting the links in the side navigation box.

FURTHER DIFFERENTIATION

The second group of three sections—Education, Membership, and Shop—uses a blue background for the content pages. Above the text column is a section photograph. The Education pages are topped by a photograph of children enjoying a kinetic sculpture, and the Membership pages all have photographs of members looking at artwork in one of the galleries.

The Shop section has a deeper hierarchy and is topped by three rollover images for its three secondary level links: E-Tickets, Rental Gallery, and Museum Store. This is the e-commerce section of the site, functionally different from the other sections, so it seems appropriate to use a separate section page here. (See Chapter 10 for further discussion of branded e-commerce.)

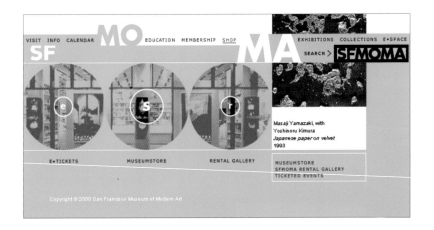

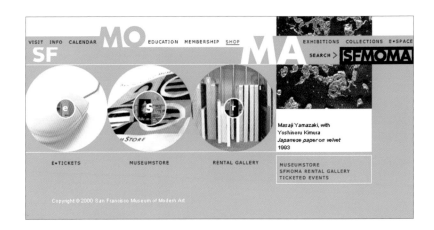

(THIS PAGE) Here are two views of the Shop page as loaded and in a composite view showing the three links in their mouse over highlighted state.

BRANDED ONLINE EXHIBITION

For the third division of the site, the background color changes to orange and the layout switches from vertical to a horizontal triptych of pictures. There's very little text, just captions. This is because the pictorial layout becomes the secondary navigation—simply click on a picture to follow the link. All three of these sections utilize a horizontal layout. Unfortunately, many browsers hate to scroll sideways and most find it at least awkward. Going against standard practice forces viewers to see these pages differently, creating yet another way to establish the SFMOMA brand.

Even as the navigation changes, it remains remarkably clear, consistent, and usable. It even works in a nonhierarchical situation. Furthermore, when reduced to a simple statement, all of SFMOMA's site navigation is fit into boxes. The box takes on a number of forms: the main navigation bar, the branded search box, the secondary rectangles, and even the navigational timelines and collages are like compartmentalized boxes. But it is the consistency with which these navigational boxes are implemented that makes them such strong elements. Add to this the careful use of the Futura typeface as a kind of museum brand or extension of the logo, and you've got navigation that says SFMOMA on every page.

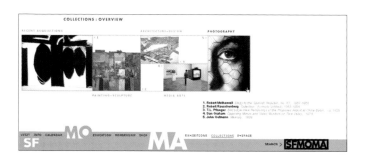

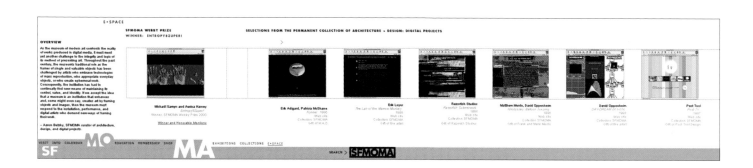

(TOP RIGHT) The Exhibitions page is arranged like a timeline. Here, the brand scrolls to the right to reveal the complete extent of current displays. **(SECOND TOP RIGHT)** The Collections Overview page uses a collage of images for its secondary navigation. Roll over an image and its identifying text turns red.

(ABOVE) The E-Space page uses the same layout as the Collections Overview, but the Webby Prize link does not move down a level within the section. Instead, the Webby award is handled in the News section of the site, and the link leaps straight over to a vertically arranged, green page with all the information.

WWW.APPLE.ORG (URL)
APPLE COMPUTER (CLIENT)

DESIGNING ONLINE IDENTITIES (CHAPTER 3: NAVIGATIONAL CONTEXT)

DISTORTING REALITY IN 3D

Before venturing a look at the branded navigation for a really big site, it is helpful to look at what its site plan reveals. The site map for Apple Computer is a basic, two-level map with eleven divisions, each with a number of sections. One can assume that many subsections lead down to the thousands of pages that make up this hierarchically deep site. But hold on one moment. This may be one company, but it isn't a single site. While it's not immediately apparent, this plan actually comprises a number of interrelated sites, all of which bear the unmistakable Apple-branded look

It all looks very logical from a corporate, organizational point of view, but Apple is not trying to convey a corporate point of view through its Web site. Such is not the stuff of the carefully polished Apple brand image. It's time to navigate differently.

Site Map

Worldwide Apple Sites Go

About Apple
- Media & Analyst Info
- Job Opportunities
- Investor Relations
- Contact Information
- Apple & the Environment
- Privacy Policy
- Legal Information
- Web Badges

News & Events
- Hot News
- Apple eNews
- Features
- Seminars
- User Groups
- AppleMasters

QuickTime
- Movie Trailers
- QuickTime TV
- Features
- QuickTime Streaming Server
- Download QuickTime

iTools
- iTools
- KidSafe
- iDisk
- iReview
- iCards

Market Areas
- Education
- Creative
- Small Business
- Games

The Apple Store
- The Apple Store
- Apple Store Worldwide
- Apple Store for Education

U.S. Retail & Service
- Find a Dealer
- Loans & Leasing
- Product Registration

Support
- Product Support
- Protection Plan
- Technician Training
- Software Updates
- Product Specifications
- Tech Exchange
- Tech Info Library
- Apple Solution Experts

Hardware
- iMac
- iBook
- Power Mac G4
- Macintosh Server G4
- PowerBook
- Displays
- AirPort
- Firewire

Software
- AppleShare IP
- AppleWorks
- AppleScript
- ColorSync
- Final Cut Pro
- iMovie
- Mac OS
- Mac OS X Server
- QuickTime
- Sherlock
- WebObjects

Developer
- Apple Developer Connection
- ADC Membership
- Technical Information
- Business Opportunities
- Apple Solution Experts
- Macintosh Products Guide

(ABOVE) This site plan reveals a domain that is so wide and deep that it requires a third organizing axis in the form of subdomains. There is the root domain, www.apple.com; there are subdomains, such as www.store.apple.com, a related www.mac.com domain; and there are hierarchical divisions, such as www.apple.com/products/. There's also a drop-down menu of over two dozen localized versions for Apple's worldwide locations.

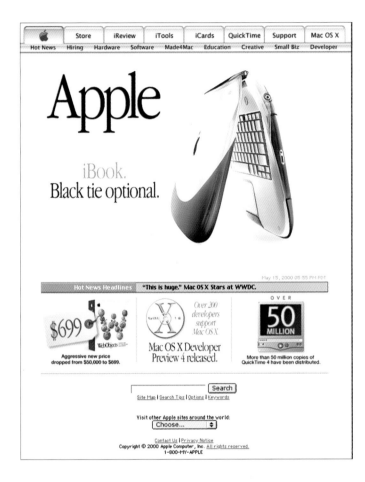

ESTABLISHING BRAND PRIORITIES

Compare Apple's home page to its site plan. Strangely, the very logical, straightforward arrangement of the site plan is not reflected in a one-to-one correlation with the navigational elements on this page. It's important to remember that while a hierarchical scheme is necessary for the building of Web sites, browsers of a site need have no knowledge of the actual hierarchy employed. This is why Apple's site plan, with its categories and divisions, is so nicely logical but relatively superfluous to the design of the home page and its carefully branded navigation.

First of all, the brand look has been strongly defined since the day back in the early 1980s when Apple adopted a version of Garamond Condensed to represent its corporate identity. It is seen in the name prominently displayed on the home page, all over town on large "Think Different" billboards, and on all Apple's print ads and packaging. It's as important and recognizable as the Apple logo itself.

Now Apple is doing the same thing, using the same Garamond Condensed with its operating system, giving it a clearly branded appearance. The interface for Mac OS X, officially dubbed Aqua, uses highly refined, 3D, transparent objects—the lozenge look. The same elements have been adopted for the navigational elements of Apple's Web site with the 3D, transparent tab bar, the aqua highlight color, and an occasional pulsing animation. The look becomes the brand.

(ABOVE) Apple's home page, with its top navigation bar of tabs and secondary navigation bar of textual links, looks like a classic hierarchical arrangement but is not. Apple chooses its links for marketing, rather than organizational purposes.

SELECTING TABS, JUMPING THROUGH HIERARCHIES

The top-level tabs are chosen not for their hierarchical significance but for their marketing importance. Under each tab is a hierarchical navigation bar of secondary links. Notice that the Hardware and Software links, Apple's bread and butter, are relegated to secondary link status. The page features hardware most prominently, and QuickTime and Mac OS X, both categories of software, are featured at the tab level. This is more evidence of the attention given to usability and branding as opposed to strict organization for this site's navigation.

The most obvious example of Apple's use of navigation to heighten the importance of information above its hierarchical niche is with news items. In the site map, the second division is for News & Events, yet there is no News & Events tab on the home page. There is, however, a secondary link for the Hot News section, and more significantly, a Hot New Headlines bar with a thirty-six-layer, animated GIF ticker.

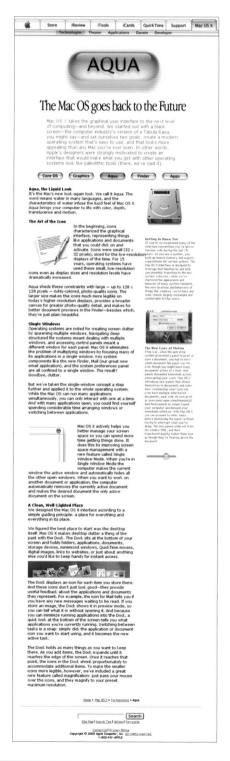

(ABOVE) Each tab brings forward its own secondary navigational links, and each features a different highlight color. For the Mac OS X tab at the end, the color is intentionally aqua, and the featured links are lozenge-shaped to match the new user interface.

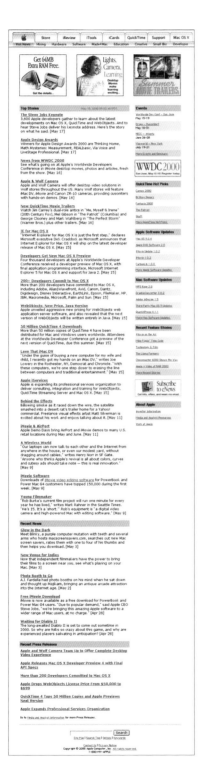

DYNAMISM IN ITS PLACE

Interestingly, the news ticker is the only bit of dynamic HTML on the home page, although the main image does rotate randomly among Apple's currently featured product each time you load the page—a sort of static dynamism. Other pages feature QuickTime—there's a whole section of QuickTime movies—but Apple is not going for a high-octane, cutting-edge site. Instead it's using very sharp design to show off high-octane, cutting-edge products.

A big company with active development and marketing groups is going to produce more news than is easily digested by the typical browser. Each listing approach has its advantages, but only the branded approach enables a company to direct attention where it most wants it. It is the navigational hierarchy that is more important to users than the physical hierarchy of pages in a plan (which is likely to be more important for designers and Web architects).

(ABOVE) Compare the animated GIF headlines of Apple's home page to the hierarchical listing of news by clicking the Hot News link. There are all kinds of news, events, press releases, software releases, and even old news.

BRAND CONSISTENCY ACROSS SUBDOMAINS

Apple's domain is also a good example of a site with many entry points. Despite the number of nonhierarchical paths through the site, the structure of this collection of related pages shows a classic top-down arrangement, with the home page on top. Yet one could just as easily enter through the Apple Store and feel that the organization was top-down from the store's home page.

Or one might enter through the Support home page, www.apple.com/support/. Of course, as an entry point, these are primary and secondary navigational schemes. But however you count the depth, it's a navigational brand that has been carefully selected to match the function of the site section.

The tip-off is that no matter where you enter, Apple's 3D, transparent tab bar brands every page. "This is Apple, the land of the Aqua look," it declares. Various site locations have additional navigational brands, but they are always chosen to work harmoniously with the corporate image of Steve Jobs' Apple.

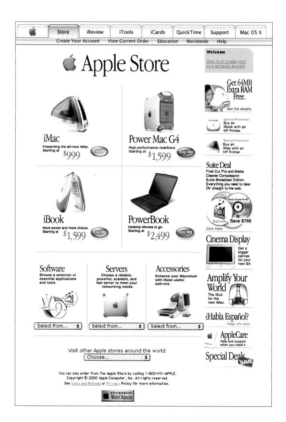

(TOP RIGHT) The home page for the Apple Store, and most of the pages in the store subdomain, is built on the fly using WebObjects, and its tertiary navigational scheme is simply the product images with image map areas defined for links.

(BOTTOM) The tertiary navigational scheme for Apple's Customer Support home page is based on clearly delineated product lines. Rollovers are used to identify the links and a fourth level of navigation.

THE POORLY BRANDED COMPETITION

Just for comparison, look at the home page for Compaq, formerly the number one PC manufacturer. There's no need for a separate site plan here, because the home page serves this purpose. There are plenty of places to go, but not much direction—one feature story, a couple of product specials, and a few news links.

This laissez-faire attitude toward navigation creates ambiguity. Do I want "desktops," under "products & services," or do I want "home and home office," under "solutions for"? The strict reliance on hierarchy makes it difficult to rank relative importance. This has also created a large number of choices at the second hierarchical level without providing any visual clues. Essentially, all links at the same level are the same shade of gray. Is this any way to brand a computer manufacturer?

Did Compaq forget that it's in a competitive market where every perceived edge helps? One could just as easily be looking at Dell's or Gateway's sites, and these links would be nearly as valid and generic-looking. It's easy to be critical of Apple and its emphasis on a patina of high polish but you have to admit that it makes the Web site much more usable and a lot more fun.

(ABOVE) Compaq's hierarchical site plan is providing the major focus and the primary image for this home page. There's no attempt to brand the experience, only a lonely Compaq logo.

Many reasons exist for the success of the Web, but there's no arguing that its existence as an informational medium is key. Even the vocabulary of knowledge has been changed by the onslaught of Web-based data. What used to be simply information has been transformed into content, and content has become the coin of the realm for most Web sites.

Whether it's straight text, images, or multimedia elements, information is the product and Web pages are the package. Unfortunately, the stuff of one page can become indistinguishable from the stuff of some totally unrelated page. This situation is the effect of HTML as a broadcast medium. Yet in a sense, this effect is one of the Web's strengths—the ability to associate diverse elements. It's almost the equivalent of time travel. One can read about dinosaurs on one page, leap practically in a single bound to join the search for extraterrestrial intelligence, and then wander over to a Web merchant to order violin strings.

Philosophically, this flattening of the information hierarchy brings great egalitarian value, and in many ways was the goal of the Web's founders. But it is public enemy number one for Web branders. For Web designers, differentiation is paramount. They eschew the generic in the never-ending quest for uniqueness.

The well-documented limitations of the Web make branded content a special challenge. The time-honored palette of solutions used by graphic designers in advertising and marketing is severely constrained. The somewhat predictable result is more sameness—endless pages designed to look like Amazon or Yahoo! Duplication may be the sincerest form of flattery, but in the age of Xerox, flattery isn't worth much.

The designer's job is made more difficult by the limited palette of letters that are the constituents of language itself. Words convey our meaning, but a message often includes much more than the meanings of words. This chapter examines sites that package information in ways that turn text into a brand message.

Is it possible to turn content into something that is as immediately recognizable as a can of Campbell's soup or a box of Jell-O brand gelatin dessert on the grocery store shelf? Packaging is certainly a large part of it, but a consistent, trustworthy product is what makes the package compelling.

COVERING THE SAME STORY IN THE SAME MEDIUM

The verdict is in and Microsoft has been found guilty, but everyone has a different opinion about what should be done to remedy this illegal monopoly in the software and operating systems markets. The story has particular significance for the Web and the way the Web is viewed. To some, evil Microsoft is out to brand the Web with its own Windows flag, while for others, Microsoft is the savior crusader bent on saving the world from Web chaos. It's interesting to see how the story is reported on the Web within the Web brands of several significant newspapers.

[4] CONTENT DELIVERY
BRANDED FORMS OF INFORMATION

READING THE NEWS IN THE POST-INTELLIGENCER

On the day the guilty verdict was announced, the top headline of Bill Gates' hometown paper, the *Seattle Post-Intelligencer*, proclaims "Bitter Harvest" and lists eight more case-related headlines along with a link to the text of the decision. It includes a one-paragraph excerpt from the lead article, and the whole group of links is enclosed in a thin gray border.

Now examine the presentation of this shattering news. The P-I, as the paper is known locally, puts its identifying logotype at the top in a brown-edged box that includes the weather and links to the paper's sections. This tops a three-column layout with news headlines and briefs in a wide center column. Nonhierarchical links fill a fourth gray column on the right, which is topped by the P-I's distinctive logo. (It happens to be a re-creation of the globe atop the paper's headquarters in Seattle.) Follow the topmost link to read the lead story. This site is about linking and not about branding.

(LEFT) The P-I's interior page layout remains basically the same. The story fills the full width in the center, the hierarchical links column expands to include secondary links for the current section (business), and the nonhierarchical links column changes to list the day's headlines.

(RIGHT) There's not much to read on the *Post Intelligencer*'s home page, but there are enough links to keep you on the case well past the first cappuccino of the morning.

READING THE NEWS IN THE WASHINGTON POST

Look at how Judge Thomas Penfield Jackson's (the deciding judge in the case) hometown paper, *The Washington Post*, covers the story. It's the top story of the day (though not the featured story), rating a three-word headline, a one-sentence synopsis, and five related links, including an MSNBC video.

Despite its Washington Post logo at the top, this page looks remarkably similar to the *Post-Intelligencer*'s page. Obviously many differences exist, but this basic column layout with brown and gray navigation columns has become almost generic for newspaper sites.

In their quest for usability (which in this case is nothing more than familiarity), these papers seem to have forgotten that they can do many things with a basic layout of columns to make a paper look distinctive. Certainly the tone of the writing is important, but picking up a paper like the *Wall Street Journal* and recognizing it immediately from its size, column spacing, and typography is easy. It's distinctive, and for the journal's regular readers, the distinction becomes familiar and comfortable.

(LEFT) Even the article pages for the *Washington Post* and the *Post Intelligencer* use very similar layouts, although the Post is a little more generous with sidebars than the P-I.

(RIGHT) The column layout in the *Washington Post*'s Web site makes this article perhaps slightly more readable than most informational pages on the Web, but one could hardly call it distinguished.

Now take a look at the online version of the *New York Times*, America's newspaper of record. Again, the breakup decision is the top story in a central column of headlines and briefs, but something looks different on this front page.

The black-on-white centered logo at the top with the date underneath and a small box at the right for the weather match the layout of the print version. But in an ironical twist, the space to the left of the logo, the place reserved on the printed front page for the paper's well-known motto, "All the news that's fit to print," is filled with a banner ad. But in other ways, the Web version of the paper is trying to look familiar to its loyal print readers. For example, the banner is separated from the stories by a thin black rule, just as it is in the print version.

Another important identifying feature of the *Times*' pages makes them distinctive compared to most other newspaper sites. Look at the headlines. They are real typeset headlines, not plain HTML text. Someone takes the time to set each headline using Century Old Style, the standard Times typeface, to create the GIF images each day. It's all part of what makes the *Times* the *Times*.

(ABOVE) This familiar layout looks more like a newspaper, and specifically, more like the printed *New York Times* itself.

THE LAYOUT IDENTIFIES THE BRAND

Look at the way story pages are laid out. A straightforward heading brands the page and its division within the site's white-on-black hierarchical navigation buttons are in a simple row with the horizontal banner ad below. Everything that follows is news.

The story is topped with the typeset headline and followed by the byline. The text begins with a three-line red drop cap inserted into the table as an inline graphic. It seems likely that the *Times*' Web department has a collection of twenty-six drop caps that can be placed as needed. But the fact is that somebody has to make sure that the drop cap gets inserted for each story. It's a little extra work, but it's the *Times* way. A right column without a border is inserted into the beginning of the article. It starts with a graphic relating to the story and includes a list of cross-reference links: related articles, video, document, and links to the *Times* online forum.

(ABOVE) It's just a column of HTML text like the other papers, but the text is not fighting with endless navigational boxes.

The effect of this consistent layout is that viewers don't jump all over the place following a random train of thought. You read the article and then perhaps other articles on the same subject. You can go to the top of the business section or back to the home page to browse another section. But you have to put down one section in order to go on to the next, as you do with a real newsprint and ink paper.

Interestingly, the *Times*, which only relatively recently has inaugurated a full-color printing press, makes very little use of color on its Web site. It shows up only in the backgrounds of sidebars, in photos, drop caps, and banner ads. It seems to be a conscious decision to use black and white as the branding color scheme for Web news.

One could argue that simply re-creating the physical experience of reading the paper is not a very exciting or even valid use of this new medium. But in this case, it creates a site of carefully branded information.

Visually, the *New York Times* has managed to present its regular readers with a familiar view of the news. At the same time, the *Times* has branded its online experience for all Web readers to share. Whether you like it or not, it remains "Timesian."

Technology — The New York Times on the Web

Home | Site Index | Site Search | Forums | Archives | Marketplace

Don't — CLICK HERE

The Microsoft Antitrust Trial

Breakup of Microsoft Ordered
By JOEL BRINKLEY
(June 8) Judge Thomas Penfield Jackson ordered the breakup of Microsoft, saying the severe remedy was necessary because Microsoft "has proved untrustworthy in the past" and did not appear to accept his ruling that it had broadly violated the nation's antitrust laws.
• The Appeal: Browser Is Key
• The Company: A Vow to Fight
• The Consumers: Few Changes
• The Industry: Culture Intact
• The Law: Whither Antitrust?
• Market Place: Investors Pause
• The Politics: Muted Comments
• The Remedy: Breakup Etiquette
• Advertising: How to Spin?
• Online: A Chat Frenzy
• Diagram: What Now?
• Chart: A Money Machine

Final Criticism of Breakup Plan
By STEVE LOHR
(June 7) In a spirited final filing, Microsoft condemned the government's plan to split the company in two as "a radical step" that seemed to treat software as if it were pornography.

Few Changes in Breakup Plan
By JOEL BRINKLEY
(June 6) Responding in detail to Microsoft's criticisms, the Justice Department rejected any substantive changes in its plan to break up the company.

Case Will Test Justices' Prowess
By LINDA GREENHOUSE
(June 4) When the Supreme court confronted its first Internet case three years ago, the justices received special training from their library staff. Soon, the Microsoft antitrust case will be heading toward the Supreme court. But in the world of platforms, applications, source codes and interfaces, familiarity may not be fluency.

Judge Delays Ruling for U.S. Reply
By JOEL BRINKLEY
(June 2) Judge Jackson unexpectedly agreed to delay his final ruling for about a week, giving the Justice Department time to reply to Microsoft's proposal to water down the government's breakup plan.

Microsoft Readies Final Arguments
By THE ASSOCIATED PRESS
(May 31) Attorneys for Microsoft are busy preparing their final legal response. It will be Microsoft's last opportunity to make its case before the judge enters his final

A Monopoly?
Is Microsoft a monopoly that is stifling the development of the computer industry?
Go to Forum

REVIEW
• Profiles of Major Players
• U.S.'s Long Antitrust History • Point and Counterpoint
• Previous Antitrust Cases Open to Interpretation
• Sherman's 1890 Nod to Populism
• Analysis: Why Industries Fear Microsoft
• Analysis Antitrust Strategies Set
• Profile: Joel Klein
• Profile: Paul Maritz

DOCUMENTS
• **2000 Trial Documents**
• Findings of Fact in Microsoft Case
• Transcript of videotaped testimony of Scott Vesey, a Boeing executive. (text file)
• Case Witnesses
• Excerpts From Bill Gates's Deposition.

CHRONOLOGY
Important Dates in Microsoft's History

SITES
• DOJ: Antitrust Case Filings
• Microsoft's Legal Documents
• Microsoft Freedom to Innovate Network

(ABOVE) In the case of U.S. versus Microsoft, so much news has been generated that an Index of Articles link is included. This index is laid out just like the articles' pages, but instead of paragraphs, it's just a list of links organized chronologically.

UNEARTHING THE NEW

Despite the fact that many are tradition-bound institutions, museums have taken readily to the Web. Their role as disseminators of information fits perfectly with the creation of useful sites. Also, they already have the content; it's just a matter of putting it on a server. For museums, Web sites are opportunities to expand their collections into unlimited gallery space. But displaying objets d'art on the Web is not the same as hanging a picture on a wall. The stuff has to be repackaged for proper Web consumption.

THE FIELD MUSEUM EXPERIENCE ONLINE

Now visit The Field Museum, the vast nineteenth-century warehouse of natural history artifacts on the lakefront of Chicago. Right away, in the use of contrasting typefaces, appears the classic tradition that is the heritage of the museum and the pragmatism that is its driving force today. The rest of the homepage is a straightforward presentation of a few featured links with some standard navigational elements. Not much information is here, but that's as it's supposed to be. A home page is like the cover of a book—it grabs your attention and leads you to what's inside. (This fact is even true for portal sites, which though they may contain a huge amount of text, usually present only enough information to pique your interest. It's all just links to the real information.)

(ABOVE) The only hint of neoclassicism on the museum's home page is the use of an old style typeface, Monotype Bembo, for the GIF text of the logo and headings. Bembo is used throughout most of the site for headings, and it helps set the traditional museum-like tone of the site. In contrast to the finely serifed Bembo, the GIF text for the navigational links is set in a more rationalist, highly engineered sans serif face, Bell Gothic, the typeface developed for telephone book listings.

The museum's home page includes a black bar across the top with the most general nonhierarchical links: search, site map, and help. The classic (and classical) logo bar follows with a simple list of eight hierarchical links for the site divisions and then six additional non-hierarchical Quick Links down the side. Thus the navigation for the site is established.

THE SIMPLE DETAILS OF READABILITY

On the Museum Information divisional page is a title and a GIF image set in Bembo, followed by four paragraphs of HTML text. Each paragraph is set off with colored text headings and accompanied by a photograph from the museum's collection. You have to scroll to reach the bottom, but reading down this column of text is easy. In fact, reading this text is just a bit easier than most text you find on the Web. Why is this?

A few simple HTML tags have been added to improve the readability of this text. First, a column is established by constructing the page with tables. This technique allows the designers to define a sufficiently narrow column width to improve readability. The newspaper sites discussed above do the same thing. Secondly, the text is minimally typeset using sans serif type and an olive green color for headings. Each paragraph also includés an image with a runaround defined to keep the text flowing to the left.

For basic information of the museum's workings, this minimal formatting at least makes things readable and gives the pages a pleasant, welcoming feel, even if they aren't particularly distinguished. Greater effort has been expended for what the museum refers to as its Online Exhibits, and especially for its most recent unveiling, Sue.

Structurally, this is a site within the site. Although the Sue site exists as a distinct entity, it is officially part of the fieldmuseum.org domain. Sue is more than a pile of old bones; she is perhaps the biggest story to come out of the museum since its founding.

(ABOVE) As you move down in the hierarchy of pages of the site, the title bar changes, introducing a divisional color scheme, and the navigation column expands to reveal the secondary links for the site division. A third standard HTML text-based navigational element is added to the bottom of the page. And all of this together frames the first level of information.

BRANDING SUE

Sue, as stated on her site (www.fieldmuseum.org/sue), is "the largest, most complete, best preserved *T. rex*." Less obviously stated is Sue's price, $8.36 million, very big news indeed in natural history museum circles. That kind of expenditure warrants a Web site with plenty of information.

First, the audience for the Sue site is probably heavily weighted toward younger viewers. Still, this site is a serious one. The tone is not one of baby talk or "Gee whiz kids, isn't this neat?" Instead, the prose and presentation are straightforward, an unembellished relaying of fact accompanied by photographs of the site's star and her journey to the central hall of the museum.

This site is actually a story site presented as chapters. The chapters are listed as links in a navigation column down the right side of every page. There are no fancy buttons, or even a rollover. Each link is represented by the text of the chapter heading. It's a very direct scheme, consistently implemented to minimize distraction from the information contained on each page.

Sue gets no Bembo headlines. Everything is sans serif, and the GIF text is anti-aliased to blend in with the background. Most pages include a heading, a picture, and a single column of minimally typeset text. You can read the pages sequentially by clicking the Continue button at the bottom of the page, or you can browse at will using the navigation column. Are we seeing the precursor of what will soon be online books?

(LEFT) Sue is a big deal for The Field Museum, so she gets full branding treatment complete with her own subsite.

(RIGHT) On pages within a chapter, the navigation bar expands to include the section headings, providing additional navigation to each of the chapter's pages.

THE CHAPTER BECOMES A GALLERY

The Image Gallery chapter is less like a book and more like the halls of a museum. The end of one gallery leads on to another. Unfortunately, no way exists to choose a gallery to view. You must finish one and proceed to the next to see more of the show. This experience is supposed to be like strolling through real galleries in the museum, but on the Web it is somewhat confining.

One additional nonsequential link is featured on most pages. Either above or below the navigational column (depending on how long the title bar is) is a small square image. These difficult-to-identify details are actually links to additional information.

Without changing the design criteria, the Sue site presents book-like sequential information with a number of interesting diversions, which makes it a useful resource, as well as a site that you can read straight through. At the same time, this site is like traditional museum exhibitions in that it entertains us and deepens our knowledge and understanding of the subject.

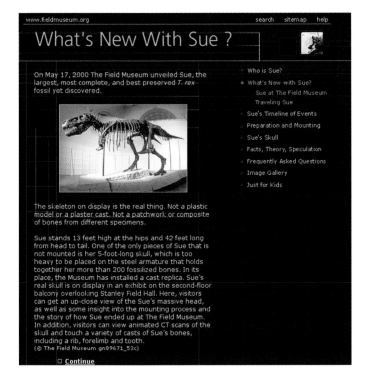

(LEFT) From chapter to chapter, all that's altered is the information itself and the background color. It's a subtle change that helps give the chapter pages coherence.

(RIGHT) Instead of a column of text, this page includes images in a frame in the middle of the page. Next and Previous buttons enable you to flip through the images one at a time. The effect is like an old-fashioned filmstrip.

If you're going to write about the "New Media," you better present yourself in a way that's actually new, or at least in a way that gets the attention of Web-bleary design professionals. This problem is the one that *NewMedia* magazine faced in designing its Web persona. Interestingly, the solution is not full of flashy animated images, but instead relies on the careful presentation of textual content. What a refreshing concept!

CUTTING-EDGE BRANDING AND TECHNOLOGY

The most obvious initial identifying feature of this site is the bright green background. What is it about this color that shouts NEWMEDIA? For one thing, it provides plenty of contrast to the text. Also note how the background image used for this home page includes not images but an enlarged text symbol, the right angle bracket. This integrates with the navigation scheme. As you'll see in a few paragraphs, NewMedia is using the angle bracket to brand its navigation.

Just as important, if not quite so loud, is the NewMedia logo with its clever use of reversed letters that allows the upside down *M* to do double duty as the *w* at the end of new. Although this trick seems obvious when stated, most people don't see right away that a letter is missing in this logotype. You have to stare at it for a moment to realize that what is obviously the *W* letterform is actually an *m*. At the same time, the red dot over the *i* also helps to draw the eye in to see it.

Everything is arranged to highlight the text and bring the reader into the site. At the same time, the site makes very clear that it is NewMedia, a site about the business, design, and technology of all that is new media.

It's cutting-edge navigation for a cutting-edge crowd.

(ABOVE) The bright green color, cleverly rendered logo, and the hint of angle brackets in the background are all part of the NewMedia brand image.

But so far, nothing really new is here. You have to enter the site before anything radical happens. Clicking a content link opens a new window with one of three content divisions highlighted, biz, design, or tech. The little script that opens the content window also does version and platform checking so that the correct browser-specific version of the site can load. It's the price *NewMedia* has to pay for using cutting-edge technology.

This isn't just a Web version of *NewMedia* magazine; it actually presents information in a way that is impossible with print media. First, information from all three content divisions is visible at once. One division is always highlighted and displayed in a wider column, but the other two divisions are always visible in the background. Try holding three sections of the newspaper at the same time.

Each content division is divided into two sections. The top portion of the column is the Browse window with current headlines, bylines, and story synopses. The smaller, less important portion at the bottom of the column is a New to You section with headlines presented on a gray background.

More importantly, angle brackets appear all over the place, used for scrolling the columns of text up and down or linking forth or back. Move the cursor over a downward-pointing angle bracket, and the column of text scrolls to reveal the rest of the contents. Click a right-pointing angle bracket, and the linked article fills the column. It's all very directional. The viewer is constantly reminded, "This way to NewMedia."

But a dark cloud lurks over this glowing site. For all the careful design, innovative navigation, and subtle branding, this *NewMedia* site doesn't work. The JavaScripts controlling the navigation and the browser-specific code required to hide two columns while highlighting a third are just too fragile. Essentially, every new browser version breaks the site, and a major programming effort is needed to make it work again. This is the current reality of Web design.

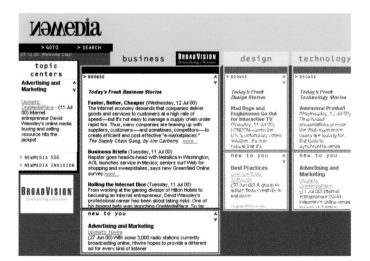

(THIS PAGE) Here are three different views of the same page. Each column represents what might otherwise be a separate division of the site, but only one column is active at a time.

THE SAME BRAND COLLATERAL WITH
REALISTIC TECHNOLOGY

Enter the newer *NewMedia* site. The brand is the same, but now the emphasis is more toward the information itself rather than the cutting-edge technology image. Information is added daily, with the previous day's stories moving down the column as newer information takes their place.

Interestingly, no longer is the site in motion, but the information itself is. In the new *NewMedia*, each column becomes a daily brand, and one gets the sense that to keep up, one had better check back every day. Yet the technology behind this site is not nearly as interesting or cutting edge as the old *NewMedia* site.

The story takes center stage, and in this instance, the enlarged image is actually a Flash movie that plays once. The sidebar contains all the division-specific links from the home page, and additional related links are at the bottom. Except for the three divisional links under the banner ad, the hierarchy here is almost strictly by calendar days. Put another way, the organization of information is by division and day. Links to related information are all nonhierarchical. The *NewMedia* brand is not about forced hierarchies, but instead encourages each viewer to find and follow their own thread through the site.

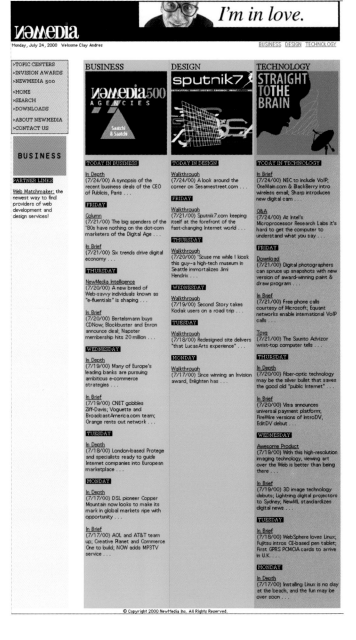

(LEFT) *NewMedia* has given up on the idea of having all three subject divisions visible at all times. Now when you click a story, you go to a new page—no more JavaScripts to refill the column you're looking at. The column is clearly marked (branded) with a divisional title and a sidebar in the divisional color.

(RIGHT) In the more recent incarnation of *NewMedia*'s home page, the three subject areas, Business, Design, and Technology, receive equal column billing, but now each column has its own high-visibility color, and each is topped with a high-contrast image.

NAVIGATIONAL OPTIONS

There are two ways to find stories. The hierarchical division system and a subjective arrangement are accessed from the menu box to the left on every page, and many of these navigational elements are branded with *NewMedia*'s angle brackets. Clicking the Topic Centers link opens a pop-up menu of subjects. Actually, these subjects are just hierarchical subdivisions, so that Advertising is a subdivision of Business, Broadband a subdivision of Technology, and so forth. It's a way to organize content into a topical hierarchy instead of the non-hierarchical dating system that is the primary subdivision method.

Informationally, choice makes the new design easier to navigate. Finding stories, reading them, and moving on to the next story is a more straightforward exercise. The cutting-edginess of the old *NewMedia* site with its navigational quirks required an investment on the part of the user to feel comfortable. But negotiating this technologically advanced site made you part of the *NewMedia* in-crowd.

FINDING THE TECHNOLOGY TO MATCH THE BRAND

The sheer volume of information overwhelmed the old design. When it worked, it worked on a smaller scale and was not easily expanded. Although the new design works well for readability, it breaks no new ground in this area. It's as though having been burnt badly in the browser wars, the new *NewMedia* is relying less on technology and design and more on the content itself to create its brand image.

If a lesson exists here, it is that branding your content by creating a technologically advanced site is not enough. Design and technology are not ends in themselves. This idea is true even for a technologically advanced audience. If information needs to be communicated, articles printed, read, and digested, then content has to be readily available without the technology creating an obstruction in the information supply chain. In some ways, the groundbreaking old design for *NewMedia* was like a poster with elegant white typography over a light background. It just couldn't be read. In print communication, and even print on the Web, neither the design nor its usability in the harsh Internet environment can be ignored.

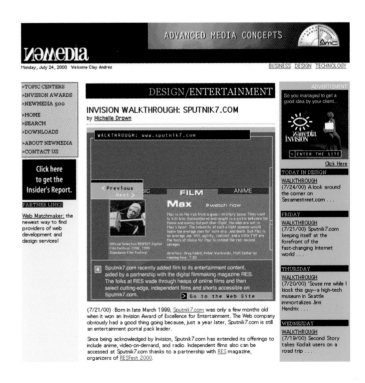

(ABOVE) The Flash movie heading the title story for the design division includes Previous and Next buttons, which provide a navigational scheme within the navigation and a story within the story; there are two ways to read the same story.

Unless you are an industrial designer or a programmer, you probably don't associate products with user interfaces. For Web branders, Web sites are the product, and the inherent interactivity of the Web means that every product has a user interface, and it is this interface that is one of the most important measures of success for any Web site.

Creating a compelling user experience is a difficult assignment, because every site is a unique product. Until recently, Web designers didn't have the tools to duplicate the successful user experience of one site for use in another. This meant that each site was a different experience for both the designer and the user.

But the reality is that the pressure for one site to look like another is creating a sea of look-alike sites, and two factors are encouraging this tendency. The first factor is the use of e-commerce packages that include what amounts to a canned user experience—select items, add to shopping cart, proceed to checkout, fill in billing and shipping information, and complete order. The second factor is the result of a mentality that wants to play it safe by looking like already well-established Web sites. Thus, the large number of Yahoo! and Amazon.com look-alikes.

Many Web sites consider the me too interface a positive development. If you're a portal, you should look like a portal, so people know intuitively how to navigate your site. But copying your Web site from high-visibility sites such as Yahoo! and Amazon.com is not intuition, it is mimicry, and the result of this kind of thoughtless copying in many PC applications is evident. Furthermore, sameness is bad news for Web branders, but this is by no means a hopeless situation.

Chapter Four discussed how newspaper sites have established status quo Web standards. Most sites standardize navigation in this way, too. The so-called navigation bar is perhaps the most ubiquitous example. A navigation bar isn't inherently bad, but it can't simply be pasted on like a Groucho Marx moustache. A navigation bar must be incorporated into the overall design of the site. Not only are the elements of the site important to the site brand, as discussed in Chapter Three, but the actions that lead visitors from page to page become an important part of the brand definition, as well.

To put this in more pragmatic terms, users don't return to your site if they can't find what they want there. Your site will be branded as difficult and unfriendly. On the other hand, if the site presents information in a way that your visitors enjoy, you've created a positive association for your site's brand image. Finding a solution that creates a user experience that is both familiar and yet memorably unique in some way is the challenge Web site designers and branders face.

[5] CUSTOMER EXPERIENCE
FEELING THE BRAND

WWW.KODAK.COM/COUNTRY/US/EN/
CORP/FEATURES/ENDURANCE/ (URL)
KODAK (CLIENT)

DESIGNING ONLINE IDENTITIES (CHAPTER 5: CUSTOMER EXPERIENCE)

EXPERIENCING AN AWE-INSPIRING CHILL

■I 077

Already some of the sense of adventure that made the Web such an exciting place to explore is lost. There's a "been there, done that" attitude. Thrills are still available, and Kodak, one of the world's best-known brands, supplies a vicarious thrill in the form of a reenactment of Ernest Shackleton's near-disastrous trip to the South Pole. You may want to put on your earmuffs and boots before proceeding.

Kodak's *Endurance* Web site, named for the ship that nearly entombed Shackleton and his crew, exists within the www.kodak.com domain as a feature story. In this case, Kodak features the expedition photographer, Frank Hurley, who just happened to have used Kodak brand film and even a 1914 Kodak box camera for additional snapshots. The site is a testament to the enduring qualities of Kodak products and the timeless Kodak brand. Kodak allows the story to speak for itself as an encouragement to all to take lots of travel photos.

SETTING THE SCENE

The first element that loads is a branded picture frame. The Kodak name appears in the top horizontal frame (not an HTML frame) along with the slogan "Take Pictures Further," which is a bit of an understatement in regards to this site. The company logo is at the left of the lower horizontal frame, which includes site-specific navigational elements in Kodak's distinctive gold color.

The picture frame is further enhanced by the addition of a water-stained, woodlike frame and the use of an early twentieth century wood type font that's used for the title, the *Endurance*, and the three navigational links. This font gives the site an old-timey feeling of adventure.

The viewer is told that it's 1914 and a team of explorers has set off to be the first to cross the Antarctic continent. But what is important from Kodak's point of view is the photograph of the ship. Note the use of the present tense and watch how this photo leads directly into the adventure.

The oval photograph of the square-rigged *Endurance* is just a teaser. The oval outline enlarges into a rounded-corner rectangle, and the image within is rotated to reveal the actual Frank Hurley photograph. The caption reveals the truth about the ice-locked ship, "They never reached land."

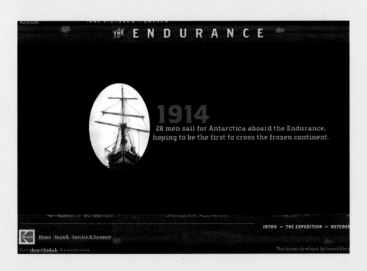

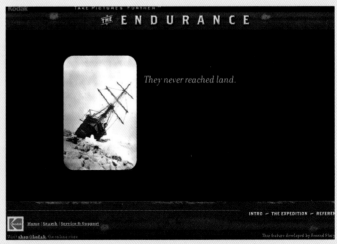

(THIS PAGE) The top and bottom navigation bars of these pages frame a relatively fast-loading Flash animation, starting with an introduction to the story. The photo of the ship appears and then rotates to its tenuous position in the ice of the Antarctic seas.

INTRODUCING THE HERO

Then a second sequence begins, explaining about Kodak's hero, Frank Hurley, and the expedition is ready to begin. Note how the site includes the viewer as an ex officio member of the expedition. This is not a comfortable afternoon's stroll through the galleries of the museum or an evening's browse through the exhibition's book of reproductions. No, you must take part. There are decisions to be made.

The designers of this site use some of the same techniques used by documentary filmmakers to add action to a story with no actual footage. Second Story takes what are truly remarkable still photographs and gives them immediacy and life by focusing on the details and then adding animated pans and zooms. It is very skillfully done and remarkably effective. This technique makes the user a part of the journey, as if it were a personal experience.

Also, notice two brands that are really at work here and what they're doing to help each other. The outer frame reminds us that this amazing adventure is happening within the Kodak domain and a Home button leads straight back to the corporate host for this subsite. But as soon as the Flash introduction begins, the viewer is quickly carried out to sea aboard the Endurance, headed for Antarctica with Sir Ernest Shackleton.

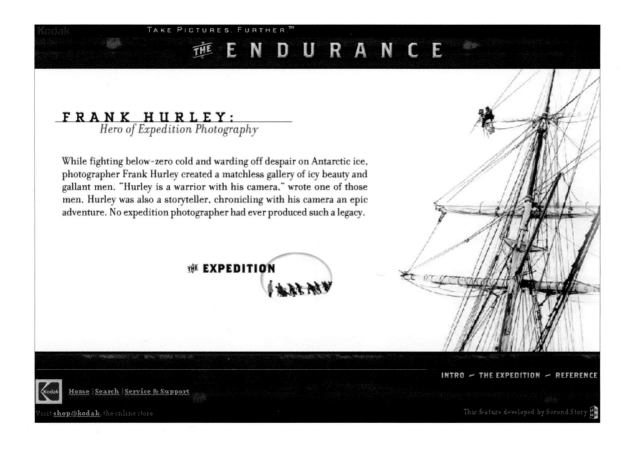

(ABOVE) The introduction finishes with the full photo of Hurley in the rigging.

EXPLORING THE SCENERY

Kodak's retelling of the disastrous expedition continues with a second Flash animation. The journey sets off from the whaling station on South Georgia Island.

Each location is highlighted on the map and accompanies one of Hurley's photographs and an excerpt from the exhibition's official book by Caroline Alexander. Viewers can continue sailing the seas, abandoning ship, taking to the lifeboats, holing up on Elephant Island, and trekking across mountainous South Georgia. Or they can pick their stops simply by clicking the map. Remember, however, that you must make it to the whaling station and return with a rescue ship before any of your crew perishes.

This site is daring and at the same time a little bone chilling. The use of Hurley's photographs, which comprise one of the most remarkable documents ever recorded, certainly helps. But even the map is carefully constructed to enhance the feeling of adventure that pervades this site.

What really makes this site an adventure for the desk chair explorer is a sense of journey. It could be a trip to a tropical paradise or a kiddie-oriented theme park, but is instead a retelling of a voyage you wouldn't want to be a part of. But as a Flash adventure, viewers not only enjoy this adventure, but are also left with a desire to explore further.

(LEFT) After the introduction, the screen is split so that a map of Antarctica with the route of the Endurance on the left and explanatory text and images on the right shows. The top and bottom navigation bars remain the same.

(TOP RIGHT) Rather than playing as a movie, each frame of the Flash animation making up the map is activated by rolling over highlight points. This changes the text in the title bar so that the viewer can learn the significance of each point without clicking to load the accompanying narrative frame. (BOTTOM RIGHT) Wherever one chooses to navigate, the map label is updated along with the route. You can also choose to zoom the map in for greater detail or out for the big picture.

WWW.JETBLUE.COM (URL)
JETBLUE (CLIENT)

DESIGNING ONLINE IDENTITIES (CHAPTER 5: CUSTOMER EXPERIENCE)

FINDING NO BLUE MEANIES IN THE FRIENDLY SKIES

The adventure of air travel, if not as harrowing as a couple of weeks in an open boat in the Waddell Sea, is a trying experience. And worse, the problems start on the ground before you've even left for the airport.

People suffer the ignominies of air travel because there's no other way. Even online travel sites are something of a challenge, as one must navigate among a confusing array of ticketing options, seemingly random restrictions, and mileage award programs. Booking an airline ticket online becomes an exercise in rocket science.

This phenomenon of confusing travel sites is just another example of "me, too" site design. Upon examining multiple air reservations sites, it becomes obvious that they all share what looks like three different reservations systems. Regardless of the user interface, the user experience quickly becomes a nasty frustration.

But it doesn't have to be this way if you choose to fly JetBlue. You may think of JetBlue as the "Fly Different?" airline. It has no class designations, all leather seats, and a completely electronic ticketing system. Even the telephone operators have a sense of humor. A look at the JetBlue Web site is like a step into the future, a look at how air travel might be in the future.

THE IMAGERY AND ICONOGRAPHY OF TRAVEL

The simple yet strong logotype is in the upper-right corner, and in what browsers have come to expect as the logo corner is the almost naively friendly message, "Hello," with an orange daisy. This daisy, especially in this particularly orangey orange, is loaded with Flower Power, Peace Now, and sixties symbolism. This retro imagery is used in a wholly updated context, and it's very effective.

The background for this page is a ribbon of textured blue that appears to be jetting across the screen; this in cool, efficient contrast to the happy orange imagery. The orange is also used for the navigational icon system that's composed of six rollover buttons.

And just in case it's not clear what to do with a rollover link, there's a message attached to the daisy, "Roll over orange circles to start." It's friendly without sounding condescending. These rollovers are the entirety of the hierarchical site navigation.

The simply animated GIF contains practically the entire textual message of this home page. It is four words that fade from one into the next in a fourteen-frame animation: reinventing, redefining, rethinking, and rediscovering.

(ABOVE) Immediately, one notices that JetBlue's site is different. It's got breathing room—room to stretch out one's legs and get comfortable. For one thing, the page is right justified, which isn't very common on the Web. Is this page difficult to decipher? Hardly.

ADVENTURES IN ONLINE RESERVATIONS

In talking about branding the user experience, it's noteworthy that the JetBlue site makes a strong statement right from the opening page. One knows that flying the JetBlue Web site will be different, less cluttered, and perhaps even fun. Simply click the "Fly there" button to begin the adventure.

There are directions—"select an area"—and a green arrow, made more vivid by the animation of its downward direction, points to three options: when and where, e-ticketing, and how to jet blue. Veteran JetBlue travelers can skip steps and speed up the ticketing process.

This next step down into the hierarchy adds one more layer of hierarchical choices: timetables and destinations. These icons have their labels attached and are also rollovers. It's clear that there's room to expand this icon system to add more choices across the middle.

Unfortunately, JetBlue hasn't finished implementing these links yet. The company is so new and is expanding so rapidly that it has not had time to implement the timetable, and the destinations page is clearly waiting for additional information. But it's evident that the brand experience is carried from the first page all the way into the deepest interior pages.

(LEFT) For those travelers who need further direction, the icons and labels contain self-identifying rollovers that lead through the ticketing sequence in order.

(TOP RIGHT) This page is clearly labeled, "Fly there," but one's attention is drawn to the new large buttons that contain typical airport iconography and a list of options on the left.
(BOTTOM RIGHT) On level down within the "Fly there" division the new icons for timetables and destinations are color-coded green.

BRANDED FORMS PROCESSING

Click the e-ticketing link to move on to the next step. When you examine the form itself as separate from the JetBlue page, it becomes clear that while the drop-down selection menus help, the use of titles to separate question sections is also useful. Just as importantly, you don't see too many questions on a single page. You don't get a sense that Big Brother is breathing down your neck.

Browsers can continue to travel this reservations model, selecting, confirming, and purchasing. Along the way, little notes of encouragement in big blue circles appear, "Make sure your e-mail address is correct," and "Almost done." With all the information necessary filled in, it's time to hit the orange daisy and "buy it."

fly there | **jetBlue**

buy a ticket fly there work here have fun learn more speak up

when and where

e-ticketing

how to jetblue

step: ① ② ③ ④ ⑤

contact information

remember this information
for my next visit ☑

your name (first, last)	
street address - line 1	
street address - line 2	
town/city	
state and zip/postal code	
country	United States
phone number	
alternate phone number	
fax number	
e-mail address	
will confirm by	○ Email ○ Fax

make sure your email address is correct

passenger information

passenger 1	Mr
first and last name	
passenger 2	Mr
first and last name	
passenger 3	Mr
first and last name	
passenger 4	Mr
first and last name	
passenger 5	Mr
first and last name	

almost done....

payment information

total payment price	$1325.00
name of cardholder	
credit card number	
card issuer	
expiration date	Month: □ Year: □

JetBlue fares are non-refundable. Changes may be made any time prior to scheduled departure for a fee and applicable fare adjustment. Cancellations may be made any time prior to scheduled departure for a JetBlue credit. Credit is valid for 1 year and subject to change fee. For a complete list of JetBlue policies, please check the 'how to' section of the web site.

✳ buy it

Chill
After clicking this button, please be patient. It may take as long as 30 seconds to authorize your credit card payment.

A WEB-SAVVY MESSAGE TO WEB-SAVVY TRAVELERS

The message here begins, "Chill," and you're asked to wait while the order is processed. It seems JetBlue's trying to convey that it's really quite Web savvy. It's all part of the overall tone that says, "You're cool, we're cool, so let's all be friends." JetBlue gives the site a feeling of exclusivity, that even though it's on the Web where anyone can access it, it's really meant for a select group of cognoscenti. It's a nice trick for an airline specializing in low fares rather than luxury travel.

JetBlue has created an online travel experience that makes browsers want to choose it, even though they've never even laid eyes on one of its jets. This is what a positive brand experience can do for a product.

Some people call what JetBlue is projecting, an attitude, but others prefer to think of it as a commitment to human values rather than corporate ones. It's easy to respond positively to the bold colors, simple imagery, and lighthearted text. It's not a big deal, but it tells browsers that thoughtful human beings work here, instead of a committee of bureaucrats.

(ABOVE) Even as the forms become longer and more detailed, the JetBlue experience remains remarkably consistent and pleasant.

DESIGNING ONLINE IDENTITIES (CHAPTER 5: CUSTOMER EXPERIENCE)

ENJOYING A CARBONATED EXPERIENCE: COKE.COM

Is it possible to overdo the user experience? Can the balance be tilted to the interface so far that the purpose of a site is completely lost? What if the site is all about interface and image? Case in point: Coke. Yes, it's selling sugar syrup, but the Coke brand has been more important than the actual product for years. Or so it seems from the ads.

Coke's Web site (www.coke.com) is as much about feeling good, as it is about products. It is a lightly carbonated, highly caffeinated Flash experience with very little to say about the popular beverage and nothing at all to say about Coke's other products. It is a sophisticated site.

(ABOVE) The initial Flash animation fills the screen with Coca-Cola red and begs for exploration.

INITIALIZING THE VIEW

The background is unabashedly red. Condensation seems to drip down the sides of the cold, highly stylized bottle of Coke. Bubbles of carbonation explode around the sides as the glistening cap is taken off the bottle with a pressurized release of Coke. The classic Coca-Cola logo, larger than the cap it's ostensibly printed on, is really the primary element of this page.

As the cursor moves around the screen, changes happen. The slide strip moves left and right, faster and slower, and three out of five images trigger a hollow popping sound and an animated label: Pop the top and experience it all, Bringing it home, and Turning it up around the world.

The text for these tag lines may mean nothing, but their effect has a certain click-me quality, and in fact, this slide strip is a second hierarchical navigation bar, and each of the activatable slides leads to one of three divisional experiences. Also note that Coke can expand the number of experiences by activating another slide at any time. Coke leaves room for future enlargement of the site in an interesting and original way.

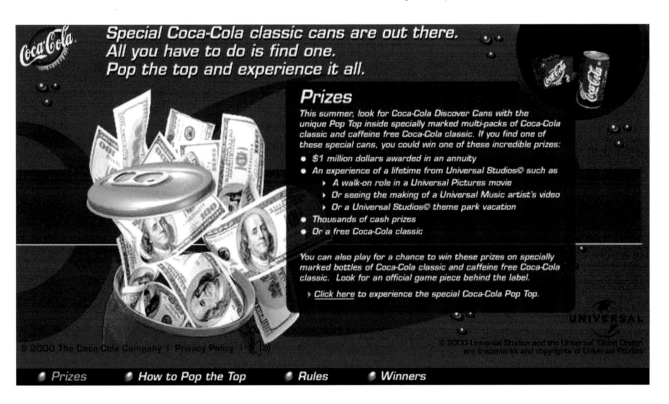

(ABOVE) This page is too gaudy to be tasteful, but Coke's annual $1-million-dollar giveaway is one of the world's most popular promotions.

THE CORPORATE COKE LOOK

And there's more. Remember the abbreviated red-on-red navigation column on the right side of the home page—About the Company, Investor Relations, and News Coke? These pages activate with a flash and a gurgle when rolled over and serve as a portal to Coke's corporate site, www.thecoca-colacompany.com. Imagine if it had to refer to itself by this cumbersome name all the time.

Something's missing from this site. It's not fun, and there's no adventure or any sense of user experience. Perhaps this look is appropriate for the official company site of one of the world's greatest and most enduring brands. But that's not what this chapter is about.

(ABOVE) The Coca-Cola Company corporate site has all the same elements as the Coke site—red background, chilled cola cap with logo and bottle, and the old-fashioned Coca-Cola script logo.

BUYING THE COKE BRAND

Back at the carbonated Coke site, one more link is at the bottom of the navigation column, the Coca-Cola Store link. The Coke site is actually the front end for www.coca-colastore.com (another domain name that isn't going to bring any quick hits). Just as this site is all about bringing the Coke brand to one's online and desktop experience, the Coke store is about the insinuation of the Coke brand into every corner of daily life.

The store looks a lot like the Coke site, and it has a little bit of the animation. But it also looks a lot like a standard e-commerce site. Some luster rubs off on the store when entered through the carbonated portal, but its luster that isn't really there. Like the bubbles, the glamour of Coke's fashions is elusive.

(ABOVE) Coke.com is really a front end for Coke's new Web store. Unfortunately, the store fails to take advantage of the clever branding established by the animated and engaging introduction.

SWEATING THE DETAILS, LITERALLY

The first experiential division features Coke's summer sweepstakes. Click the slide, and a new Flash movie is loaded. A highly animated screen explains the contest amid splashes of Coke, rolling cans, exploding cash, sound effects, and music.

This page doesn't have a lot of interaction, but Coke is counting on the prospect of cold, damp bills to create excitement here. A standard-style navigation bar is at the bottom with the four sections of this division as rollover links. The rollovers generate bubbling sounds. The How to Pop the Top link loads a high-tech-looking page

that encourages the exploration of the special prize-winning can to the accompaniment of a jazzy beat. It's just further hype for a simple giveaway, but nothing's simple about the treatment given to it on this Web site. Every carefully choreographed piece of animation pulls the viewer deeper into the realms of Coke.

Click the Coca-Cola logo in the upper-left corner to reload the home animation. Click the second slide, Bringing It Home, to enter the world of Coke's popular polar bears. Not much is happening on this page, except for the animated GIF polar bear character labeled Toggle this. That's because this division isn't about branded Web interactivity but about branding your desktop. Browsers can download a screensaver and other not-very-useful desktop applications.

(ABOVE) The arctic cool of this page is set in blizzard blue, and the only red shows up on the small bottle of everyone's favorite beverage being consumed by the baby polar bear on the right.

THE SOUNDS OF COKE'S WORLD

A click on the third slide, Turning it Up Around the World, loads yet another Flash animation, the Coca-Cola jukebox. First, a title screen loads with a flurry of ribbons. Then the ribbons turn interactive, and the viewer is instructed to click to begin. After clicking the interactive ribbon, the main applications page loads. This page has no instructions, but several icons are clearly meant to guide viewers to the content. All of this activity happens to the accompaniment of a steady rock beat.

Browsers can listen to three main selections: Feel the Beat, World Jukebox, and Personal Music Companions. Again, this is big brother Coke finding ways to brand more aspects of your life.

(THIS PAGE) The Coke ribbon is turned into an interactive display that leads to an unlabeled page with icons linking to the World Jukebox.

In the beginning, and as recently as two or three years ago, big brands were avoiding, or at least ignoring, the Web—the wait-and-see strategy. The Web was still a playground for esoteric start-ups and high-tech companies that were actually in Internet-related businesses. For traditional consumer-oriented companies with $100 million dollar advertising budgets—the big brands—the Web was barely a blip on their radar.

Yahoo! and Amazon changed this perception by becoming big brands themselves and, in the case of Amazon, by cutting into traditional big brand markets. No one ignores the Web any more. From a purely advertising perspective, the demographics of Web use are just too attractive to be ignored. Web users are better-educated, younger, more active, and they spend more money. This situation is not good news for the television networks.

The Web is the next medium and the big brands know it. The question then becomes how to acknowledge this medium without diluting their already carefully molded images. How do companies like Coca-Cola (see Chapter Five) and Proctor and Gamble, which have worked for decades to establish and maintain their mass-market and broadcast images, present themselves in the new medium, the Web? Do the Campbell's Soup twins play well at 600 x 400? Does the ever-annoying Energizer Bunny keep going and going all the way to your desktop browser?

The answer in both cases is categorically no. Unless such icons of traditional advertising are recast to suit the new media and its more sophisticated, less patient audience, many successful brand images simply run out of gas. The same is true when you try to move a magazine to the Web. You can use the same words, but without recognizing that the context has changed, the result is content that is at best cumbersome and at worst, impossible to find and then read.

Rest assured, however, that the task is not impossible. In fact, a successful Web image, augmenting what is already an immediately recognizable print and broadcast image, can be a powerful tool for extending brands into new and larger universes.

[6] CLASSIC BRANDS
THE NAMES WE LOVE

ENJOYING THE FULLY EQUIPPED IMAGE: THE MERCEDES SITE

What is the special nature of Mercedes-Benz motorcars, or, for that matter, what is so attractive about any luxury item? Is it beauty, superior function, or just plain snob appeal? The Mercedes-Benz name is often synonymous with luxury. For one thing, you have to be prepared to spend a lot of money. But do these qualities of luxury and exclusivity translate well to the Web, the most egalitarian of media?

Although Mercedes-Benz is not a dominant brand, it is certainly big, immediately recognizable, and a clear brand leader. The company has established this leadership position through an unabashed commitment to luxury driving, attention to design details, and superior engineering. It has applied the same standards to the design of its Web presence, and the result is a site that is quite beautiful to browse through and something of a tour de force of Web technologies.

The Mercedes-Benz USA Web site (www.mbusa.com) opens with an introductory page featuring the familiarly distinctive and highly polished Mercedes-Benz three-pointed star logo. Always prominent on its cars and in its advertising, the star also finds its way onto every page of this site.

All the many photographs on this site are special—lots of low camera angles, subtle motion blurs, and dramatic lighting. One often gets the sense of climbing hills or rounding corners at high speed. These super models are posed to reveal every curve.

This nearly monochromatic home page is the essence of elegance. The high-contrast, black-and-white photo, the use of a classically proportioned book typeface, Baskerville, and even the thin white rule separating text from image, all create an overriding sense of refinement.

(ABOVE) Visitors are greeted with a straightforward "Welcome to the Mercedes-Benz USA Web site," along with a photograph of a car. It's all simplicity and elegance.

ELEMENTAL BRANDING

There is no attempt here to establish a navigation system or answer all possible questions on a single page. Instead, this page represents a fork in the road. One can choose the standard route, "Click to Enter MBUSA." But perhaps more interesting is the single bright element on the page, the big yellow *C*, which leads you to this site's virtual test drive, "Click here to learn more about the model year 2001 C-Class." Even if you have no interest in or knowledge of this so-called C-Class, this link looks like an invitation too good to turn down.

The Flash introduction finishes with the tag line, "C the possibilities," and if you would like to have the privilege of seeing more, you must pay with the most valuable coin of the Web realm, your name and e-mail address. Only registered users may peek behind the curtain.

(LEFT TO RIGHT) This Flash interlude begins with a yellow circle on a gray field. Mood music starts up and the animation begins. The circle becomes a shape, which becomes a line. An image fades in from the background, and the unidentifiable shape of the line is matched to the headlights of what one presumes is a new C-Class auto. The animation continues with more heavily rhythmic music and another shape transformed into car details. It's as titillating as a striptease. One never actually sees an entire car, just body parts.

Browsers are welcomed into the inner sanctum with a greeting and a smile. The virtual column on the left includes nonhierarchical links and the M-B logo. The text is contained in a small table cell and set in sans serif type, which gives it the proper Germanic, high-tech look. Even the female model, with her close-cropped hair and sleek black suit, has the air of German austerity that has come to mean expensively engineered luxury items.

The next page, "C yourself being inspired," instructs you to "Roll over the dots and click to explore." Clicking a dot takes you down into the hierarchy of this subsite and reveals the first look at a nearly whole car. Was it worth the wait? Obviously, if you've gone this far, the first glimpse of this new model holds a certain excitement for you.

From a branding perspective, Mercedes has used all its classic icons and its new *C* logo to help build anticipation for the great unveiling. Such is the power of strong brand recognition.

Even at this level in the hierarchy, information is presented using simple rollover dots to change text and add highlights. The underlying neutral gray background emphasizes the yellow used to identify the active labels and buttons. The tone of the text is matter-of-fact, like one knowledgeable person speaking to another. So much understatement can mean only one thing: if you have to ask, you can't afford one.

(LEFT) Bright yellow areas provide the key highlight against the gray, almost austere background. Very small Web-tool icons provide navigation forward and back through this JavaScripted tour. **(RIGHT)** These views of whole cars are enhanced by the introduction previously to the individual body parts.

BRANDING TONE TELLS A TALE

Compare this subsite to Volkswagen's Turbonium subsite discussed in Chapter 2. Where Turbonium is supercharged and hip, the C-Class site is cool and elegant. One is humorous, the other serious. Yet both sites use big-brand logos along with unique navigational elements, strong contrasting colors, and carefully pitched and typeset text to sell German cars to the American public.

In terms of Web branding, both Turbonium and C-Class successfully create big-brand experiences for their carefully targeted audiences. Both Volkswagen and Mercedes know their markets and are able to define these in terms of a Web-savvy audience. They've also gone a step further to create strong product brands. For Volkswagen, it's the Turbo Beetle, whereas for Mercedes-Benz, it's the new C-Class with its round geometric *C* logo and vivid yellow highlight color.

And as if to prove some point about the speed of change on the Internet, the introductory page reviewed has changed in a matter of two days. What was a one-page introduction is now two pages. The brand elements are all the same, as is the navigation. But the imagery has been updated and a little bit of history added with a photograph of the famous gull-wing Mercedes of the 1950s. Apparently, Mercedes is trying to draw a comparison between the shape of the classic gull wings and the aerodynamic curve of the new C-Class autos.

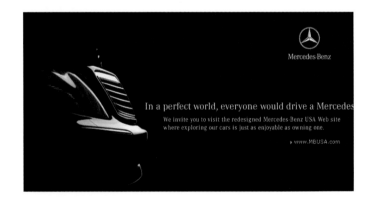
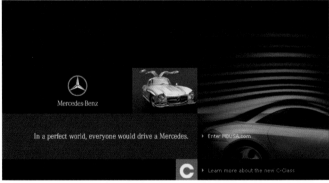

(ABOVE) Mercedes-Benz's updated two-page introduction, with a kind of front gate page, automatically refreshes to a redesigned crossroads page. What hasn't changed is the look of understated elegance and the consistent use of familiar branding elements.

CONSISTENT IMAGERY THROUGH A DEEPENING HIERARCHY

The underlying site, the basic hierarchy and content, has also been updated with new imagery and pages, but its design and navigation remain the same. A site based so heavily on user perceptions and changing tastes needs to remain fresh without having to redesign the structure completely. This site makes it clear that the establishment of a strongly branded structure can allow for tremendous design flexibility as a site grows and changes.

Every content page includes a striking car photograph as a key element. More importantly, Mercedes can easily plug in new photos and descriptions on any page at any time. The navigation bar with four links to the next level of information, Features, Comparisons, Connect, and Purchase Assist, need not change, just the data.

The last layer in this informational hierarchy reveals just how much data is being stored in this site. Yet the information is so logically divided and clearly displayed that it doesn't seem overwhelming. The narrow column of sans serif type and the use of GIF text images for headings help tremendously with readability. And each specification page is branded with a slightly larger-than-thumbnail photo along with the manufacturer's suggested retail price and the model designation.

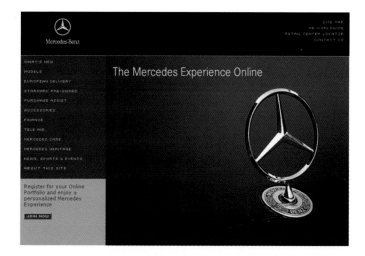

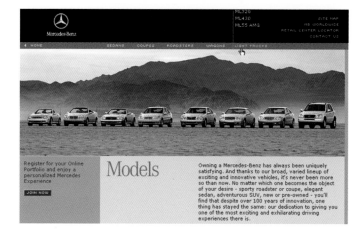

(TOP) On the actual home page, everything is imagery and links. For instance, the jewellike treatment of the hood ornament against the deep metallic blue Mercedes paint is calculated to increase one's desire for the object beneath the ornament.

(BOTTOM) Mercedes current model list takes the form of a striking photograph of silver cars against a desert background of blue and purple mountains. Above the photo is a horizontal strip of model types, the navigation bar for this site division. Roll over a model, and the list of specific models pops up in the black space at the top.

FIRST-CLASS NAVIGATION

Each page has three levels of navigation—links to other specification pages listed in a column on the left, hierarchical links to other sections of this division in the horizontal navigation bar, and links back up the hierarchy to previous divisions as indicated by back-pointing arrows. It's all very thoughtfully arranged and elegantly designed, just what the consumer of luxury items demands in a first-class accommodation.

After all, every visitor to the Mercedes-Benz site is a guest to be welcomed and pampered. This treatment is what customers expect of the Mercedes brand, and in presenting the numerous products of the brand, this Web site must also communicate the very image-conscious brand message, as well. The photographs do most of the image communication work, but all the other elements, the colors, links, and typography, play important supporting roles with the result that the site runs with all the smoothness one expects of a well-designed automobile.

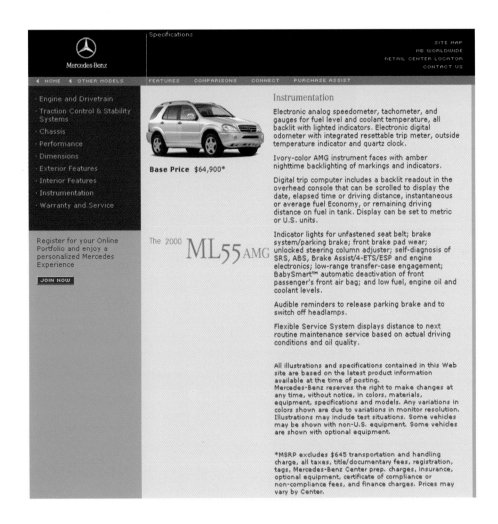

(ABOVE) Each model includes nine long pages of specifications, everything you would want to know about these cars cleanly and logically organized.

PLAIN BROWN WRAPPER: THE UPS SITE

Okay Web branders, it's time to play the distinctive color game. If green is the color of money sites, blue the color of health sites, purple the color of women's sites, red the color of culinary sites, what is brown for? This is branding for a plain brown wrapper, along with trucks, uniforms, and tools. Here's another clue: "Brown paper packages tied up with string. These are a few of my favorite things." Brown is the brand identity of The United Parcel Service, a company whose truly global presence is characterized as much by its reliance on brown as on its classic UPS parcel logo designed in the 1960s by Paul Rand.

A Paul Rand identity is a sure sign of a really big brand. Some of his most famous logos were designed for Westinghouse, ABC, NeXT Computer, Yale University, and IBM. He's the biggest brand among branders.

(ABOVE) UPS has branded everything with color, even the navigational icons of its site. The distinctive UPS delivery van, the wireless tracking slate used by UPS drivers, and the UPS letter envelope are all familiar branded elements. But by creating sepia-toned icons even the clock becomes a UPS-branded timepiece.

SHADES OF A BROWN BRAND

UPS has become a brand name almost without trying, and yet, someone had to decide that brown was the way to go (probably Rand himself). Does what worked for trucks in the 1960s also work for Web sites in the twenty-first century? Upon viewing the UPS home page, the answer is yes.

This home page is more yellow than brown, but it is all UPS. The global navigation bar at the top has UPS logo teamed up with the Olympic rings for a special big-brand promotion. To the right of this branded anchor are the hierarchical navigational elements and icon system, all brown. The photographs in the feature section of the home page are also colored monotones, which is not only a striking effect, but also creates smaller images for faster download times.

(ABOVE) The UPS site is full of forms to fill out and they are kept as simple and readable as possible. Furthermore, the form pages are both browser-and platform-agnostic to include the widest possible user base, a major concern for the biggest brands.

SHIPPING, THE UPS WAY

Browsers can track, ship, calculate costs and times, order pickups, find drop-off locations, and order supplies with a single click. In fact, these functions represent an online version of calling UPS for service. They are the interface for an online application that's available throughout the site. Wherever you wander within the UPS domain, a brown truck is following you.

Seeing an application presented as a hierarchical navigation bar is unusual, but because the functions are not necessarily sequential, it works. Most of the site's interactive functions require filling out forms, and the UPS site does nothing extraordinarily appealing or innovative in this area (a little Rand influence could help here). But the subfunctions of each division are nicely presented in what looks like a horizontal drop-down menu, but is actually just more GIF text in tables.

COFEATURING BROWN

Even though the ability to ship and track packages is the primary purpose of this site, these functions are treated as background activities to the prominently displayed feature stories on the home page. The summer's promotion highlights UPS's sponsorship of the Sydney 2000 Summer Olympic games and the UPS-employed Olympians. Actually, there is no need to return to the home page, because the Olympic ring logo on every page links to the UPS Olympic pages.

Once a browser check is performed, the index page loads with a JavaScript animation used to set the page elements. All the circles on the page activate rollover GIFs. The dots underneath the yellow background link to the identifying text across the bottom, whereas the picture rings pop up explanatory text and animated GIFs.

(ABOVE) This subsite is a big brand partnership. The UPS-Olympic index page contains only logos, and serves primarily to check the the host browser for JavaScript and CSS compatibility. If the browser detect passes, then the overview page, the real home page for this subsite, loads.

The Olympic ring metaphor as it's described here may seem a bit heavy-handed. But in execution, the scheme works well. The page achieves a strong Olympic feel without relinquishing the obvious UPS sponsorship. But why does this subsite exist? You may as well ask why UPS has chosen to be an Olympic sponsor— it's a marketing and public-relations site. It's an opportunity for UPS to make everyone feel good about sending brown paper packages in its brown trucks. The site also happens to be quite thoughtfully designed.

UPS has taken this PR site very seriously and has included a lot of content organized in a fairly deep hierarchy. They are able to keep the site orderly and useful using a consistent layout and strong navigational tools. Eventually you get down to a very personal level with individual feel-good success stories.

(THIS PAGE) The cobranded site is clearly UPS's work. Although the Olympic and UPS logos receive equal treatment on the bottom navigation bar. The yellow background continues the brownish UPS theme. Five colored rings (another obvious Olympic reference) slide in from the sides and take their places against the yellow background. The animation ends as photos fill the rings and the word *brown* is added as a fourth medal color, the final UPS touch.

(TOP LEFT) The five-button hierarchy across the bottom moves to the top for all the interior pages, and a section-specific hierarchy of links is in a column on the left. Featured links fill a middle column, and explanatory text follows to the right. This blue column includes its own story line, along with More and Back JavaScripted buttons to navigate through the text. **(TOP RIGHT)** Clicking a hierarchical link steps down in the hierarchy and expands the list of links in the navigation column.

(BOTTOM) Future Olympic hopefuls at a UPS-sponsored sports camp. Each child in this section has a story that can be told quite generously in the content space of the page.

GILT BY ASSOCIATION—UPS/OLYMPIC STARS

Another feature of every page in this cobranded subsite is the little circle in the yellow bar under the top navigation. It's labeled Stories, and the picture in the circle changes randomly with each page load. These five ring stories are from the subsite's home page. Clicking this circle transports the browser through the hierarchy to the pictured story.

This page gives UPS a chance to highlight all of its Olympic projects, including the employee-athlete program. These down-home success stories help to personalize the site and turn a huge global corporation into a friendly giant.

Graphically, these pages are beautifully laid out. The clock with the moving second hand, the superimposed full-color head shot of Tongula, and the blue sprinting image in the background make a strong composition without overwhelming the rollover numbers that represent the stages of Tongula's day. It is the visual presentation that helps make the story a compelling one, one that represents success for both the featured athlete and UPS' corporate image. Suddenly, UPS brown doesn't look so dull anymore.

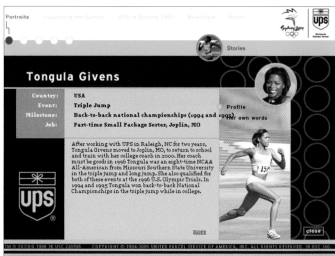

(THIS PAGE) Tongula Givens, a UPS driver and sorter who also just happens to be a former national champion triple jumper. Her typical day is presented in this collection of rollover snippets around a clock. There's also a brief bio along with an impressive-looking photo of the sorter/athlete in action.

CUTIUS, ALTIUS, FORTIUS, SWOOSHIUS: ABOUT NIKE.COM

It's just a shoe company, but it happens to be the shoe company that redefined footwear, and while it was at it, it also redefined branding. All it took was a little swoosh—lots and lots of little swooshes. Interestingly, where other big brands may have struggled with the transition of big brand marketing to a new medium, the Web seems to have been tailor-made for Nike.

Nike may have moved into nearly every crevice of footwear manufacturing and apparel and accessory markets, but it is first and foremost a sports shoe company. So it is only logical that the world's quadrennial gathering of the fleet-footed provides a special showcase for Nike products. What percentage of UPS deliveries from Portland, Oregon, (Nike's world headquarters) to Sydney, Australia during the last two weeks of September contained shoe boxes? Although you might think of the UPS-Olympic alliance discussed in the previous section of this chapter is perhaps one of pure marketing with little inherent synergy, Nike embodies the Olympic creed—citius, altius, fortius (faster, higher, stronger). But which brand is stronger, the Nike swoosh or the five Olympic rings?

The complexity and sophistication of the design of the home page result from the juxtaposition of contrasting colors and disparate elements. The largest, most prominently featured image is of "Marion Jones in Swift." Notice how this composite image doesn't mention the Olympics directly, but only alludes to the games. Understatement is a critical component of Nike's image. You find no "Will she win five gold medals?" or attempt to create additional hype beyond all that created by the more traditional media. The intensity is evident in the photograph and the Nike Swoosh on her shoulder, though small, is clearly evident. Jones has been branded.

(ABOVE) The intent of Nike's home page is unmistakable. It puts the unabashed stamp of Nike all over the Sydney games.

PRESENTING THE WORLD, STARRING NIKE

The featured link on this page is an inserted Flash animation. A single rotoscoped figure (an animation based on live-action footage) races across the cell in slow motion from the right. Stars of the games follow, but it is the final moment of the animation that brands the entire site, Nike.com/2000, and then an invitation to "Get Inside."

A third featured image that shares the narrow band across the top with the Nike logo is labeled in red, RFS—Radio Free Sydney. What is this image? Why is it so intriguing? It has all kinds of associations, but the fact is that Nike uses the image to draw viewers into one of its unique Olympic features. Yet there is still no direct mention of the Olympics, and no use of the Olympic rings (which is strictly controlled by the International Olympic Committee), yet the association is obvious.

Two medium-sized image maps link to the Nike store and the Nike custom shoe shop. Four smaller rollover icons link to additional Nike sites, Nike Digital Video, NikeFootball.com (which is a soccer site), Nike Shox, and Dreamcast Indoor. Each of these icons represents its own brand with its own site, and room exists along this orange stripe to add more logo links to future Nike sites.

BRANDING WITH A SINGLE SWOOSH

Image, color, and that little swoosh—that's all it takes for Nike to establish its brand on a Web page. The brand is so strong that it even dominates the Olympic thrust of the site. In fact, even though Nike is a major Olympic sponsor, providing uniforms for the USA team members, the company has not paid the International Olympic Committee (IOC) for permission to mention the Olympics, with a capital O, or use the Olympic rings on the Web. In contrast to the UPS site, Nike is not attempting to cobrand anything. Instead, Nike is dominating the competition and doing it with grace and style.

This home page is all about branding. It doesn't really contain any information; it's just a central switching station to get browsers somewhere else. But before you get where you're going, the Nike-ness of your endeavor is firmly established. This home page doesn't even establish a distinct site hierarchy. Most of the GIF text links in the navigation column lead to task-oriented nonhierarchical pages, like Ask Nike, Talk to Us, Privacy Policy, and so on. The links to NikeBiz and to the Nike Store take you to strictly hierarchical domains. Although these two destinations may provide the site's key content, they are the expected. What makes Nike's site so interesting is that it goes beyond mere expectations.

NIKE'S WORLD BODY—POOR PUN OR POWERFUL AMBIGUITY?

In celebration of the Olympics, Nike has created the worldbody.nike.com subdomain. Clicking the Get Inside link causes a quick JavaScript detect and then opens a new window the width of your screen. This high bandwidth site is meant to appeal to high bandwidth fans.

The whole show lasts about thirty seconds, all it takes to state Nike's theme for its World Body subdomain. At the same time, they've established a color scheme of orange, blue, and green. Nike is also very creative with the theme of world body. Does the thin line represent the rock-strewn road that all athletes must travel, or is it an artery pumping blood through the active body? This ambiguity is useful; the multiple interpretations of the imagery create depth and strength and give the site an exciting tension akin to the anticipation of a race. This tension works in Nike's favor, because it's hoping that some of this excitement will carry over to its gear. The tension created by the site can't help but color your personal Nike experience the next time you put on a pair of running shoes. Wow, you really can run your fastest and jump your highest. (Whatever happened to PF Flyers?)

YOU ARE NOT A LOVELY FLAG...

SKIP INTRO

(ABOVE AND THE FOLLOWING TWO SPREADS) Nike's World Body introduction begins with an orange stripe that looks like a road. A faint heartbeat accompanies what could be corpuscles coursing through the orange stripe. The beats get louder, and then the sound of what might be a didgeridoo starts up and the orange road begins to widen. The roto-scoped runner, tiny at first, is followed by the words, "You are not a lovely flag..." then getting bigger, "You are not an anthem... You are not the country you were born in... You are a cell within the world body..." Then the road turns blue and drums join the sound chorus, "One of us all." the beat and runner accelerate, blue changes to green, "Yet one of a kind," the beat heats up further and the road returns to orange: "Singular. Unique," and then the image explodes. The tag line, "Celebrate the World Body," finishes the introduction.

YOU ARE NOT THE COUNTRY YOU WERE BORN IN.

SKIP INTRO

YOU ARE NOT AN ANTHEM…

SKIP INTRO

SKIP INTRO

CELEBRATE THE
WORLD BODY.

SKIP INTRO

PROGRAMMING ON THE CUTTING EDGE OF DESIGN

This active, complex site uses extensive Java programming to provide large quantities of information taken from multiple media and manages to present it all in a coherent browser window. The use of these advanced Web technologies is appropriate for a company whose image is based as much on innovation as on style.

When the introduction completes, Nike's World Body content appears. Nothing in this subdomain is static. On this first page, the balls are in constant motion, and you see a message, "Play with our balls." When you click and drag in the orange stripe, the balls get all excited. It's also noteworthy that these pages are available in many languages, including Japanese and Korean. The time stamp in the upper-right corner is the current time in Sydney, which is useful for timing your Olympic explorations, but once again, the *O* word is never used.

In fact, all the World Body content is translated into eight languages. The site's designers believe this translation is a unique, history-making feat in the annals of the Web. They know of no other site, and neither do I, that provides constantly updated content in so many languages. The nike.com team, along with Blast Interactive, has a Web team in Sydney that sends all content to translators around the world. As soon as the stories are available, they go up on the site. This site is Nike's vision of The World Body, and it's a truly global concept. By contrast, the olympic.com site is only available in English and French, the two official languages of the IOC (the International Olympic Committee).

(THIS SPREAD) In addition to the first screen in this sequence with a red corpuscle representing "blood + guts, athletes," there is a fingerprint for "skin, product"; an open mouth for "tongue, uplink", an ear for "eardrum, downlink", and the back of a neck for "spine, schedule." The row links finishes off with a Nike swoosh.

VIVIDLY METAPHORICAL LINKS

It doesn't look as if the site has a hierarchical navigation scheme, but each of the gray images of body parts in the bottom stripe is a sectional link. Rolling over one of the metaphorical images changes the whole main image section of the page. Do the metaphors seem a bit far-fetched? Nike might say they are thought provoking, but they seem just plain attention getting. But whether these are appropriate metaphors doesn't matter. What's more important is that they are used consistently in support of Nike's idea of the World Body, and therefore are a powerfully unifying theme.

The first real athlete presented is Marion Jones. First, snapshots of various sizes fill the screen and a message, "Loading Scrapbook Images…" appears. Then the voice of Jones at the bowling alley starts up and a moving collage based on the scrapbook images follows. In a way, it's less static than an interview video, and it doesn't require any video streaming technology.

There are also ten tiny pictures across the top bar and a drop-down menu with the names of another twenty athletes. These athletes are the Nike elite, and there is information about them as real "blood + guts" athletes and people, as well. Nike has been similarly thorough in listing all the events in which these athletes will participate in Sydney.

The effort to create this site, the quantity of information collected, the attention to design details—was it all worth it for a site that was out of date and gone from the Web in a matter of weeks? Perhaps there is no answer. Clearly big brands are willing to spend big bucks to be associated with sporting events (see Chapter One). Nike has gone a step farther and branded a whole sporting event with its swoosh. The IOC couldn't be happy about this situation.

This discussion raises another question: Who is the real big fish here? Although the Olympic brand may have the edge in stature, Nike has a commanding lead in fleetness.

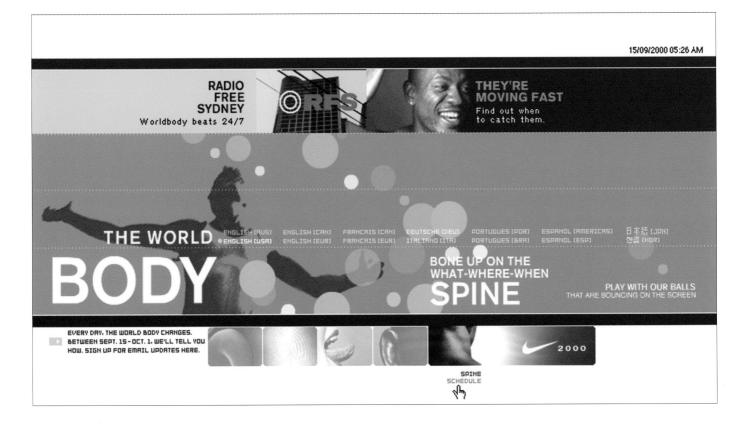

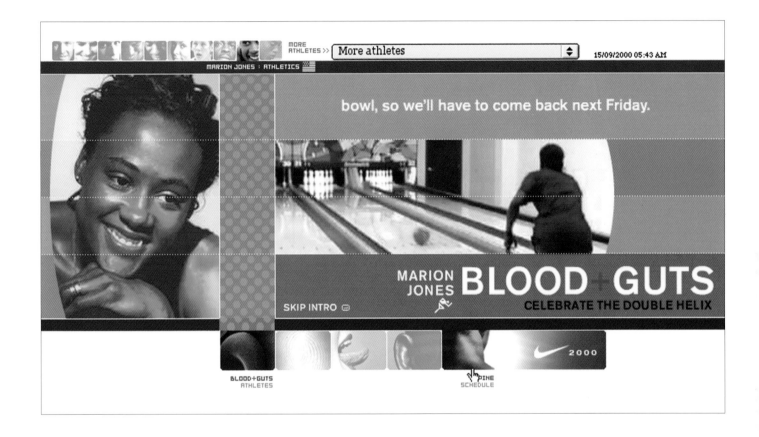

(ABOVE) Along with the changing images, Jones's words appear, becoming part of the same visual display. Then comes a list of Jones's events and stats, along with the option to click on more interviews. There are two little links labeled, Spine: My Events, and Skin: My Gear. For those who want to read about Jones's many events or wear the same things she wears, these nonhierarchical links are to the Spine and Skin sections.

Just as many so-called antique stores sell few, if any, genuine antiques, boutiques are seldom the small, independent stores they once were. Big brands have invaded the world of boutique shopping, and the landscape of shopping has changed forever. What used to be exclusive shopping avenues are now populated with the same stores wherever you are in the country. It's all part of the "malling" of America. But what of the Web? Need it be "malled" as well?

It has been stated in other chapters that the Web is the great brand equalizer. One could argue that a virtual lemonade stand on the Web has as much chance of receiving viewers as Minute Maid has. In reality, the Web is not quite so egalitarian. Turning lemonade.com into a world brand takes a lot of work. (In fact, such a site exists, but only a single semiamusing page exists at this point. On the other hand, Minute Maid, which is owned by Coca-Cola, has a substantial, if dully corporate-looking, site.) But obviously, the Web provides an affordable means for smaller, newer brands to present themselves to a very large audience. Or even to present themselves to a small, very specific audience in a very large space. For less than the cost of a single television commercial, the world is yours. And although plenty of examples exist where much was spent for very little on the Web, that's not what is being discussed here.

Before reviewing boutique brands, they must be defined. First, something fashionable exists about boutiques. If you're going to sell plumbing supplies at your online boutique, they better be designer plumbing supplies. One also gets the sense that boutiques are small, or at least that they offer a limited number of items. Yet small and stylish doesn't preclude being a well-known brand. In fact, the Web is probably the best medium for turning boutique brands into big brands.

[7] BOUTIQUE BRANDS
SMALL FISH IN A BIG POND

CURIOUSLY STRONG APPEAL

Is basing a brand completely on humor possible? Well, having a worthwhile product helps, which is probably what the British candy company, Callard & Bowser, saw in Altoids-brand peppermints when it purchased the company many years ago. Callard & Bowser later merged with Suchard and has since been purchased by Kraft Foods, Inc., which, in turn, is owned by Phillip Morris. So, though Altoids is an internationally advertised brand with terrific name recognition, it qualifies as a boutique brand within its larger corporate hierarchy.

MAKING MUCH OF A LITTLE WHITE TABLET

People need only hear the name Altoids to supply the tag line, "The Curiously Strong Mints," and the billboards with the scantily clad musclemen holding the small, bright red tin of mints present an absurd-yet-sophisticated juxtaposition that creates the joke and makes the product package so appealing.

After the curiously strong tag line, what can be said about a breath mint's image that fills a whole Web site? For starters, anyone coming to www.altoids.com is likely already familiar with the product and probably likes both the mint and its ad campaign. The site is a way to take the ads further, to create an entire Altoids universe of the absurd. And as you find out, hidden among the various features, you can even buy Altoids online.

Nearly everything that happens within this site takes place on or inside this tin. For branding purposes, the Altoids tin has become almost as recognizable as the Coke bottle. In addition to the lid of the tin, there are top and bottom border rows with nonhierarchical links. The Altoids mint-leaf logo is included in the top border, and the trademarked tagline is included in the bottom border. The tin itself is divided into twelve squares, each with a completely different image. Some of the images are animated GIFs; all are brightly colored, with bold typography, and retro imagery. The intentional effect is an orderly chaos of good-humored fun, which is the same tone Altoids cultivates in its print ads.

It looks like a table, but this page is actually a rather complex arrangement of nested frames. Each of these frames contains documents that are further divided into frames until eventually an arrangement of three by four frames is achieved. The number twelve is significant, because it can be divided by two, three, and four, which means that the number of possible permutations is quite large. In Altoids' hands, even geometry can be fun.

(ABOVE) Notice that the arrangement of images on this page is in the shape of an Altoids tin. The feeling is strongly retro — the somewhat pastel colors, the typography, the rounded shapes, and even the tone of the text are all reminiscent of a 1950s amusement park.

(THIS SPREAD) Clicking a link reloads a frame or frames with a new document. So if clicking on the "In the Beginning..." square, the link reloads the frame containing the two lower right-hand squares with The Altoids Story.

This matrix of frames is a unique way to create functional divisions and present the hierarchy in what appears to be a totally nonhierarchical way. There's no sense of traveling downward in a page structure. It's an original presentation of a fairly straight-forward organizational scheme, and clicking through all the squares to see how the tin changes is fun.

MAXIMIZING THE TIN'S REAL ESTATE

One of the drawbacks of limiting the navigation to twelve squares on a tin is that no room is left for expansion. But the company has figured this one out, too. The matrix is randomized, so the content of the squares changes. Several of the HTML frames include doc-uments with a JavaScript randomizer, which means that more important content can be fixed in place, like the Outside the Box, Free Money, Souvenir Shoppe, and The Altoids Story squares. Nice Factoids, Urban Myths, Hi Jinx, and the others can come and go. This technique works because most of these links are purely for fun; they present content that serves to build the brand image, but they contain no substantive information about the company or its products.

But a tremendous amount of flexibility still exists. For example, every square has its own identity. Except for the general retro quality of the squares, the typography, colors, and design of each has very little in common with the others. The grid of the tin holds the designs together.

GETTING BROWSERS INSIDE THE TIN

Because every site should try to engage its browsers in some way, one of the eighteen rotating links includes a weekly users' poll. What's most interesting about this link from a design per-spective is that the poll content fills four squares in the matrix. It's just another design permutation.

Because the face of the tin is endlessly changeable, this means that the navigation is also changeable. Where's the back to home button? Each section frame has a close button. Clicking the close button has the effect of moving you back up in the hierarchy to the previous state. As mentioned earlier, you can also click the little Altoid at the bottom to "flip the lid." This button is essentially a home button. When clicked, the matrix of twelve squares returns, putting you back on the home squares.

(ABOVE) Altoids' user survey engages browsers directly with its interactive polling, but it never breaks with the design structure of frames.

SUCCESSFUL SHOPPING WITHIN A GOOFY AESTHETIC

Practically speaking, the most useful link on this site is for the Souvenir Shoppe. This link is to the e-commerce portion of the site. This subsite, with its glowing highlights, little stars, and its use of alternating dark and light bars to give the effect of a corrugated aluminum diner, is the ultimate expression of the malt shoppe aesthetic.

Remember, Altoids.com is a boutique site. As e-commerce sites go (see Chapter 9 for e-commerce in more detail) the shopping experience is straightforward, and the shopping basket and checkout are handled very cleanly. Of course, to make the cost of shipping worthwhile, browsers will end up buying mints by the caseload.

This site is really for the seriously addicted mint consumer. From a Web branding perspective, to imagine doing more with a small package than Altoids has managed here is difficult. At no time does the site stray from the comfy home of the rounded-corner tin. Even as the face changes, the navigation is constant, and the top and borders outside the tin remain fixed.

When your entire brand is limited to peppermint, cinnamon, and wintergreen, consistency helps. But inventive presentation of such a narrow product line helps even more. This site exudes inventiveness and at the same time creates its own little environment for the exultation, inhalation, and ingestion of small mints.

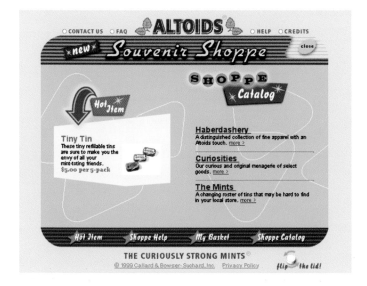

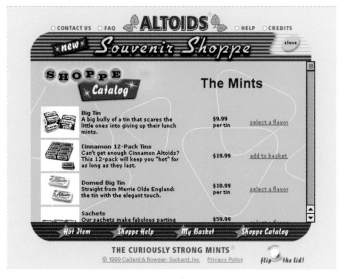

(LEFT) The Shoppe takes over the entire tin and includes its own hierarchy within the persistent top and bottom borders of the entire Altoids site.

(RIGHT) This shop does not contain a huge selection of items, but viewers can buy mints, along with a few logo clothing items and posters.

TENTING TONIGHT: OUTDOOR CHIC WITH WALRUS GEAR

Is having a boutique for tents possible? Not in the traditional sense, but Walrus Gear's online catalog fits all of the criteria for inclusion in this chapter. Walrus makes expertly designed tents, and although its emphasis is on technical rigor, the results are quite beautiful. And although a tent isn't exactly a luxury item, the market for these products is distinctly high-end. The site, too, like any well-designed selling space, shows careful attention to detail and to the customer experience.

MAPPING THE SITE FUNCTIONALITY

The slightly awkward introductory sequence for the Walrus site does most things right. The home page makes a strong statement establishing the Web brand through the use of color, layout, and imagery. But clicking the Enter link loads what appears to be a second entry page that offers little more than the first page.

This setup is perhaps the result of a corporation that designs and manufactures tents as three different brands. No matter, because after getting past the first entry, the site is a model of cleanliness and concision.

The entrance page itself consists of a center column between the left and right columns of an earthy green background color. Within the center column are three horizontally arranged frames that create top and bottom color borders for the content. Clicking the Tents link loads a new center frame. The technology of the site is limited mostly to the use of frames. It is clearly intended for use across a wide range of browsers.

(THIS PAGE) The difference between these too-similar pages is that home page one includes external links to Walrus's other corporate entities, Moss Tents and Armadillo Camp, whereas home page two establishes the basic hierarchical navigation for the rest of the site.

STITCHING THE ELEMENTS TOGETHER

This arrangement of frames remains persistent across all the main content pages. The topmost and bottommost frames are purely navigational in function, but they provide color contrast and a beginning and end to the branding and content frames. These important visual functions help give the site its consistently clean and functional appearance. Everything is neatly contained without a lot of fuss or extraneous material, which is generally good design practice and specifically an essential quality of efficient tent design.

These four frames are stitched together like the panels of a tent. The black of the top frame blends down into vertical black dividing lines of the second frame. These become dashed black lines in the content frame. In the bottom frame, the stitching is reversed to become white dashes on the dark blue background. Not only is this graphically strong, but the very subtle tent panel motif also helps brand the entire site.

QUIET ZIPPER PULLS
Our quiet zipper pulls of braided cord and plastic tabs that are large and easy to use - even with gloves on.

GROMMETS
Made in the U.S. out of solid brass, our spur grommets are as tough as they get. With multiple grommets on each strap you are guaranteed a tight pitch.

VESTIBULE
All Walrus hooped Vestiubules have many different uses.

MOUSEOVER ABOVE SIDE PANEL OPEN AWNING PANEL

HIGH VISIBILITY GUYLINES
Bright, easy to see guylines with adjusters.

SEAM-TAPING
We were one of the first to seam tape our entire line of rainflys and tailored floors to assure waterproofness.

THE TENT
While the flysheet is the roof over your head, the tent body is your living room. You want your living room to be nice and dry, with no intrusive insects, and your tent should be too.

WRAP BAG
By simply wrapping up the tent and folding it into the elastic rimmed compression sack, your customers will no longer have to deal with a stuff sack that seems to shrink as their trip goes on. Available on all models except the Micro Swift and the Arch Rival XV.

(ABOVE) As you move down in the hierarchy of this site, the middle frame of the page is divided in different ways to accommodate the content and extra levels of navigation. This main frame scrolls to view the abundant and cleanly laid out content.

DOWN THE RABBIT HOLE OF TENT SELECTION AND SPECIFICATIONS

Walrus arranges its tents into functional categories, and a step farther down in the hierarchy presents pages for specific tent lines. The arrangement of frames remains the same while the main content document changes. Frames are particularly useful for creating persistent navigation for changing content. The abundant and diverse content that I mention earlier fits very consistently into the scrolling frame. This technique allows Walrus to present many kinds of information without actually changing the presentation.

The final level of the hierarchy shows a Walrus tent in all of its engineering and design glory. The content frame is divided into table cells that make two basic columns. On the left are images of the tent, complete with dimensions and an enthusiastic review from *Backpacker* magazine.

The persistent navigational frames create a path that provide easy cross over to other pages at the same level or back up the path to the top. This scheme is fairly basic, but in this instance it's executed with great clarity. Also, viewers never lose sight of the two-tusked Walrus logo with its tagline of "fast, strong, beautiful." These words are also applicable to the design of this site.

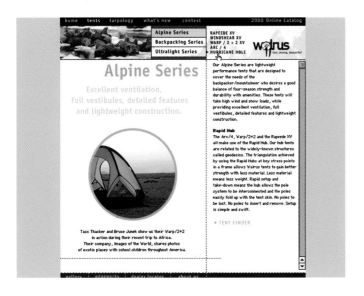

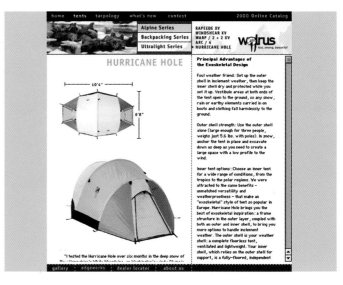

(LEFT) The branded navigational frame has changes to include an additional level of navigation that leads down to the tent product pages.

(RIGHT) The right column of text includes a functional description and pricing information for the featured product on the page. The narrow column helps make the text more readable.

COMPLETING THE BOUTIQUE EXPERIENCE

As a boutique, the Walrus site is incomplete because none of the products can be purchased directly. However, scrolling to the bottom of the content frame of any of the tent pages, reveals Walrus-branded links to Buy Online.

This feature is becoming more common among manufacturers who choose not to compete with their vendors, even online. It sounds old-fashioned, but it remains a valid business model. On the other hand, it provides a new model for online boutiques as places to browse rather than shop.

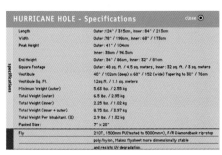

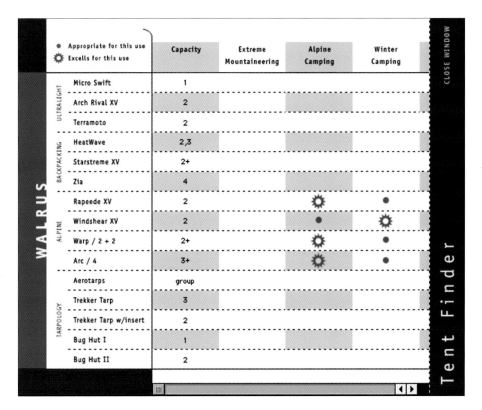

		Capacity	Extreme Mountaineering	Alpine Camping	Winter Camping
ULTRALIGHT	Micro Swift	1			
ULTRALIGHT	Arch Rival XV	2			
ULTRALIGHT	Terramoto	2			
BACKPACKING	HeatWave	2,3			
BACKPACKING	Starstreme XV	2+			
BACKPACKING	Zia	4			
ALPINE	Rapeede XV	2		☀	●
ALPINE	Windshear XV	2		●	☀
ALPINE	Warp / 2 + 2	2+		☀	
ALPINE	Arc / 4	3+		☀	●
TARPOLOGY	Aerotarps	group			
TARPOLOGY	Trekker Tarp	3			
TARPOLOGY	Trekker Tarp w/insert	2			
TARPOLOGY	Bug Hut I	1			
TARPOLOGY	Bug Hut II	2			

● Appropriate for this use
☀ Excells for this use

WALRUS · Tent Finder · CLOSE WINDOW

(TOP LEFT AND RIGHT) The View Full Specifications page presents a long list with color rules between each row. What could easily have been a dull list becomes another attractive element through careful use of color and typography. Similarly, the Tent Finder page uses contrasting color and dashed lines to present a complex array of horizontally scrolling information in a cleanly logical fashion.

(BOTTOM LEFT) Choosing a vendor links you directly to the specific product page at the vendor's site.

SHOPPING THE BIG BRAND BOUTIQUE

Banana Republic is unquestionably a big brand, but it began life as a kind of anti-boutique in San Francisco. Selling odd lots of used clothing and updated copies of vintage travel wear displayed among Jeep bodies and banana leaves, the store seemed as much a political statement as a fashion one. All but the name changed when an even bigger American brand, The Gap, bought the fledgling chain and turned it into the luxury shopping mall outlet it is today.

Such is the power of brand recognition that a successful packager of the Hemingway safari image can transform itself into a supplier of work-chic for Silicon Valley types. Its stores may not provide the personal touch of old-fashioned boutiques, but Banana Republic defines the mass-marketed boutique of the Internet age.

The cluttered jungle motif of yore has been updated with polished wood cabinetry and sleek stainless steel and glass. The stores have a certain spacious elegance, at least when compared to their brethren Gap stores. These touches are all necessary ingredients for a boutique-like store with a higher-priced product. Consumers want to feel, if not quite at home, at least very welcome. After all, Banana Republic would like its loyal customers to visit often and linger while they're there. Both are qualities of a successful Web site, as well.

ENTERING THE ONLINE BOUTIQUE

Right from the start it's evident that this site is selling luxury "Luxury. Wear it to Work. For man. For woman." The tag line accompanies a relatively large (in screen size) animated GIF that alternates between the image of a working man and a working woman.

It's interesting how un-luxurious the office backgrounds of these pictures are. It's a way to provide contrast to the fashionably dressed models, as if to say, "Here's your chance to provide some color and elegance in an otherwise drab world." This idea is really the essence of the Banana Republic brand—to make the wearer stand out in a world of office equipment.

BRINGING THE PHYSICAL STORE ONLINE

Banana Republic has established an icon system based of white capital letters on color squares. The system is used in its stores on clothing hangtags and sewn-in labels, and for the Web site's navigational buttons. The typography for these icons is based on ITC Franklin Gothic, a classic, geometric sans serif design.

The original 1902 typeface by Morris Fuller Benton has been a standard for newspaper advertising in the United States ever since it was designed. The capitals are slimmed down a bit for these icons, much as the clothes are all presented in long, lean poses. Franklin Gothic has a nice work-ethic, no-nonsense quality. Again, it's an elegant element that provides a strong contrast to Banana Republic's goods.

The entire hierarchical navigation for this site is contained in these four square icons—man, woman, home, shoes. Banana Republic has chosen this way to divide its product lines, and it creates very strong branding within each site division. At the same time, this site features pants. Where the icons are hierarchical, the For man, and For woman links skip a hierarchical level and go straight to the pants listings.

(LEFT) While the featured image alternates between headless man and slouching woman, the label, "Work (pants)," remains fixed, which gives it the effect of floating over the pictures.

(RIGHT) All the important design elements for this site are established on this home page. The rectilinear layout of color blocks and images is the height of elegance The colors themselves (purple hues in this case, but changing with the seasons) have a strength and solidity and at the same time are quite stylish.

CHANGING WITH THE SEASONS

Everything that happens above the bottom navigation frame changes with the seasons, just like a store display window. Although the branding elements remain unchanged, the different colors and imagery give the summer page a very different feel. The seasonal changes encourage return visitors to find out what's new. Both pages are unmistakably familiar to Banana Republic's loyal customers.

Just as men remain men and women remain women, the navigational hierarchy of this site also remains unchanged through the seasons. Well, almost unchanged. Don't forget that this store is a fashionable boutique. The *G* square (gift) of summer becomes an *S* (shoes) in fall, and the gift division falls to the Gift Finder link. These changes show how difficult sticking with a tight, square design of four icons is.

(ABOVE) Here's a screen shot of the summer's display, very warm and casual in contrast to the cool office aesthetic of the fall page.

HIERARCHIES ARE NOT FASHIONABLE

Each of the four main product divisions has a starting page with a list of product categories. The color of the type is picked up from the division's icon square, which becomes gray. The rigidity of squares and the look of these pages contain a certain hard-edged quality. But the design itself is not rigid. Instead it is very consistent in the way it uses design elements, including shapes, colors, typography, and layout. Actually a good deal of flexibility exists for making content changes and for creating distinctions among the product lines.

From any of the divisional home pages, items can be found by category. So from the Woman division, click on the Skirts category link to view the selections. In addition to the skirts on this page something else is going on here and it's happening all over the site. All the photographed items fall within the featured color scheme of the site. For fall, there a lot of cool blues and violets with beige. Just as color is a crucial defining element for the Banana Republic display windows and print ads, each site update brings completely new hues. The warm summer colors shown below right were defining colors not just for the home page, but also for the summer fashions themselves.

(LEFT AND RIGHT) The Man and Woman divisions also have product finders like The Short List, which is not a list of shorts, but a selection of the most fashionable items.

(TOP RIGHT) The Shoe page is the only divisional page with two square images—one for men and one for women—and no categories. Looking at these shoes, though, you might think they were intended for two different species of animal.

FASHION GIVES WAY TO SHOPPING REALITIES

From the category page, click a featured item or click the View More button to see the full product line. You have to click a page number to see more items, or use the Choose a Category drop-down menu to specify your shopping goal further.

This straightforward presentation of navigational choices is the shopping equivalent of looking through a rack of skirts, going on to the next rack, or strolling over to another part of the store. Interestingly, not a single price has shown up yet in the exploration of this site. This is more evidence that this site is a shopping, rather than an e-commerce experience.

Prices aren't revealed until the product detail pages, almost the lowest level in the site hierarchy. Choose a color, size, quantity, and shipping destination. And finally, in a red-bordered box most of the way down the page, click the all-important Add to Bag button to make a purchase.

More importantly, from the perspective of Web branding, the buying experience, like the shopping experience, takes place completely within a frame of Banana Republic branded elements. The box that is bananarepublic.com remains constant. Everything that's presented, from the most current style to the on-sale cast-offs, gets the same treatment within this online boutique.

The pure product-driven hierarchy of this site leads from main page, to division home pages, to categories, and finally to a product page. But at several points, side paths are available; for example, the pants featured on the main page and the wardrobe links, such as The Short List links. These side path pages are the only ones on the site with rollover text set in the seasonally correct color and with items from different categories featured together. In fact, these pages are a defining part of the Banana Republic online shopping experience—the casual rather than product-directed shopping experience.

Without such diversions, the site would be in danger of feeling like any other mall store online. Instead, the quintessentially boutique shopping experience has been translated into an online experience, albeit a very big-brand boutique.

(TOP LEFT) Instead of a page full of skirt thumbnails on its Skirts page, bananarepublic.com presents a different shopping experience based on a few, carefully selected featured items. **(BOTTOM LEFT)** Just as in the stores, the display of items is spacious. No thumbnails are shown, just full views, but only five images per page. This method works only with a limited inventory.

(RIGHT) On the product pages, a descriptive name for each product is in all capital letters followed by a brief paragraph description. There is more detailed information, including color swatches, size chart, fabric care, or related products from the More Product Info drop-down menu.

Of all the wonderful opportunities that the Web offers, the ability to create completely new brands overnight may be the best. But are so many new brands really needed? Of course. How else are all the unneeded services never before imagined going to be offered, using up every conceivable dot-com domain name in the alphabet? Anyone for gorblats.com? Or if gorblats.com is registered by the time this book goes to print, consider mygorblats, egorblats, or igorblats. A good name like this won't last long.

Certainly names are important in the branding scheme of products, but what about for the Web site? For brands that exist solely online, the site is the product. A decade ago, the secret to success for software companies was to think of an idea and then to print T-shirts. Such is the state of dot-com enthusiasm, or is it madness?

It's easy to joke about the overabundance of new brands, but one fact remains—the Web makes it possible to provide services that previously were not available. Search engines and portals are whole new business categories. The transformation of so-called bricks and mortar businesses into click and order businesses is a huge online phenomenon. And although this affects existing businesses as much as new businesses, the Web also provides an opportunity to redefine the way that business owners provide goods and services.

The Web provides an obvious paradigm shift for business transactions in the twenty-first century. As a result, the brands that you know and love must adapt and change so as not to be overwhelmed by the inundation of brands from every corner of the Web. This flood of new brands is discussed in this chapter, especially the dot-com brands that could not have existed in the pre-Web world.

DOT-COM BRANDS
WHERE HTML IS HOME

IN THE BEGINNING...

First came Yahoo!, a pure invention of the Web, a sort of light-in-the-wilderness guide to a chaotically expanding universe. Yahoo! succeeded by humanizing the Web-searching experience. Popularity brought advertising and assured Yahoo!'s preeminence as the Web's number one site. Endless new portal sites in the Yahoo! mold have followed.

With an understanding of how alluring good portals could be, the Web begot Amazon.com, and Web commerce was born. "Earth's Biggest Bookstore," may be bleeding cash, but it shows that the Web is Earth's biggest 24/7 bazaar. The lesson that Amazon.com teaches is that the Web is an enormous mercantile force.

THE BIG BANG BROWSER

But before Amazon.com and Yahoo! had a reason to exist, users needed a browser. Although Microsoft's Internet Explorer is grabbing market share now, Netscape Navigator, the successor to Mosaic, first introduced Microsoft's executives to the World Wide Web and its unbounded potential for exploitation.

Although Netscape may have lost the browser wars (pending litigation against Microsoft notwithstanding), it is still a major force. What synergy Netscape can gain from its acquisition by AOL-Time Warner is difficult to assess, but it clearly involves a rebranding of Netscape as more than a software developer.

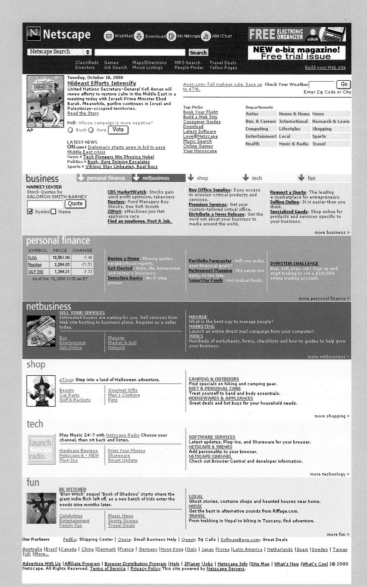

(ABOVE) The first sign of Netscape's rebranding is a completely redesigned domain as a full-fledged portal site or, as designer William Drenttel likes to call it, an information hub.

TAMING THE WILD PORTAL

By their very nature, portals are meant to provide a link for everyone. For designers, providing a link for everyone means cramming as many links as possible into the space of a single screen. This stands in direct opposition to basic Web-design precepts, primarily, to keep the design as simple and uncluttered as possible. Above all else, clarity is essential for any successful design. William Drenttel, founder of the design firm Helfand & Drenttel, and his art director, Jeffrey Tyson, have shown that it can be done when they redesigned Netscape's page.

There are over one hundred links on Netscape's home portal page. Incredibly, there used to be more. When Drenttel started on the project in April of 1999, netscape.com was a Yahoo! me-too.

Drenttel's first attempt at redesigning Netscape's home page repositioned Netscape away from the channel model. Although graphically cleaner and more user-friendly than many information hubs, it was not a model of uncluttered beauty.

SAME BRAND, NEW OWNERS, NEW DESIGN

The acquisition of Netscape by AOL-Time Warner gave the Netscape domain much greater importance, both as a recognizable dot-com brand and as a source for advertising revenue. This site was expected to turn a profit, and to do this, it needed a new redesign. But the problem remains the same, including something for everyone on a single page without creating a bland, flat hierarchy that interests few? Portal sites need to attract as many people as possible on the first page by including something for everyone. Information architects may decry the portal model as an inefficient way to deliver information over the Web, but it does not matter. Users expect to see big, broad portals, which are, after all, some of the biggest brands on the Web.

So Netscape, too, must play the portal game, but it chooses to play by changing the game board. The Netscape board is more colorful, makes better use of the space on the page, and, most importantly, organizes all links into a clear, informational hierarchy. In essence, it takes a physical site hierarchy that is both broad and deep and arranges it for presentation as a virtual site map.

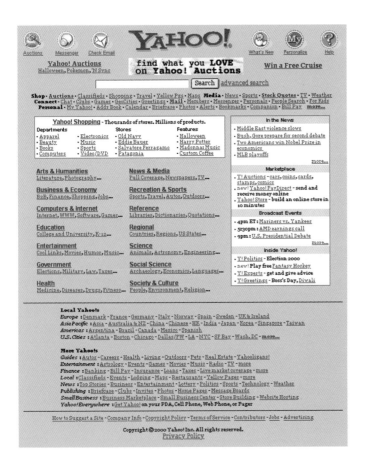

(**ABOVE**) Yahoo! is the archetypal portal with hundreds of links arranged in channels. This channel model is the standard for all sorts of portal and portal-like sites.

(**OPPOSITE**) Despite the unwieldy number of links still present, Netscape's interim page design was clearly divided into content zones that helped to structure the information.

LATEST NEWS .com

Monday, Oct. 2, 2000
Updated every 15 minutes
- <u>Supreme Court, in new term, to take on clean air, water, police searches</u>
- <u>Israeli-Palestinian clashes intensify</u>
- **Business**: <u>Dorel Shares Drop After Profit Warning</u>
- **Sports**: <u>Pirates' Manager Gets the Ax</u>

<u>More News...</u>

WEATHER SEARCH

[] [Go]
Enter City Name or Zip Code

TOP PICKS

<u>New: Business Tools</u>
<u>Buy Software Online</u>
<u>Consolidate Debt</u>
<u>Download/Netscape CD</u>
<u>Free Web Presence</u>
<u>Investor Challenge</u>
<u>Instant Messenger</u>
<u>Industry Headlines</u>
<u>Love@Netscape</u>
<u>New! 5¢ Calls</u>
<u>Online Games</u>
<u>Take a Survey for a Chance to Win $500</u>

SHOP NOW

<u>Baby Clothes</u>
<u>Digital Cameras</u>
<u>Pet Accessories</u>
<u>Shoes & Apparel</u>

WEB TOOLS

<u>Book Flights</u>
<u>Communications Center</u>
<u>Communities</u>
<u>Hardware Reviews</u>
<u>Make Better Decisions</u>
<u>Netscape 6</u>
<u>Plug-ins</u>
<u>Shareware</u>

Chat WebMail My Download

[Lycos Search ▼] [] [Go]

Netscape
Netcenter

| Netbusiness | Free Time |

MARKET CENTER
Stock Quotes by
SALOMON SMITH BARNEY

[] [Quote]
☑ Symbol ☐ Name

SYMBOL	PRICE	CHANGE
DJIA	10,704.50	+53.60
Nasdaq	3,650.30	-22.52
S&P 500	1,441.08	+4.57

As of Oct. 2, 2000 12:00 pm ET

<u>Quotes</u> delayed at least 20 mins.
<u>Disclaimer</u>

NETBUSINESS
- <u>Time saver</u>: The average payroll process for a small business has 54 steps and takes 36 hours annually. Do you have that kind of time?

BUSINESS NEWS
- Latest from <u>CBS MarketWatch.com</u>.
- Breaking tech news by <u>ZDNet</u>.
- <u>eCompany Now</u>: Street Life -- Get the word on stocks.

CAREER CENTER
- <u>Win $50,000</u>: Enter Star Search 2000 from Monster.com.
- <u>Office Fashion</u>: Read about the trashy coworker and more.

PERSONAL FINANCE
- <u>Mutual Funds</u>: All the information you need about mutual funds – tips, advice, taxes and a comparison tool.

Search Links
<u>Classifieds</u>	<u>Maps/Directions</u>
<u>Decision Guides</u>	<u>Netbusiness</u>
<u>Directory</u>	<u>White Pages</u>
<u>Office Specials</u>	<u>Yellow Pages</u>

Shopping Shortcuts
<u>Baby Clothes</u>	<u>Jewelry</u>
<u>Business Buying</u>	<u>Kids Clothes</u>
<u>Digital Cameras</u>	<u>Pet Accessories</u>
<u>Electronic Gaming</u>	<u>Shoes & Apparel</u>

Today's Features...

AP

Mideast Riots Out of Control: Israeli and Palestinian officials call for an end to the bloodshed that has killed more than 30 since Thursday. Officials fear the area's worst violence in four years will upset fragile peace talks. <u>Read the Story</u>
<u>Bush, Gore Prep for Debates</u> | <u>A's and Mariners Clinch Playoff Spots</u> | <u>Olympics Wrap Up</u>

Poll: How important are the debates in your pick for president?
○ Very important ○ Somewhat important
○ Not important at all [Vote]

<u>Struggling with a Small Business</u>? Reach 20 million new customers for free.

amazon.com.
BUY BOOK BESTSELLERS HERE

<u>Netbusiness</u>: Find services, get estimates
<u>Investor Challenge</u>: Win $10,000
<u>Business Web site</u>: For free
<u>Avon.com</u>: Enjoy a refreshing weekend
<u>Election 2000</u>: Special Report

N Netscape
Personal Finance
Investor Challenge
<u>Enter the Investor Challenge</u> and start picking your stocks today. $10,000 online account grand prize.

Channels

<u>**Audio**</u> > <u>Netscape Radio</u>, <u>Multimedia</u>...

<u>**Autos**</u> > <u>New Cars</u>, <u>Used Cars</u>, <u>Classic Cars</u>...

<u>**Business**</u> > <u>Career Center</u>, <u>Free Agents</u>...

<u>**Computing & Internet**</u> > <u>Free Software</u>, <u>News</u>...

<u>**Entertainment**</u> > <u>Movies</u>, <u>Music</u>, <u>TV</u>, <u>Celebrities</u>...

<u>**Family**</u> > <u>Kids</u>, <u>Teens</u>, <u>Genealogy</u>, <u>Seniors</u>...

<u>**Games**</u> > <u>Sports</u>, <u>Lounge</u>, <u>Clubroom</u>, <u>Worlds</u>...

<u>**Health**</u> > <u>Nutrition</u>, <u>Fitness</u>, <u>Women's Health</u>...

<u>**Home Improvement**</u> > <u>Remodel</u>, <u>Decorate</u>...

<u>**Lifestyles**</u> > <u>Women</u>, <u>Pets</u>, <u>Gay/Lesbian</u>...

<u>**Local**</u> > <u>Dining</u>, <u>Movies</u>, <u>Events</u>, <u>Arts & Culture</u>...

<u>**Netbusiness**</u> > <u>Buy</u>, <u>Manage</u>, <u>Network</u>...

<u>**Netscape**</u> > <u>Developers</u>, <u>Security</u>, <u>4.7</u>...

<u>**News**</u> > <u>Biz</u>, <u>Politics</u>, <u>Sports</u>, <u>Tech</u>...

<u>**Personal Finance**</u> > <u>Invest</u>, <u>Portfolio</u>, <u>Insurance</u>...

<u>**Real Estate**</u> > <u>Homes</u>, <u>Apartments</u>, <u>Mortgages</u>...

<u>**Research & Learn**</u> > <u>Reference</u>, <u>Education</u>...

<u>**Shopping**</u> > <u>Computers</u>, <u>Books</u>, <u>Music</u>...

PORTAL REBORN

"From a design standpoint, we couldn't go anyplace new without a new structure that would rein in the content," says Drenttel. So rather than continue the endless links approach, Drenttel tried a layered approach. But it wasn't until he flattened out the layers that he hit upon a way to deemphasize channels completely.

At the top is a dark blue navigation bar, branded with the Netscape logo. The dark blue gives this band the kind of borderlike quality users expect to see at the top of the page. It's an effect that opens up space underneath.

More importantly, browsers can find the search function on this top bar. Netscape Search is the first choice in the search engine's drop-down selector. Additionally, a list of ten section links, probably chosen for this important location because of their popularity, is displayed. On the right is space for two banner ads, plus one more link, which alternates between Get Management Training and Check Shipping Rates, both services of Netscape's newly branded NetBusiness venture. This simple layout creates a strong structure for the page.

Netscape is establishing a brand, not just with its logo but also with the color blue. This shade is the darkest shade of Netscape blue, and all the links in this band are in the lightest shade. It's difficult to brand the color blue, but Netscape's consistent use of a single blue hue in several shades is one of the strongest branding tools (after the actual logo) of this page.

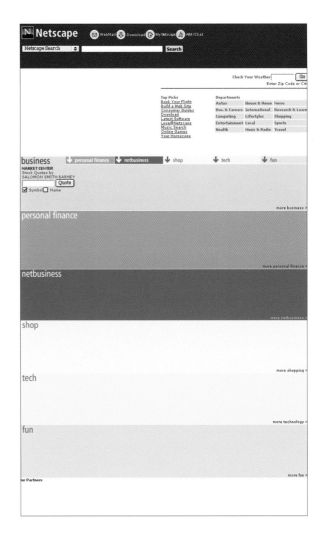

(TOP RIGHT) The top navigation bar includes four icons for nonhierarchical links to Netscape/AOL-branded services: WebMail, Download, My Netscape, and AIM/Chat. These icons were used in Netscape's previous home page design but are now smaller and more clearly labeled.

(BOTTOM) This image shows the structure of Netscape's home portal with all the changing links and the content removed. The bands of color create a hierarchy of information that direct the viewer's eye through this sea of choices.

CONTENT IN ITS PLACE

Putting the darkest color band on top creates a border and provides contrast for the taller white band that follows. This white space is the main content area and also where the eye goes to first for information.

These first two bands, which represent only about a quarter of the total page real estate, already contain a tremendous number of links across a broad range of areas. But compared to the endless lists of a Yahoo!-like page, this breadth is pretty easy to take in. The clear delineation of content areas helps to bring this page into focus and prevents the usual chaotic effect of similarly broad sites.

The unusual central link bar separates the more general features of the top of the page from the more topical ones that follow. The question is, is this link bar part of the top section of the page or part of the bottom? It's both. It falls within the first 400 pixels of the page within the so-called page fold. So it is visible without scrolling on even the smallest monitors. The link bar provides a way to view the content of the lower reaches of this rather long page without scrolling; therefore, it is part of the top.

However, graphically the link bar appears to be attached to the bottom half of the page. Netscape provides a good example of color branding by using blue for the background of the first three bands and blue letters on a yellow background for the other three bands, which clearly binds the link bar to the bars that follow it. Functionally, the link bar forms a bottom navigation bar for what precedes it, while visually forming a heading strip for what follows. This clever ambiguity enables the strip to do double duty.

The graphic structure of the page is further strengthened by the color tints used for each band, the white hairlines used to separate bands from each other, and the light blue hairlines used to separate columns within each color bar. There's nothing wishy-washy about the way elements are juxtaposed; they remain clearly differentiated.

The down-pointing arrows of the jump-down links make it clear that clicking these color bars leads somewhere, and the labels—business, personal finance, netbusiness, shop, tech, and fun—make it pretty clear what you can expect. Using two hues to differentiate business (blue) from pleasure (yellow) not only improves the clarity of the page but is also a carryover from Netscape's previous home page design, which used two color-coded tabs to represent Netbusiness and Free Time.

(TOP) The main content bar is filled with news from Time Warner–owned CNN, which provides constantly updated headlines for the entire home page.

(BOTTOM) Everything that falls under the main navigation and content bars is divided into three blue and three yellow bands topped by a bar of jump down links, one for each of the five following bars, plus a tab for the first blue bar, "Business."

A FAÇADE OF ORDERLINESS

Although Netscape's home page includes scores of links leading off in all kinds of directions, content areas on the page give this amorphous collection a clear definition. The hierarchical links are not gathered together in a single navigation element. Instead, the hierarchical links are the More arrows at the bottom-right corner of each color bar. The graphic design is what gives this site its hierarchy.

Which brings up an interesting point: This Drenttel-designed page is like a reverse wild-west façade. Instead of a fancy design on a rather modest building, this page is a simple, clear design hiding an enormous collection of sites and information behind it. In fact, the rest of Netscape's sites, subsites, and subdomains have yet to be redesigned.

The next step for the development of this page will enable users to customize the content by essentially creating customized hierarchies. Many portals and search sites already provide this capability, but the Netscape-branded experience is designed to accommodate this kind of content rearrangement with great flexibility. The content areas expand and contract but remain true to the Netscape colors.

THE FIFTY PERCENT SOLUTION: WEB SITES FOR WOMEN, WEB SITES FOR MEN

In the last year or two, Web sites geared toward women's concerns and interests have become more popular because women are spending more time browsing. Special-interest Web sites are also blossoming. In its basic form, a women's Web site is not much different from a women's print magazine—articles about subjects of interest to women, including health, personal finance, and family, with the addition of some chat features on the same subjects. In the dot-com realm, women's sites such as www.oxygen.com are big Web business.

However, oxygen.com suffers the same weaknesses as the entire industry of "women's" publishing. It is difficult to take a publication seriously that, with no sense of irony, juxtaposes stories about the death of two women sailors in the bombing of the USS *Cole* in Yemen, with the following headline, "Fall TV Preview: What's worth your couch potato-dom?" Isn't there something tasteless about an information hierarchy that equates sex, diet, and world politics?

Furthermore, is it necessarily so that a commercially successful formula for print magazines is the best way to attract a loyal female following on the Web? Couldn't a new medium encourage new thinking on this subject rather than perpetuate a very stale status quo?

Although oxygen.com exhibits many features of a great dot-com site, the site could as easily exist as a print magazine and TV network. Except for a few interactive features, like a schedule and some games, Oxygen looks and reads pretty much like a host of other women's publications.

(LEFT) Oxygen is a huge, new brand that includes numerous topical divisions, well over a dozen cobranded sites, and a TV production enterprise, all for women.

JUST THE GUYS

On the other hand, where are all the "men's" sites? For those of us who wear the mustache in the family, there's Guyville, with its very male aesthetic. The logo is chunky, almost muscle-bound in appearance. The colors are distinctly gray and brown, not at all like the warm upbeat hues of Oxygen's home page. The layout is downright rectilinear, and the features are listed with very little fanfare. There's nothing especially subtle here. A more adventurous layout would make this hunk of a home page more interesting, but this was clearly not a priority for the guys (and gals) at Guyville.

Interestingly, the content is not all that different from that of a women's site—it emphasizes lifestyle issues. In fact, the major hierarchical divisions, Health, Style, Work + Money, The Finer Things, Gadgets, and Sports, easily apply to both sexes. The final category, Women, is the difference (as in, "vive la difference"), and there's another important difference. The icon system of male bodies (except for that last category) is as masculine as the site's logo and color scheme.

(ABOVE) "Where men can be guys." Make no mistake about it. Guyville's Web site is no self-reverential women's refuge.

A GUY NEEDS TO KNOW

Within the site's divisions, the tone of the images and text is downright wry. This information is not earth shattering, and it is clear to the guys of Guyville that none of this style information needs to be taken too seriously. For instance, clicking the Grooming Guide, the icon of Mr. Style with his carefully groomed Afro and excruciatingly tidy goatee, links to a page featuring an article about the perfect shave and another article on keeping your hair nice and clean. This is seriously guy-oriented stuff, not so different from the content of a women's site?

Similarly, the A Guy for Different Occasions section with an animated GIF version of Mr. Style, all dressed and "moving and grooving" in a '60s disco way, present fairly inane content, but in a sophisticated, slightly humorous way. And clearly there is a segment of the male population for whom the availability of this information is truly useful.

(TOP RIGHT) The navigational hierarchy for each of the divisional home pages features GIF rollover icons in a column on the left, a banner ad on top with the logo, and featured nonhierarchical links beneath. The color scheme of manly earth tones remains.

(BOTTOM) The navigation bar of full frontal icons is a cleverly animated Flash movie. Instead of a standard rollover, the man icons seem to come to life, stepping forward to present themselves for more careful inspection. Each icon includes an expanded tag line, so Health becomes fitness, nutrition, and tips, and Women becomes dating, marriage, and fatherhood.

THE BROTHERHOOD OF GUYS

Guyville is not yet heavy on content, but the site is actively building its community. In addition to the hierarchical navigation based on icons and the standard nonhierarchical links for company information, contact data, and other administrative information, Guyville's content pages include a box of community links.

This element of community is member-oriented and includes branded lozenge-shaped buttons for My Guyville, Email Group, Member Directory, and IM Software (that's Instant Messaging software) as well as links for message boards and chat rooms. Membership is required, and payment is in the form of your demographic profile: name, address, phone number, and a list of interests.

Come on guys! What are you waiting for? Don't you want to be a part of the largest online community of men, or maybe you'd like to win prizes of gadgets or cash? This is a pretty standard line of approach for community-building Web sites. What Guyville does nicely is to build its brand recognition within the site. The consistent use of the "guy" motif for icons, the straightforward, no nonsense layout, and even the very masculine color choices all help create positive associations for the target audience.

Guyville.com's site designers have also managed to make these design selections with an eye towards irony or at least with a knowledge of the correct level of rhetoric for a site whose attraction is based on vanity, basic insecurities, and male bonding.

(ABOVE) Joining the animated icon with the photograph in a single box that hangs over the column border helps to unify the composition of this page.

ROCKET BRAND SCIENCE

Black Rocket is a network services platform from a company with the clipped identity of Genuity. This is the kind of name that only a dot-com company can come up with, but it's appropriate for a company selling products to other dot-com-ers. Actually, Genuity is a rebranding of GTE Internetworking, and Black Rocket is a new brand of integrated networking services. It's all presented as though this were a completely new undertaking, just like the start-ups targeted to buy the product. But Genuity has been involved in supplying backbone technology for the Internet and World Wide Web for some time. It's an old dot-com in new dot-com clothes.

Describing what Black Rocket is to individuals who are not familiar with network servers can be difficult. Is it hardware or software, physical or virtual, a product or a service? It's all of the above, and so the audience for this site is quite select. Yet the design of the site is constructed with the same careful attention to brand building and navigational hierarchies that characterizes all the sites in this book.

THE SUM OF ITS PARTS

Genuity's home page is divided into stages that can be examined individually and then assembled. The first element, as is so often the case, is a table containing the company logo and a darkish navigation bar. Each of the six links is associated with a small color square, but no rollovers highlight the fact that these are links. This bar appears at the top of every page on the site.

The next stage is a nonpersistent vertical navigation column with three featured links. These links can change to feature different elements of the site. For instance, the Vision link is doubly important, showing up in both the persistent (areas that stay the same) and nonpersistent (areas that change) navigation areas. The mustard yellow provides a nice contrast to the gray of the navigation bar, while the theme of little squares attached to all-caps sans serif lettering is continued. This technical, even scientific-looking aesthetic provides plenty of contrast to the elegantly serif lettered Genuity logo, with its hand-drawn, chalklike *i*, looking as if it were ready to take off.

The bottom navigation bar contains all the familiar parts of the first two stages discussed here, yet it is clearly less important or at least not so noticeable. The links in this bottom bar are more generic, About Us, Jobs, Investor Relations, and so on.

This is basic corporate stuff, except for the Ask Genuity Live link that isn't downplayed but is emphasized on a sienna-colored background. The colors and placement of this button actually tie it into the vertical elements, including the Genuity brand logo at the top of the column, giving it much more visual importance.

(TOP) The vertical navigation column with its yellow background features nonhierarchical links, each with a brief explanation. Rollovers switch the background of both the red link and accompanying text to gray. **(MIDDLE)** The top navigation bar displays more important links in the darker strip on top, with secondary links in the lighter strip beneath.

(BOTTOM) The bottom navigation bar repeats the colors of the top bar, but with less contrast in the text. The yellow squares and text size are smaller and the gray lettering is set on a gray background.

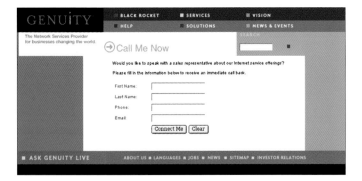

All of this site's pages have a strongly consistent visual identity. Here is the Sitemap page. For instance, the contents of the Sitemap and the Call Me Now page are framed in exactly the same way, including the page title and the Search form field. These features are standard on Genuity's interior pages, as are the color framing elements on both sides.

Genuity's home page is framed with the same three stage navigational scheme. These establish the Genuity brand look for the entire site—the background color bars, the small color squares, and the sans serif, all-caps type.

(TOP AND BOTTOM) The Ask Genuity Live link is a form page that uses all the persistent elements of the home page, the top and bottom navigation bars, along with an additional page labeling element that is used to brand each division of the site. The same is true, in a somewhat stretch version, for the Sitemap page.

(RIGHT) The three navigational stages are dovetailed, so that the first element of the top and bottom bars can be viewed as part of a longer left-hand column.

The main image square in the middle states the case for Black Rocket in the form of a Flash movie. The movie finishes with the Black Rocket logotype and the model rocket in the hands of a young rocket scientist. Notice the Buck Rogers–like black rocket on the launching pad in the bottom-right corner of the page. Genuity is trying to create an atmosphere of childlike enthusiasm for rockets (the network) and space (the Web). This page is saying, "Rockets are fun, but you don't have to worry about the engineering. We take care of the hard part for you." There's the sense that purchasing Black Rocket is supposed to be as easy as child's play.

While the Genuity and Black Rocket brands are nicely established by this site, it's difficult to figure out what Black Rocket really is. Genuity is one of those new entities known as a "solutions provider," but this is no excuse for the pervasive presence of vague prose. At no point does the site specifically state what Black Rocket is. How does Genuity really implement its "Network Services Platform," and what does this item look like? It turns out that all of this information is contained within a downloadable white paper but is strangely missing from the site's pages.

This lack of specifics might be the result of overzealous branding. Although Genuity got the branding right, it's got some work to do on the content. It's like getting the rocket into space but leaving out part of the payload.

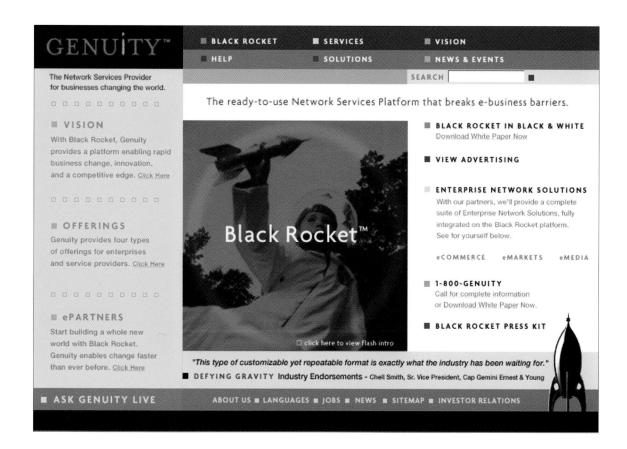

(ABOVE) This is the home page, with real content filling the center of the screen. It is this content that gives the page its more immediate visual interest and explains the page's existence — something worth careful framing.

The popularity of Web shopping is no great surprise. In the United States where shopping has moved from urban centers to suburban malls, to mail order, the convenience of the click-and-order experience is undeniable. Compared to a catalog, the essentially unlimited space and distribution of a Web site are incredibly powerful tools. For many people, staying home and shopping online makes much more sense than braving mall parking lots between Thanksgiving and Christmas. You can buy almost anything on the Web. Thus, the consumer faces a proliferation of e-commerce sites.

The trouble is that gerbil food, toe socks, lightbulbs, cars, and sausages all sit on the same shelf when they are sold from a Web site. The sites seemingly share the same little shopping cart icon, the same selection and checkout systems, and even the same-styled order confirmation messages. Because e-commerce is driving not only Web utilization but also Web technology, e-commerce technology is driving Web design, as well.

That little shopping cart icon in an array of different sites, represents a bit of the backend software coming to the forefront of the user experience. Building a shopping application from scratch takes a lot of work, and there are few software packages that make this process easier. Therefore, it is easy to see why most e-commerce sites use the same software packages and have similar features.

On the one hand, the presence of the same e-commerce features is no different from seeing the same credit card machines at all stores. Familiarity makes the online shopping experience easier. On the other hand, the Web site is the brand, and when it comes to e-commerce, the shopping experience is as important as the items being sold.

[9] E-COMMERCE BRANDS
THE CORNER STORE

It's difficult to get excited about something as mundane as an online grocery store. But what is it like to wander the souks of Marrakesh in search of bargains or visit the natives of the Amazon rain forest to collect tribal crafts. Such are the shopping experiences available for exploration at www.eziba.com.

In many ways, eZiba is a dot-com-only experience similar to those discussed in Chapter 8. One is not just shopping but is engaged in an exploration of crafts. Cynically, this has the trappings of a fatuous quest, but the fact is that eZiba is not just a typical crafts shop. The context of the site transcends the typical shop-bound buying trip. Viewers can experience the flavor of international travel in the way items are presented. This experience is not due to context alone, but due to the accompanying content, as well.

All the many photographs on this site are special—lots of low camera angles, subtle motion blurs, and dramatic lighting. One often gets the sense of climbing hills or rounding corners at high speed. These super models are posed to reveal every curve.

This nearly monochromatic home page is the essence of elegance. The high-contrast, black-and-white photo, the use of a classically proportioned book typeface, Baskerville, and even the thin white rule separating text from image, all create an overriding sense of refinement.

THE HANDCRAFTED AESTHETIC

eZiba is a completely new brand, one of many e-commerce creations that invests heavily in traditional media advertising in the hope of luring customers to its site. Investing in media advertising is expensive, so it had better be worth the trip for new customers at eZiba.

Nesting, or more precisely, weaving, is an important aspect of the eZiba image. The elements of this page create a woven effect. The overlap of the vertical gray column on the left with the sand-colored bar containing the logo creates the beginnings of the warp and weft motif of this site's layout. A circular, woven emblem marks this intersection. Instead of the generic shopping cart symbol, a handcrafted basket icon continues the weaving theme.

The thematic colors are distinctly earthy, utilizing subtle shades of herbal dyes. It makes the vivid bloodred color of the consonants of the eZiba logo stand out more boldly.

The clearly stated motto, "Handcrafted goods from around the world," is visually reinforced by the two other elements present in the banner. First, the image of a pair of dark hands (the artisan's, presumably) presenting the featured object, a comely alabaster vase. The contrast of the photo not only heightens the appeal of the vase, but also emphasizes the object's handcrafted nature. Second, the small but very clear world map in the color bar conveys the international scope of the site and its offerings.

The brand is established by the eZiba name, the handcrafted motif, and the subtle weaving of elements, color, and imagery to evoke an international flavor. Now they have to sell the goods.

(ABOVE) A trip to eziba.com is rewarded with an online experience of no-frills elegance. This brand is image-conscious and displays a very image-dependent site. The small amounts of text are set in sans serif, and headings are all typeset GIFs.

ALTERNATE TRAVEL ROUTES

There are five ways to shop on this site—world region, product category, gifts, auctions, and direct search—and you can access each shopping path in two ways. The main navigation bar across the top lists all the site divisions, including the five shopping links. On the home page, the table includes the company slogan, and on divisional pages, the eZiba logo and the search widget are in-cluded. The regional links are implemented as an image map with bloodred rollovers, the only dynamic element of the home page.

The catalog is divided into two main organizing principles, product category and world region. Each is divided into subsections that narrow the selection. As the search narrows, there are fewer catalog pages and the number of items become easier to browse among.

The display and navigation of items on the pages is the same across all shopping paths. Each item is shown in a smallish square with the price and a very brief description, three items to a row. Clicking an image brings up a detail page with an enlarged view and a thorough description.

(LEFT) Clicking the World Regions link in the top navigation bar of the home page leads to the World Regions divisional home page, skipping over a hierarchical level to a list of all 1,130 items in 189 pages of the catalog. Clicking the region list in the color band on this page to narrow the listings produces the same result as clicking an image map region on the home page.

(RIGHT) Like the World Regions divisional home page, the product categories division is also set up to default to the complete catalog listing and to provide a list of categories that enables you to speed more directly to your destination. By providing the entire catalog and the list of categories, the Web designers give the consumer a choice of taking the express elevator instead of riding up the escalator.

NO HAGGLING OVER PRICES

There are a couple of other options available from the detail page. Most importantly, shoppers are encouraged to click the Add to Basket button. You can also enlarge the image further or e-mail the item page to a friend. The fact is, the programming support for this site is fairly basic. Instead of featuring the work of hard-toiling programmers, this site emphasizes the work of artisans.

eZiba also sponsors auctions, which run like other online auctions, but everything eZiba does is branded. The elements surrounding the eZiba auction pages are the same as those surrounding the catalog pages—the woven colors and brand logo that identify eZiba so clearly. The sandy colors of the catalog become a clay-gray to differentiate the auction pages, but the effect is the same. eZiba's use of color and brand logo also carries over to the shopping basket and checkout pages.

(LEFT) Detail pages can be reached using several different routes. The content of these pages is supplied from a database, while the navigational elements around the content trace the route to the item. It's possible to traverse the route in reverse using the navigation history in the color bar.

(RIGHT) Feature stories on artisans and their crafts are regularly updated. This element is a critical part of the site because it differentiates eZiba from a typical mail-order catalog or gift shop. Shoppers have a reason to return to the site to see what's new.

Screenshot 1 (top left)

eZiba

FAST FIND [go]

HOME | WORLD REGIONS | PRODUCT CATEGORIES | GIFTS | PRODUCT SEARCH | **AUCTIONS** | ARTISAN STORIES | HELP

EZIBA AUCTIONS
Create an auction account, and bid on one of our current auctions. The Auction Calendar informs you of upcoming special auctions of rare, unusual and one-of-a-kind items. At eZiba we stand behind what we sell; see our guarantee.

CURRENT AUCTIONS
Baskets from Around the World

AUCTION TOOLS
Create an Account
My Account
Select Listings
Watch List
Log Out

General Help
FAQ
eZiba Guarantee

NEWS AND UPDATES
Capturing the spirit of the rainforest, this basket is decorated with images of the most exotic and beautiful birds of the Darien Region of Panama.

Other offerings include a backpack from the island of Luzon in the Philippines, and a set of three intricately woven baskets used for winnowing maize in Zimbabwe.

The Day of the Dead, An Auction Co-Hosted with Amazon.com
October 16 - 23, 2000
View Auction Items

The tradition of fine art and collectibles associated with the Day of the Dead (or All Soul's Day) originated in the 19th century when the image of the skeleton was transformed. For this November 2nd, eZiba is proud to offer an auction of these rare and one-of-a-kind objects, produced by some of Mexico's most famous artists and craftspeople -- with prices starting at only $1.

CALENDAR
Nov 7 to Nov 28:
Photographs of Tibet
Kevin Bubriski

Bubriski is represented photographic collection France, the Bibliotheque Nationale Museum of Art and the of Modern Art in New Boston Museum of Fin the Houston Museum o Arts and numerous oth museums He has show photographs in gallerie New York to Taipei, Te is also the author of so books, among them "P Nepal", Chronicle Book (winner of the Golden 1993 Documentary Bo and the 1994 Paul Cov Non-Fiction Award).

Screenshot 2 (bottom left)

eZiba

FAST FIND [go]

HOME | WORLD REGIONS | PRODUCT CATEGORIES | GIFTS | PRODUCT SEARCH | **AUCTIONS** | ARTISAN STORIES | HELP

EZIBA AUCTIONS
Create an auction account, and bid on one of our current auctions. The Auction Calendar informs you of upcoming special auctions of rare, unusual and one-of-a-kind items. At eZiba we stand behind what we sell; see our guarantee.

Home | Baskets and Boxes

Sticky Rice Basket | Toucan and Trees Basket | Vizcaya Backpack | Covered Bread Basket

Description	Opening Price	Ends
Toucan and Trees Basket, Panama [A]	$150.00	11/1/00 3:00 PM
Set of 3 Tonga Baskets, Zimbabwe [A]	$75.00	11/1/00 3:00 PM
Kalinga Winnowing Basket, Philippin... [A]	$49.00	11/1/00 3:00 PM
Vizcaya Backpack [A]	$45.00	11/1/00 3:00 PM
Set of 3 Zulu Baskets with Lids, So... [A]	$45.00	11/1/00 3:00 PM
Kayabang Basket, Philippines [A]	$45.00	11/1/00 3:00 PM
Snail Collector's Basket, Philippin... [A]	$45.00	11/1/00 3:00 PM
Round Winnowing Tray, Philippines [A]	$45.00	11/1/00 3:00 PM
Sticky Rice Basket, Laos [A]	$45.00	11/1/00 3:00 PM
Set of 3 Zulu Bowl Baskets, South A... [A]	$45.00	11/1/00 3:00 PM
Apayo Labba Basket, Philippines [A]	$75.00	11/1/00 3:00 PM
Covered Bread Basket, Morocco [A]	$150.00	11/1/00 3:00 PM

Screenshot 3 (right)

eZiba

FAST FIND [go]

HOME | WORLD REGIONS | PRODUCT CATEGORIES | GIFTS | PRODUCT SEARCH | **AUCTIONS** | ARTISAN STORIES | HELP

EZIBA AUCTIONS
Create an auction account, and bid on one of our current auctions. The Auction Calendar informs you of upcoming special auctions of rare, unusual and one-of-a-kind items. At eZiba we stand behind what we sell; see our guarantee.

Listing Info

Home | Baskets and Boxes | Listing 22785379

Toucan and Trees Basket, Panama
Updated: October 26, 2000 03:09:05 PM EDT. For up-to-date bidding information on this listing, click on the bid history link.

Listing Type:	English		
High Bid:	$150.00	Open Date:	10/9/00 2 PM EDT
No. of Bids: (History)	1	Close Date:	11/1/00 3 PM EST
Opening Bid:	$150.00	Quantity:	1
Bid Increment:	$2.50	Listing #:	22785379

Bid Now | Shipping/Payment | ✉ Email This Listing to a Friend
Add to Watch List | | Credit Card required to bid on this auction

Product Detail

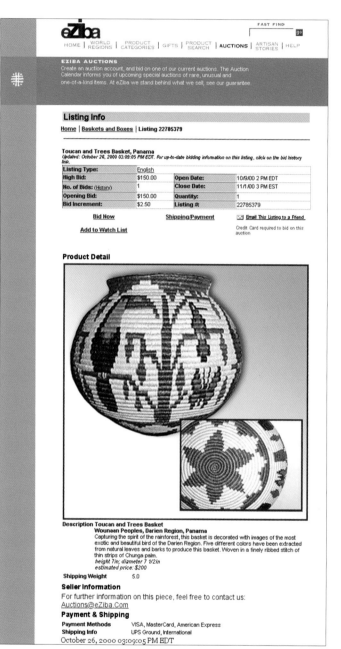

Description Toucan and Trees Basket
Wounaan Peoples, Darien Region, Panama
Capturing the spirit of the rainforest, this basket is decorated with images of the most exotic and beautiful bird of the Darien Region. Five different colors have been extracted from natural leaves and barks to produce this basket. Woven in a finely ribbed stitch of thin strips of Chunga palm.
height 7in; diameter 7 1/2in
estimated price: $200

Shipping Weight 5.0

Seller Information
For further information on this piece, feel free to contact us:
Auctions@eZiba.Com

Payment & Shipping
Payment Methods VISA, MasterCard, American Express
Shipping Info UPS Ground, International

October 26, 2000 03:09:05 PM EDT

(THIS PAGE) Each auction is thematic. Featured here is an auction of woven baskets and boxes, and each item is neatly displayed with a detailed description available by clicking. The detail pages provide both auction and item information. This auction provides more of the flavor of an upscale auction house than an eBay-like livestock auction.

BRANDED CHECKOUT

First, every catalog shopping page includes the basket navigation element at the top right. As items are added to the market basket, they are neatly displayed in a column, and an order subtotal is calculated. Clicking the Checkout link opens a series of backend-driven administrative pages that bear the unmistakable stamp of eZiba.

This well-designed site strengthens the eZiba brand immeasurably, and the positive experience of the site certainly encourages repeat visits. eZiba is not only a pleasant place to linger, but there is also interesting information and genuinely unusual items from the well-stocked and attractive crafts shop. There is the feeling that a well-informed proprietor runs the show, so shoppers have confidence in what they buy.

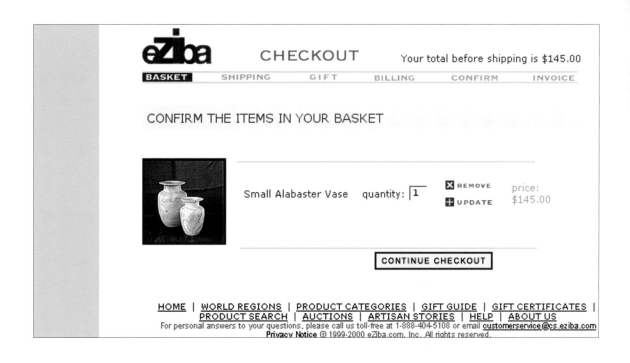

(ABOVE) Branding the checkout sequence is as simple as including the sand-colored column on the left with the eZiba logo on top. These pages include a new navigation bar for the checkout sequence. This makes it possible for experienced shoppers to move through checkout in a virtual express lane.

WWW.BLUEFLY.COM (URL)
BLUEFLY (CLIENT)

BUYING WHERE THE GOODS ARE CHEAP AND THE SITE IS BLUE

How many sites examined in this book are branded with blue? JetBlue in Chapter 4, Netscape in Chapter 8, and now Bluefly, "the outlet store in your home." Of these three, Bluefly is the bluest. It is blue on blue on blue. How does Bluefly manage to achieve any contrast and lead the customer through the selection and purchasing process amidst so much blueness?

The Bluefly brand, like the eZiba brand just discussed, is an e-commerce startup. Although everything about the brand is new, the idea of selling designer cast-offs at deep discounts is as old as the pickle in the bottom of the barrel.

Bluefly's blue home page presents all content within a blue, rounded rectangle on a darker blue field. The stylized Bluefly logo with its tagline sits (or perhaps hovers lightly) at the top over the background.

All branded navigation is including within the rounded rectangle, along with the featured content. The hierarchical divisions for the site match the product categories. The iconography is meant to be hip and stylish without an expensive, overly sophisticated look. The icons are clearly labeled so that viewers don't have to puzzle out what each distinctive icon means. Instead, one learns to recognize them through repeated use.

Other elements also create contrast against the blue page. For example, some of the images on the home page are drawings, some iconic, while the product elements are always color photos. But the strongest contrast comes from orange buttons and lozenges. Each of the featured links has an orange-colored indicator, with the largest lozenges linking to alternative navigation and custom features: See All Designers, Make My Catalog, and Sign Up Now.

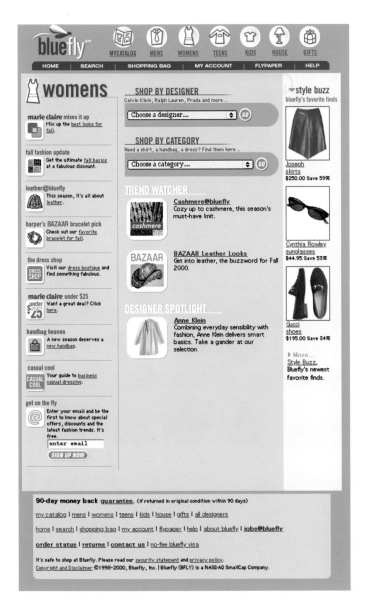

FINDING BARGAINS

The vastness of the inventory at Bluefly makes the selection process a bit more complicated than for boutique sites, but this site's thoughtful navigation helps. Looking for a new cardigan? Simple enough. Start by clicking the Womens' button and get a new blue page.

The divisional pages begin with the Bluefly logo on a line with the icon system over the background. The dark band of the shopping cart links follows. The division page begins under these two persistent elements. Narrow the search by selecting a designer or a category from separate drop-down menus. The designer and category choices are followed by Trend Watcher links (lots of leather and cashmere here) and a Designer Spotlight. In a third column labeled Style Buzz, select from specifically featured items.

(**ABOVE**) Each divisional page is carefully branded and labeled with an enlarged version of the division's icon and name. Within each division is a column of featured links to guide the item selection process.

There is a long and constantly changing list of Style Buzz items. Although these items seem to be randomly selected, they are actually chosen from the buzz list through a set of changing criteria. The result is that you are presented with different items every time you load a divisional page.

Clicking the Sweater—Cardigans/Set category, one of four sweater categories in the Shop by Category drop-down menu, links to an overwhelming fourteen pages of sweaters. Fortunately, there are ways to refine the selection. One can select by size, color, and price. The ultimate selector for this site is the designer selector.

Clicking on the $50–$100 price category reduces the number of selections to seven pages. This price range is clearly the most popular. Sixteen items are on each page, and each page is labeled with the current selection criteria, in this case Sweaters—Cardigans/Sets ($50 to $100, size M).

Clicking on the manufacturer's name for an item brings up the detail page. Bluefly maintains a very consistent brand structure around an everchanging array of choices. At Bluefly, as one would at an outlet store, shoppers learn how to find what they're looking for.

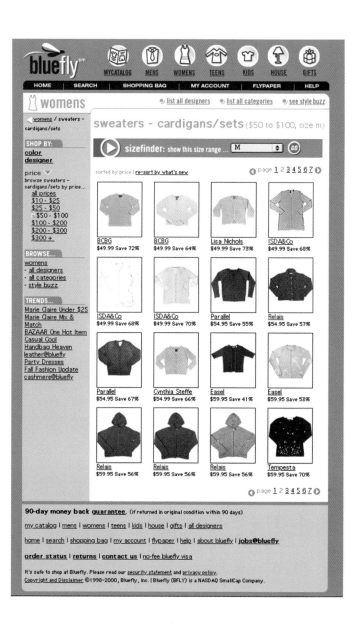

(ABOVE) The navigation among the pages is clearly laid out, so that it's not difficult to browse through all 120, or so, sweaters. Interestingly, prices within the $50 range actually start at $49. A little overlap is good, especially because so many prices fall right at the category break points.

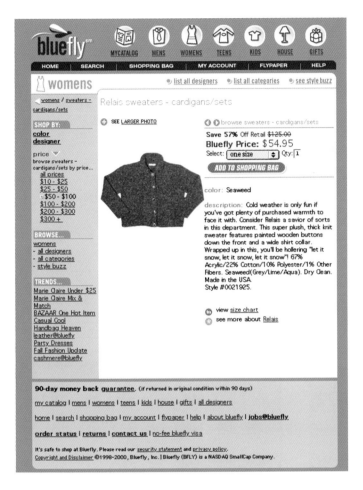

CUSTOMIZED SHOPPING BUILDS BRAND LOYALTY

To encourage repeat shopping, Bluefly offers the MyCatalog link as the first icon on the menu bar. Supply your e-mail address and answer a few questions to set up the custom catalog with your size and preferences. Bluefly also has a search function, but you can only search by department and price. You can't look for corduroy shirts, for example.

After shopping through the site for a while, it's still not clear what the Bluefly name means. It brings only "Jimmy crack corn" to mind. But the name is distinctive and easy to remember, and the color scheme of this site sets an informal, friendly tone.

(LEFT) The view of the sweater is the same on this page, but enlarged. The price, with the discount highlighted, leads the page, and a description full of positive adjectives is included, along with several additional options. Or, you can simply purchase the item.

(RIGHT) The search page, Search on the Fly, is consistent with all the other pages of the site, and the pun in the name helps maintain the slightly counterculture image of the Bluefly brand.

YOU'RE CORDIALLY INVITED TO SHOP

The Williams-Sonoma brand is not new to the Web, but it recently created a greatly expanded Web presence that does more than offer online shopping. This site gets its strength by creating a combination store, catalog, and cooking school—all clearly branded with the Williams-Sonoma imprimatur.

Williams-Sonoma uses an approach that is a little formal. Perhaps it is an attitude of propriety about the serving of food. How ironic to present such grandeur to a mass shopping audience! However, if success is any measure, it is an effective device.

STARCHILY FORMAL, BUT INVITING

This home page looks like a fancy engraved invitation. The neat gray border around a card-sized page, the centered text set in very formal Caslon, complete with open-face type on top, and italics for smaller text—it's all quite classic. Even the seasonally appropriate photograph, with its dressy table setting and perfectly roasted turkey, has the unmistakable flavor of formality.

If the tone of this page were pure snob appeal, the result of Williams-Sonoma's efforts would be no better than a fallen soufflé. Instead, viewers are treated as special guests, and it is this "specialness" that makes the stores, the catalogs, and this site so appealing to so many. How can one refuse such a gracious invitation?

This Shop page is in the form of a recipe card, like something a shopper would pick up in the store to make at home. The shopper always knows that the recipe is from Williams-Sonoma, because the logotype is prominently printed in the corner.

The content and the context of these pages creates the feeling of formal elegance. The color of the page comes mostly from the images, which are nicely contrasted against the white background. The division label, Shop, is in reverse type against a taupe color bar. It is one of those noncolors that implies sophistication.

(LEFT) Each line of this invitation/home page is a link. The bolder lines provide hierarchical links to the site's major divisions, and the italic lines link to featured connections. The bold divisional links remain unchanged, while the italic featured links change with the page's photograph and the season.

(RIGHT) Upon entering the catalog division, the bold lines of the home page become divisional links of the persistent navigation bar on top.

EVEN A PEELER CAN LOOK EXPENSIVE

The secondary hierarchical links to the shop's sections provide both navigation and the page's content. The links include a bottle of champagne in an ice bucket, a copper saucepan, fancy bottles of vinegar, and it is all presented with such clarity. The grid of fifteen items representing the fifteen shopping sections is as tidy and orderly as a featured interior in *Architectural Digest* magazine.

What's nice about the blend of content and context here is that all the photos on this page can change with the seasons, or with the inventory, without upsetting the navigation or the feeling of elegance. Each of the sections within the shopping division receives similar treatment. The heading changes to reflect a step down in the site's hierarchy and an array of subsections is presented as item photos and link names.

BE A PRO IN YOUR OWN KITCHEN

But there is something different here, too. Under the larger photo are two nonhierarchical links listed as Tips under the heading Additional Information: About Juicers and Making Crepes. It is this additional content that takes williams-sonoma.com beyond the realm of a standard e-commerce site or the capabilities of a magazine and begins to introduce the almost personal touch of a well-informed and ever-ready salesperson/chef.

Williams-Sonoma is not just A Catalog for Cooks, and it has skillfully infused its Web pages with bits from its voluminous printed content. The same is true, but in reverse, in the Recipes division of the site. The secondary navigation allows viewers to browse the recipe files in two ways: by course or by searching. There are also links for seasonally suggested menus, recipes, and accompanying tips.

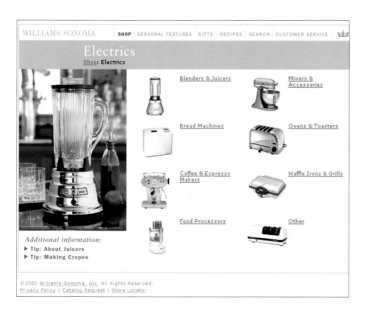

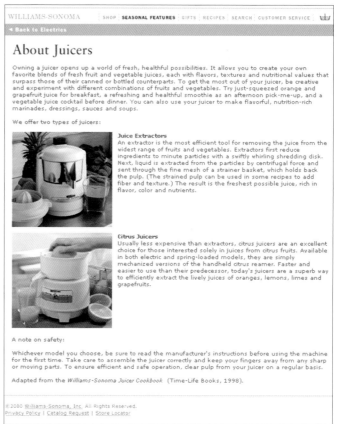

(LEFT) In the Electrics section, a new seasonally appropriate photo, along with eight subsections for blenders, mixers, bread machines, and so forth appears.

(RIGHT) "We offer two types of juicers" says this extended excerpt from *The Williams-Sonoma Juicer Cookbook*. The cookbook allows viewers to draw upon its content for use as a virtual sidebar.

This site makes no attempt to adopt the technological cutting edge. The typography is based on carefully typeset GIF headings and sans serif black text in columns. Photos do most of the image-making work. In fact, all the photos within this site, and in all of Williams-Sonoma's publications for that matter, are particularly appetizing.

Just as Bluefly gives shoppers many ways to make a selection, Williams-Sonoma is trying to maximize the number of experiences its site offers. It is a way to encourage visitors to buy something now, or at least to find something that they may like to buy later. This technique is most apparent in the Gifts division.

'TIS BETTER TO GIVE...

First, the proverbial blue-eyed boy bearing a beribboned toaster sets the gift-giving mood. Then there is a list with four categories of gifts, with two to five choices within each category. If one is unable to find a suitable selection from among these options, there are Williams-Sonoma gift certificates offered, as well. It is interesting to compare the leisurely display of choices presented by Williams-Sonoma to Bluefly's more high-tech, almost crowded presentation. Williams-Sonoma's Web site is all elegance and refinement, while Bluefly's Web site is noisy and exciting; each method is appropriate to its given context.

As nicely as Williams-Sonoma sets the groaning board for gift giving, their low-tech approach to navigation slows down the selection process. The avoidance of a more complex navigational scheme seems technophobic at this point. Perhaps the Web elves at Williams-Sonoma are planning some more technologically interesting additions to their newly revised site. It has got all the branding just right. Those shoppers who are familiar with the stores and catalogs will feel right at home.

(ABOVE) Within each subcategory page, each item is spaciously displayed in a carefully arranged matrix. But after entering a subcategory display, there is no way to skip to a different subcategory without going back up to the division home page.

Now for the ultimate questions: How do you brand the branders of big brands? What about the Web sites of the site builders? When it comes to building one's own site, what are the important considerations?

The questions designers ask their clients, those that lead to design solutions, are the same questions designers must ask themselves: Who is the target audience? What is the message? What impression do you want to make? Are designers perhaps less rigorous in designing their own sites than in creating sites for others? And is this the logical result of limited time for what might seem less important projects?

In some ways creating a personal Web identity is the most difficult project one faces. It's like writing the personal essays for college admissions. There's something slightly embarrassing about talking about oneself. Yet, if there is one universal commandment when it comes to self-branding, it is this: sell thyself.

Here is the chance to create completely unfettered designs. There is no one to say that a color is too bold or a typeface too fuzzy. It's a chance to experiment with the technology and explore possibilities that may be too radical for a typical client. But this same client will look upon design experiments as evidence of advanced understanding of the Web's capabilities.

As is evident from the sites highlighted in this chapter, the creation of a self-branded site is a golden opportunity to show who one is by being creative and original. These sites go beyond the establishment of an identity to give potential clients a feeling for the real personality of the firm. In a field as dependent on customization as Web design, a strong positive personality can be a tremendous strength.

[10] SELF-BRANDING
THE BRANDS THAT BRAND

THE PERSONALITY OF THE DESIGNER

As Web branders, we struggle to create unique identities on the Web. Sometimes this is a corporate identity in which a designer has only a limited personal stake. But more often, Web design firms are small and are very much a reflection of our own personalities. Andres.com is such a firm.

My site is perpetually incomplete, but I discuss it here because I can write about the train of thought that brought me to the design idea. My design firm, Andres.com, is very much a reflection of me. That's the easy part for a small company. Yet trying to distill the essence of myself into design elements is a painful and often embarrassing exercise. There are some things I would just as soon not tell about myself.

As a result, www. andres.com says little about me personally. The site's emphasis is corporate, concerned with the things we do. Yet my personality is everywhere.

DESIGN REFLECTIONS AND A LITTLE TEXT

First of all, as you've probably figured out from this book, I prefer a graphic statement that relies more on simple elegance than outrageous or cutting-edge design. I can appreciate both, but my preference is clear. I also know that my skills as a graphic designer lean heavily toward typography and the rectilinear.

All the pages are clearly branded with a large andres.com logo in the upper-left corner. On the homepage the logo is horizontal, and as you'll see, it is used vertically for interior pages. The play of the narrower red letters of Andres on a white background contrasts with the bolder white letters of .com against a blue background. This use of contrasting colors and letter widths is picked up and used throughout the site.

There is no HTML text used for the main pages. And rather than use a contrasting typeface, the text buttons and blocks all use Agfa's Rotis Semiserif, a typeface that is both friendly and serious. It is sufficiently robust so that the serifs don't disappear at low resolutions, yet it is more distinctive than a completely sans serif face—a perfect face for Web use.

(ABOVE) This site would not be an honest reflection of who I am and what andres.com does if I did not emphasize its written content. This simple, strong composition is the result.

THE SERIOUS AND THE PUZZLING—GRAPHIC ELEMENTS AND ANAGRAMS

And what about that content, "Zany Ale," 'Loved PE," "Limpet Men?" What is this nonsense? The problem I faced was in trying to make my three key concepts—analyze, develop, and implement—interesting to potential clients. These are obviously the three basic phases of Web design, but how much less obvious to discover them hidden as anagrams.

I've watched people ponder the links and seriously wonder what my made-up terms meant. It's an attention-grabbing device, and it never fails to amuse once the true meanings are revealed.

All the rollover images and targeted text are preloaded, so by the time you've read the introductory text, the rollover actions happen instantaneously, as fast as if they were Flash animations. Also, notice that these three links aren't really links to anything but additional text. It's a way to engage the reader. You have to do something to get to the story, and because of this, the value of the story is increased.

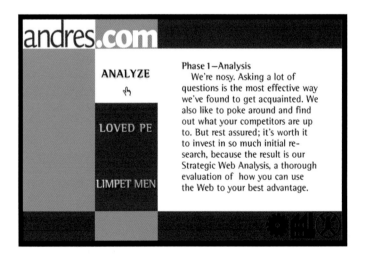

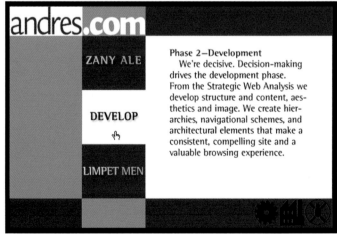

WHEN PRIMARY NAVIGATION IS SECONDARY

The icons in the lower-right corner of the table add graphic interest and provide the site's navigation. You might be wondering why I located the most out-of-the-way corner for the navigation. What's it doing there? My intention is to have browsers read the home page content first, before they even realize that other pages exist.

The navigational scheme uses the same technique of rollovers with targeted text, but it is much more concise. First, each navigational icon is a vivid, strongly contrasted (black on red) image: a cog, a factory, and a person. It's clear that these icons are meant to be links, but it's not clear what they link to. Again, you have to point to them to find out. You're not just a passive reader when you come to this site. You have to participate. The rewards for participation are the anagrams and entertaining rollovers.

All of this good-natured activity becomes very much a part of the brand. If you like the way this site looks and works, you will like the company, as well. The intent is to create good feelings about the corporate entity that is andres.com.

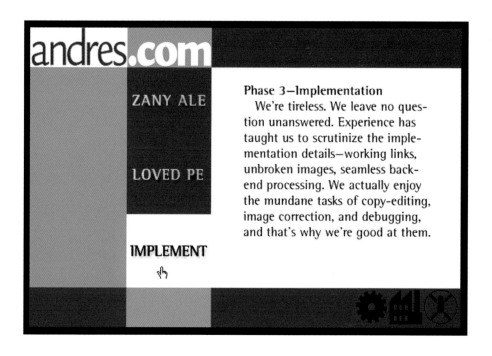

(THIS SPREAD) Are you curious enough to point your cursor at one of these buttons to find out? The rollovers unscramble the anagrams to reveal the headings, and at the same time change the message in the text area.

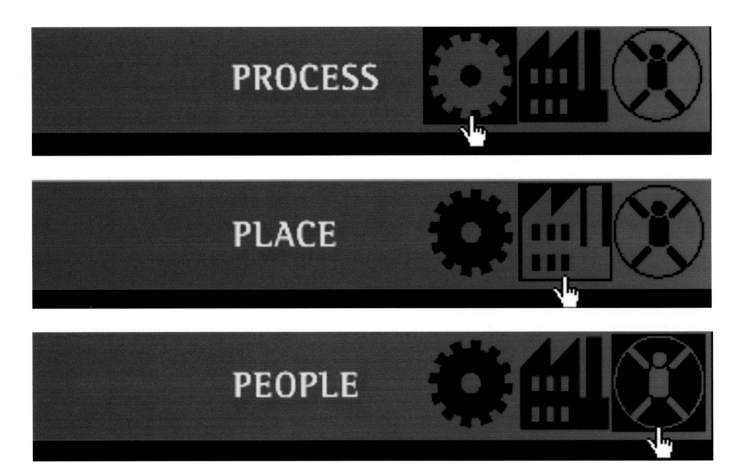

(THIS PAGE) Rolling over the icons reverses the colors to red on black and pops up the explanatory linking text: Process, Place, and People. (The alliteration of the three p's was accidental, but I thought it added a nice touch.) These are the three hierarchical divisions of the site, and each division becomes identifiable by its icon.

CONSISTENT TONE AND IMAGE EQUALS
CONSISTENT MESSAGE

Each of the divisional pages continues the branded layout estab-
lished on the home page. The contents are rearranged within the
400 x 600 pixel table so that the navigational elements join the logo
in a vertical column running down the left side of the page. The text
area stays in the same place. The current page is identified both by
its icon and by title. An ampersand is added as a fourth navigational
icon for the Home link. (I use the ampersand to represent home,
because of the "and" at the beginning of andres.com)

Even though the text is serious, the tone of the site is lighthearted.
You can see this carried on to the People divisional page. When the
page loads, all you see are five heads under the tag line, "Who do
you think we are?" This isn't meant to be hilariously funny, just
slightly engaging and amusing. The entire site is intended to be read
with a smile.

So who am I, and what is andres.com? You know almost as much
from the way the site works as from the content itself. As the site
grows, the content will become more important, but the tone estab-
lished by the engaging rollovers will continue to serve as the chief
identifier. The rollovers make the andres.com brand more interesting
and more identifiable.

Who Do You Think We Are?
PEOPLE

RAYMOND

DIANE

CLAY

KATHARINE

DANA

response@andres.com, 314 Woodbury Road, Washington, CT 06793, 860-868-4002

(ABOVE) The black column separating the logo and navigation from the page content contains both the page's identifying icon and the rollover text identifying the navigational links.

How Do Web Sites Grow and Evolve?
PROCESS

"Web sites are not static objects to be framed and admired without ever changing."

We speak of customizing Web sites, of architectural design and the hand-crafted nature of site construction; 19th century terminology for a technology leading us into the 21st century. Web site creation hasn't come close to the assembly line efficiency of the industrial age, remaining very much a hit or miss proposition. We don't like these odds, and in reponse have developed a process that assures an efficiently run project culminating in a compelling Web presence. The secret is in the effort we expend up front creating a Strategic Web Analysis of your business. This, along with a continuous cycle of analysis, development, and implementation allows us to create and maintain great Web sites in a timely and affordable manner.

response@andres.com, 314 Woodbury Road, Washington, CT 06793, 860-868-4002

PLACE

PEOPLE

& HOME

(ABOVE) To answer the question "Who do you think we are?," you must roll over an image, which activates an animated GIF. The name then scrolls out from under the head.

GRAZING THE URBAN RANCHES OF THE WEB

For this next adventure in self-branding, take a graze over to the clover-full fields, or at least the office suites of Cloverfield Boulevard, in Santa Monica, CA, home pasture of Cow Interactive. Are these people serious? On the other hand, what a great name—it's only three letters, it's an immediately recognizable animal, and yet the first reaction upon hearing the name is usually, "What?"

For less creative pokes, a name like Cow would be a burden, re-quiring constant explanation and justification. For the ranch hands at Cow, designers of cutting edge Web sites, it's an endless opportunity for humor and self-expression.

WATCH YOUR STEP

The site is entered with what looks like something substantial but is really illusory The field is maroon. There is a flat arrangement of building blocks, a greeting, and a message in the form of an animated GIF. Viewers see "moo", a cow, and the message "Cow interactive communications." Rather than have repeat visitors see the same preface each time, Cow has the elements of the page update and shuffle randomly.

Each introductory tag line leads to a different content element in the core site. These diverging paths are not an important navigational element in the organization of the site, but they introduce variation that keeps the joke from losing its punch. At the same time, this scheme accommodates newly featured elements with grace.

It's all calculated to give the Cow brand a feeling of simplicity, without being unsophisticated or flip. In fact, the whole idea of branding a design firm with the bovine ilk is both hilariously incongruous and reassuringly solid.

(ABOVE) Cow's introductory page is funny and provocative, and it won't be there if you look again. There are at least three arrangements of the ten building blocks (cow, rocket, and face), seven greetings, and five animated tag lines.

The Sun Microsystems 1998 online annual report, located at **sun.com/corporateoverview/investor/ar/1998,** features dynamic interactive financial Java applets, including Sun's "Future of the Network."

We created **championpaper.com** to manage large quantities of information. It contains powerful extranet tools that allow users to order huge quantities of paper in real-time.

(THIS PAGE) Clicking the "Sun Microsystems annual report" tag line links to Cow's work for Sun, while "The new championpaper.com" changes the content element to reflect Cow's efforts for Champion. Clicking directly on the block arrangement opens the core site in its generic state.

THE FOUR-SQUARE FIELD MOTIF

The core site opens in a new window that's approximately 4" x 8". There are four color panes that represent the four hierarchical divisions of the site, What's new at cow, *Fortune* 500 clients, A simple approach, and Powerful solutions. The bottom frame is used as a persistent black border containing two nonhierarchical links, Contact cow and Join our team, and a third client-access link providing password-protected access to work-in-progress.

There's nothing on this page but text and color. The layout couldn't be simpler. Yet in its simplicity it's a powerfully original composition. The juxtaposition of strong but subtle colors creates contrast and tension, and the use of two colors for each of the text links heightens this tension and gives the words additional force. Also Cow didn't simply use the expected linking words that you see on so many sites: Clients, Approach, and Solutions. It went to the trouble of choosing more explicit words that become part of its brand. This shows that someone has actually spent time ruminating over the meanings of things.

And the rollover animations prove the aptness of each of these division titles. What's new at Cow fades to New clients, Articles, Case study, and Speaking events, which happen to be the divisional sublinks. Each of the animations includes a fadeout, blackout, fade in, and then fadeout for each of the sublinks.

AS YE SOW, SO SHALL YE REAP

Clicking a link in any state loads the divisional page. What follows is a particularly clever geometrical transformation. The activated square is enlarged to include content, pushing the three other squares into the corner to become the hierarchical navigational elements. Thus, clicking the What's new square in the upper left pushes the navigation to the lower right.

Just as the navigation squares move around within the frame, the content and divisional hierarchy rotate. But even though the positions keep changing, the element types remain the same. It's not necessary to adhere to a stagnant layout to attain clarity, and after seeing so many navigational schemes fixed to the top row and left column, it's refreshing to find out that elements can be moved without upsetting the usability of the site.

Cow's reliance on a closed box would seem to limit its ability to include a lot of serious content. After all, there's very little room even in the expanded square for much explanation. But Cow's imagination isn't limited by this. Instead it packages information in smaller parcels for easy digestion.

Everything on Cow's site looks good. The colors, the typefaces, the clearly delineated layout all work toward creating a very positive image. But there's more, because the good humor of the images and text and the extreme cleverness of the changing juxtapositions of elements are really what help Cow to stand out in its field. Cow makes clear that it is not only a high-quality designer, but that it has an attitude about design that is uniquely Cow.

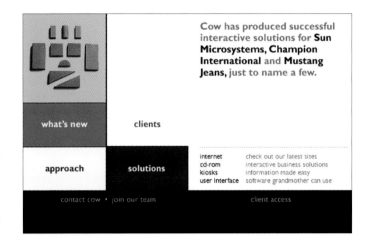

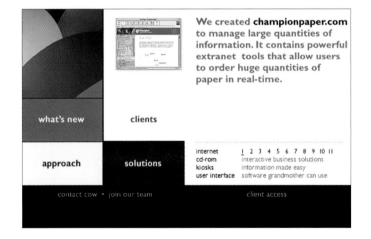

(OPPOSITE PAGE AND TOP) The layout scheme is a play on the rearranging children's blocks from the introductory page, and the block figures themselves return as icons for two of the divisions; The cow arrangement brands the What's new division, the face brands the Clients division.

(BOTTOM) Within the Clients division, click on the Internet section and the tag line next to the link, Check out our latest sites, changes to a simple list of numbered links. It's a way to expand the content without expanding the box.

THE 100 PERCENT FLASH SOLUTION

From the earthy, relatively low-tech Cow site, fast-forward to the completely Flash-based site of a design firm named Weberize. Fortunately, it is not within this book's purview to discuss the relative merits of brand names themselves. However, it's fair to observe that the demand for unique dot-com names has given rise to some particularly silly eponyms. But are these names any more farfetched than the contraction of National Biscuit Company into Nabisco, the cookie company heard round the world? Only time and marketing can decide if a name is really a great brand or just baby talk.

So what does it take to Weberize a client? The Weberize site defines its answer in a choice of standard HTML or Flash. There's something to be said for giving the browser of the site a choice of versions, instead of including a JavaScript to do an automatic Flash plug-in detect. There are those who would rather not wait for the Flash movie to download.

ANIMATED BRANDING

The Weberize Flash site is a streaming presentation, so isn't a long wait for the show to start, even on a dial-up connection. A new window opens and the movie begins with a spinning ball falling into a gray space. It happens to be the Weberize logo, complete with three-dimensional lighting effect and shadow. The logo bounces and rolls playfully into place as the other branding and navigational elements slide in from the sides. Then under the heading: "What are you trying to do right now?" The editorial message slides across the screen line by line.

"Launch a dot-com?"

"Develop an Internet business strategy?"

"Sell more?"

"Connect with customers and partners?"

"Build a brand?"

"Drive site traffic?"

Then the message area clears and the final question slides in with its answer: "Worried?" "Don't be." "We can deliver." The message is dynamically displayed, clearly stated, and it makes a positive first impression. More importantly, this is not a gratuitous use of Flash animation. It really does give a short, lively introduction to what Weberize does and the slightly humorous-yet-serious attitude it brings to its work. And when the animation is finished, the navigational links have had time to load, so viewers get the benefits of a completely Flash-produced site.

From a branding perspective, the Weberize name and the three-dimensional W logo are firmly established right from the start. The animation of the introduction piques our interest, and we already have a clear idea of the attractively clean aesthetics that Weberize favors. Also be aware of the target audience. This site is aimed at potential clients. It is a public relations, best-foot-forward sort of presentation. It's important to convey a dynamic sense of understanding the medium and at the same time show both design and technical capabilities. It's the perfect opportunity to use Flash.

DYNAMIC ICONS, METAPHOR, AND MESSAGE

Additional message details are provided through the use of metaphor—the little rollover icons on the left are matched to the three keywords under the Weberize logotype on the right. Perhaps the metaphors are a bit stretched, and there's too much reliance on popular concepts like "driving customers to your site" without any explanation. But nonetheless it's clear that Weberize has a broad base of expertise and is customer focused. The explanations feel right even if they aren't as tightly focused as they might be.

The other nice aspect of this animation is that it builds the home page while you watch. When the construction is done, the screen is all branding and navigation. All the hierarchical navigation is contained in four text buttons under the W logo, About Us, Services, News, and Clients. But the page is never static. The navigation text expands when rolled over.

The We Can Deliver sentiment seems to float over the page, expanding and shrinking. Across the bottom of the screen is a muted dashed line that follows the horizontal motion of the cursor, glowing underneath it—all subtle dynamic touches.

(ABOVE) Rolling over the top icon, a chess piece, slides open a window entitled Make Your Move and includes talk of Our Strategists. The explanatory window connected to the second icon, a wrench, exhorts you to Roll Up Your Sleeves and talks about Our Builder. And the third icon, a megaphone, talks about Our Evangelists under the heading, Shout It from the Rooftops.

THE INSTANTANEOUS DIMENSIONS OF FLASH

Each of the rollover text buttons loads a divisional page. But because this is the Flash site, there's no waiting. The secondary navigation is as straightforward as the primary hierarchy, except that all rollovers at this level underline the text instead of bloating it. In some divisions, a third and fourth level of hierarchy also becomes available.

These don't feel like steps down into the hierarchy of the site. In fact, they don't even feel like links, because the use of Flash allows elements on the page to be changed instantaneously. Roll over a hot spot and new content appears. It seems to happen right on the surface.

There are times when content speaks for itself and should be allowed to do so. There are other times when image and activity are more important. And in this case, it is the graphical treatment of the prose in a Flash context that really gives this site its character. A straightforward, familiar navigational scheme becomes amusing, the chore of reading the text becomes a game, and the image is transformed from monotone gray into a subtle study in shades. Most importantly, the brand becomes interesting. A nice logo comes to life, and Weberize takes on a well-defined creative, friendly, and at the same time, professional identity.

(ABOVE) On divisional pages, explanatory text, white on gray, fills the main content area, while a secondary level of hierarchical navigation slides into place under the primary navigational text.

PERSONALIZING A BIG WEB BRANDER

Now here's someone you should meet. This person brands Web sites for a living. He's a brand strategist for Sapient, one of the few really big names in the Web design and consulting business. And if you've studied this book carefully, perhaps you too can become a brand strategist for Sapient.

VIEWING FROM THE INSIDE OUT

What does a site look like from the inside out? After all, one doesn't always enter a site from its home page, and a site that is well branded should be so on every page. With no initial clues, what brand elements are evident three levels down in the site hierarchy? In this case, the Sapient logo, one of the most understated logos in this book, sits in the place of honor at the upper-left corner of the page. This is the most expected spot to find a logo and this place-ment bestows great prominence without distracting from the rest of the page or its contents.

There are narrow strips of navigation across the top and down both sides, and a larger column providing the second level of hierarchical navigation. The content section takes up most of the screen real estate, and it is divided into overlapping areas by color. The overlap is created by the single small photograph that provides the primary point of interest and ties the content areas together. All of the images in the interior of this site are small and fast-loading.

This is standard stuff, the expected, but it's handled with parti-cularly elegant style. For instance, all the typographic and color choices have been made with great care, and the proportions used for the layout give the page a nice balance between light and dark. It's easy to read the content, easy to use the navigation, and the entire composition is appealing without relying on the heavy use of graphics or dynamic elements. It's clean and fast.

(ABOVE) Want to be a brand strategist for Sapient? Click the Apply button and perhaps the next page added to this site will feature your picture and bio.

Des Varady on Strategy:

We bring clients a point of view about what's next — and how we can help them get there. Technology is only part of the solution; our work is about developing frameworks within which technology and people can work *together* — seamlessly — to achieve success. Greatness doesn't come from simply managing change. It's about finding ways to adapt organizations for the future — without disregarding the traits that make each company unique.

(ABOVE) This is essentially a summary page with two categories beneath it. Here, instead of the lower-level HTML text with headings in a column, Des Varady, a Sapient executive, offers his thoughts on strategy, typeset in an attention-grabbing way.

MOVING BACKWARD THROUGH THE HIERARCHY

Popping back up one level to the Strategy page—still two levels down in the hierarchy—the same elements remain at work—the same layout, navigation, and colors. What's different is the content. It's not just the image and text that are different, but also the treatment of the elements on this page.

This is still text, not a GIF image, but it has been carefully styled using Cascading Style Sheets (CSS). It's appropriate to handle this quotation differently, because it's doing the important job of establishing the tone of the company. Viewers are expected to see that even though Sapient has thousands of employees, individual voices are important; it is not a big, impersonal company. So, all the points are made in a very personal manner. In fact, they are often quotations, and many pages throughout the site mention people in the company by name.

Up one more level to the Careers divisional home page, it's evident that Sapient is pushing people and not just technology. This humanistic approach is appropriate and expected for the recruiting pages. But what of the rest of the site?

(**ABOVE**) Instead of a single featured voice, this page has a collage of portraits, and each paragraph begins with an aphoristic saying — "We use both sides of our brains," "We really are changing the way the world works," "We don't swim with the sharks here," and so on.

THE PERSONALITY OF THE SITE IS PERSONAL

And back up the last step in the hierarchy to the home page, with its large portrait and catchy quotation. Actually, there are four portraits, each with a different quotation (but the same follow-up text), and they load randomly each time you access the home page.

This is the lead story. It is about globalization, but these compelling photos are the immediate attraction. It is through these close-up shots that the page achieves its international flavor, the point of this feature. In a way, Sapient is showing its sophistication in understanding the global nature of the Internet and, by extension, commerce. More subtly, by doing this, Sapient is establishing itself as a big player, a major force, and most importantly as a world brand.

(THIS SPREAD) Even though the images on the home page look large, this is only in relation to the relatively small size of the page's content area. In fact, each image is a heavily compressed JPEG of only 28 K. You can see that there are compression artifacts in some of the image backgrounds but that little is lost from the faces. The striking expression of each remains clear.

BRANDING BY ASSOCIATION

There's more subtle world branding going on here, as well. That little strip of blue logos down the right side of every page provides Sapient with a big brand-by-association claim. There are nine logos; some, like United Airlines, Hallmark, and Adobe, are immediately recognizable, even at twenty-two blue pixels square. Others, like iWon and E*trade, are recognizable to those who frequent the Web, and then there are those like Asserthome and ChemConnect, which are more international. Each logo links to a case study, and Sapient can add or delete case studies to update the site. These are nonhierarchical links that skip a level to get right down to the important content.

Sapient isn't just selling image. Its thrust is personal. It's as if Sapient is saying, "Look at how we analyzed our client's situation to reach a successful solution. We'll do the same for you." More practically, a company as large as Sapient can hardly be said to have a distinctive design style. The company has many offices with many designers. As a result, its sites have many styles. What's consistent is Sapient's approach to defining answers, and this approach depends as much on personal contact between Sapient's analysts and its clients as on any particular designer's vision.

The same emphasis on the client relationship is evident in the featured story. It makes no difference which lead image is showing, entering the Lead Story takes you to the first page the four-page article. Each page makes a different point about globalization, and each point highlights Sapient's understanding and capabilities.

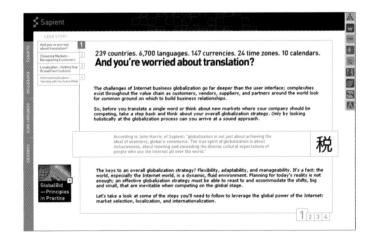

(LEFT) Here is the ChemConnect case study page, a nearly all-text explanation of the company's unique problems and Sapient's solution. Where are the screen shots? There's not even a link to the site.

(RIGHT) The lead story page is made up of headlines and inserted sidebars but very little illustration. Most of the graphic interest comes from the graphic layout itself.

SERIOUS BUSINESS SEEKS SERIOUS CLIENTS

You've got to be serious about global business, Sapient, or both to read through the entire presentation. But this is exactly what Sapient wants — serious clients. And for those who are really serious, Sapient's strategists have prepared a full globalization report.

BIGNESS HAS ITS OWN PERSONALITY

It seems likely that the case studies are the most visited area of the site. Potential clients, the intended audience for this and most self-promotional sites, want the reassurance of seeing what's been done for other clients. Yet Sapient puts their globalization story first.

This has the effect of saying, "This is who we are, big enough to be global, expert enough to handle complexity, yet personal enough to understand your business." A case study can't establish these selling points with the same cohesiveness. The same attitude is evident for Sapient's secondary audience, potential employees, in the career pages of the site where this exploration began.

It would be easy to argue that you can't have it both ways. You can't be both big and personal. Yet this is exactly what Sapient's site attempts to establish.

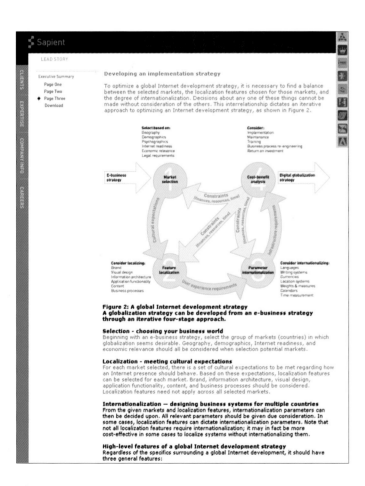

(ABOVE) From a branding perspective, the thoroughness of this globalization report is less important than the fact of its existence and the clean graphic way in which it's presented.

The Web is an intentionally utopian world. The physicists who created the Web did so without regard for operating systems, hardware platforms, or thoughts of competitive advantage. Branding was the last thing on their minds, and they believed that everyone would be equal on the Web.

They also set up all of the Web sites to be identified by simple addresses known as uniform resource locators, the now ubiquitous URLs. The URLs accept any name, but require you to categorize your address with an abbreviated suffix: .org for organization, .edu for school, .net for Internet-oriented groups, .gov for governmental entities, .int for international groups outside the United States, and .mil for military. These were the types of entities that built the Internet and were expected to dominate the Web. Oh yes, there was one more suffix, .com.

It was some years before the dot-coms came to dominate the Internet, creating a rush of Web branding. So it seems appropriate examine the sites of nonprofit organizations and educational institutions in the protected space of a single chapter. But the first question is whether it is even appropriate to refer to these entities as "brands."" It's refreshing to look at a group of sites that aren't in it for the money. Their revenue model is not based on making investors wealthy, and while they all have something to sell, often it's not a cash deal. For instance, how many sponsors get their fifteen-second pitch in before any broadcast on commercial-free public television can begin?

It is perfectly clear that brand recognition is as important to non-profit organizations as it is to the most profit-oriented corporations. Just as public broadcasting stations must advertise and compete for viewers, charities compete for contributors, schools vie for applicants, and museums attract crowds. Considering the proliferation of PBS tote bags, Harvard sweatshirts, and Smithsonian baseball caps, it is a wonder the IRS has not eliminated nonprofit status altogether.

While it sounds ludicrous to speak of colleges as brands, a college's reputation—its brand—is serious business. Would you rather have Stanford University or Whatsamatta University on your resumé? There are certainly well-established brands among charities, as well. Are you more likely to respond to an appeal from the American Cancer Society or the Retinitus Pigmentosa Foundation? The point of these rhetorical questions is that the Web gives nonprofit organizations a chance to establish themselves and their brand in a way they have never been able to before. When it comes to Web branding, dot-orgs require the same careful planning and design as dot-coms.

[11] NOT-FOR-PROFIT BRANDS
THE COMMERCIAL-FREE AND BROWSER-SUPPORTED WEB

DESIGNING
ONLINE
IDENTITIES

ROCKPORT

GLOUCESTER MASSACHUSETTS

ROCKPORT PUBLISHERS

DESIGNING ONLINE IDENTITIES

**SUCCESSFUL GRAPHIC
STRATEGIES FOR BRANDS
ON THE WEB**

First published in the United States of America by
Rockport Publishers, Inc.
33 Commercial Street
Gloucester, Massachusetts 01930-5089
Telephone: (978) 282-9590
Fax: (978) 283-2742
www.rockpub.com

LIBRARY OF CONGRESS CATALOGING-IN-PUBLICATION DATA
Andres, Clay.
 Designing online identities: successful graphic strategies
for brands on the Web / Clay Andres.
 p. cm.
 ISBN 1-56496-801-4 (hardcover)
 1. Brand name products—Marketing—Management.
2. Trademarks—Design. 3. Web sites—Design. I. Title.
HF5415.13 .A526 2002
658.8'27'02854678—dc21 2002004524

10 9 8 7 6 5 4 3 2 1

Design: Stoltze Design
Cover Image: PhotoDisc

Printed in China

658.827 AND

To the Seattle-branded Andreses: Laurie, Sharon, Hattie, Shaina, and Rachel. With love and admiration that transcend mere branding.

Most nonprofit organizations have sites that don't sell or advertise anything. The sites do not ask viewers to register or fill out a survey. They will probably never be updated, and yet they will never be outdated. Nonprofit organizations have sites that exist solely for the presentation of their content. What a concept.

One such site, Do You Remember When, provides an in-depth look at a Holocaust artifact by the same name. The artifact is a book given by one young Jewish man who was later killed at Auschwitz, to another young man who survived in the small Jewish underground of World War II Berlin and is alive today. The book itself, a notebook of sketches and observations exchanged between friends, is unremarkable. It has none of the poetry or personal insights of the *Diary of Anne Frank*, for instance. Yet the book's existence as a historical document gives the little notebook a power disproportionate to the small, personal document it is.

The United States Holocaust Memorial Museum, in Washington, D.C., is a reminder of the evil that the Nazis unleashed upon Europe over half a century ago. Part of the museum's collection is this recently donated notebook.

(ABOVE) The first page of *Do You Remember When* identifies the Web site, sets the visual tone, and quickly passes control to an introductory window.

A VIRTUAL VIEW BOOK WITH TACTILE QUALITIES

The Holocaust Memorial Museum added this notebook to its online exhibitions and is as compact as the book itself. A title page leads directly to the introductory page: "What was it like to live as a young Jew in Berlin during the Nazi deportations?" The text is set in Courier, as if typed on paper that has yellowed with age.

A second window opens with the book pictured at what appears to be actual size. Viewers see not only the cover of the actual book, but also the cover page of the site.

After opening the page, viewers see the image of the book surrounded by text that gives a thorough explanation of its historical context, just as if one were looking at this page in a museum exhibit. On one HTML page, are the seen—the book—and the unseen—the events transpiring in Berlin as the book was written. The explanatory text and accompanying photographs are placed around the image of the book. The anonymous-looking Courier is used for explanations, while quotes from the book are set in Agfa Rotis SemiSans, a very distinctive typeface. The Agfa Rotis SemiSans is used here as a subtle act of resistance against the blandness of the dominant Courier.

The advantage of displaying this book on a Web site is evident when one starts to turn the pages. Viewers can examine all seventeen pages of the book, and each one is translated and annotated and put into proper context.

Introduction
 What was it like to live as a
 young Jew in Berlin during the
 Nazi deportations? This exhibition
 details the life of Manfred Lewin,
 a young Jew who was active in one
 of Berlin's Zionist youth groups
 until his deportation to and murder
 in Auschwitz-Birkenau. Manfred
 recorded these turbulent times in
 a small, hand-made book that he
 gave to his Jewish friend and gay
 companion, Gad Beck. Mr. Beck, a
 Holocaust survivor who again lives
 in Berlin, donated the booklet to
 the Museum in December 1999. The
 exhibition centers around the
 17-page artifact, which illustrates
 the daily life of the two friends,
 their youth group, and the culture
 in which they lived.

(ABOVE) This page contains a single GIF image that is unbranded except for the small picture of the actual book. It is practically anonymous.

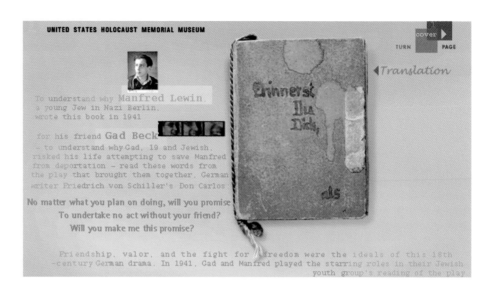

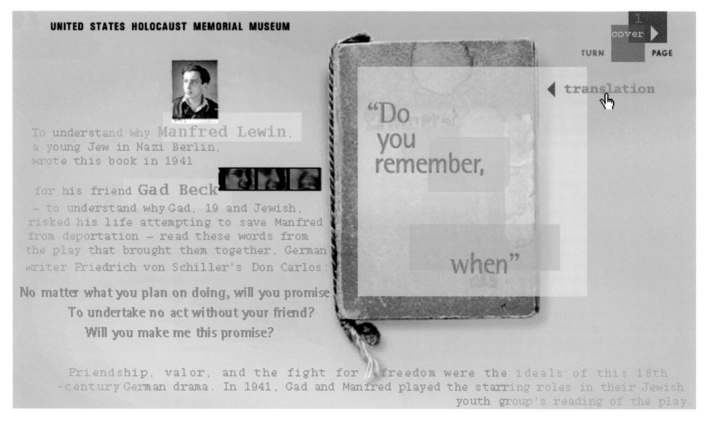

(TOP RIGHT) All seventeen pages of this little site include all the brand elements briefly viewed on the initial identity page: the name of the domain host—United States Holocaust Memorial Museum; the title of the book (though initially in German here)—*Do You Remember When*—the handwritten look of the typography; and the muted color blocks that form the background for the site's nonhierarchical navigation.

(BOTTOM) In one sense, this book speaks for itself. The handwriting on the page is in the original German, but point to the Translation button (set in a handwritten script typeface) and the text translated into English.

MORE THAN AN E-BOOK

The site is projected as though one were reading an e-book online, so there's no need for any kind of hierarchical navigation. There is, however, a hierarchy of information being presented. On each page, some of the text is highlighted—emboldened and enlarged with a contrasting rectangle of color underneath. Highlighted text constitutes areas where an image map links to additional information. This tangential material is always presented in a new window.

In an excerpt from an interview with Gad Beck (the recipient and, later, the donor of the book), the audio file is made available to the site visitor. The audio is difficult to understand, but just the sound of the old man's voice, full of emotion for his long-gone friend, makes the words jump off the page.

Using both pictures and sound to project a story is a particularly effective use of the Web. So many sites that include sound are gratuitously noisy. In the case of the Do You Remember When site, the sound adds to one's experience, making this book more personal and creating a stronger impact on the visitor.

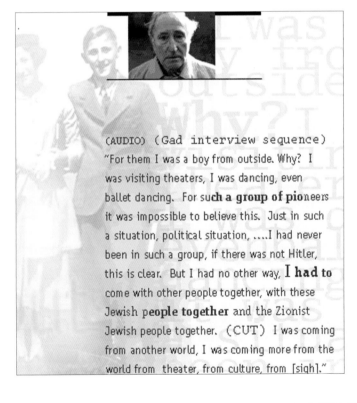

(AUDIO) (Gad interview sequence)
"For them I was a boy from outside. Why? I was visiting theaters, I was dancing, even ballet dancing. For such a group of pioneers it was impossible to believe this. Just in such a situation, political situation,I had never been in such a group, if there was not Hitler, this is clear. But I had no other way, I **had to** come with other people together, with these Jewish **people together** and the Zionist Jewish people together. (CUT) I was coming from another world, I was coming more from the world from theater, from culture, from [sigh]."

(ABOVE) This tangential page of information includes an audio clip, along with a background picture of the young Gad in Berlin at the time the book was written and a picture of him today.

BREAKING DESIGN RULES FOR A REASON

Some people will complain about the colored GIF text on colored backgrounds that appear on every page of this site. While this technique is often a mistake, especially for a site that depends so heavily on textual content, the color contrasts in this instance are carefully specified so that the text is always completely readable. The cool blues and greens of the text are picked up from the blue ink used in the actual book, while the warm yellow, orange, and red colors of the navigation segments come from the unusual orange color of the book's cover.

Another potential criticism might be the heavy reliance on graphics, which can make the pages slow to load. In fact, every page relies completely on sliced images. There is no HTML text, and many of the pages' tables are filled with image slices. The compromise is that the window size is relatively small, and that once the page is loaded, the rollover images are preloaded and work instantaneously.

In fact, the site does not feel slow, bloated, or overly dependent on images. It's easy to understand the navigational options and to read straight through the book, following the exhibit. More importantly, each HTML-based decision has been made in a way that enhances the goal of the site—to present this personal account of a friendship in the context of Jewish life in Nazi Berlin. This Web site is a powerful use of technology and design that works to expand the limits of human experience. This little site is more than a display case for a World War II artifact. The site is a window that allows visitors to pass through and nearly touch the tragic face of history.

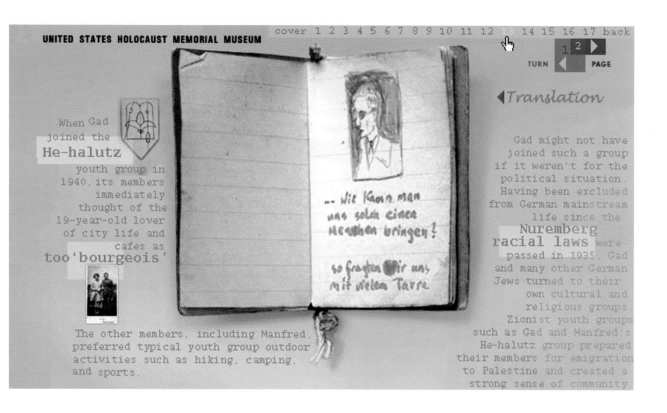

(ABOVE) The navigation scheme allows viewers to browse forward or back, or one can choose any page from the pop-up display across the top. It's just like a real book.

GIVING IT ALL AWAY

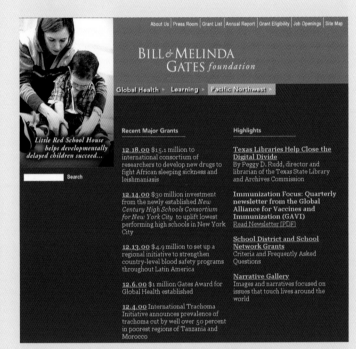

Does anybody outside of Microsoft's employment have anything nice to say about Bill Gates these days? The continuing legal haggling and the government's case against the software behemoth are compelling for their negative implications about the Microsoft executive team. At the same time, comparisons to the greedy robber barons of one hundred years ago are disturbingly apt. But what does this have to do with nonprofits and their Web sites?

BURNISHING A TARNISHED PERSONAL IMAGE

Like the wealthiest industrialists who built the museums, libraries, concert halls, and university buildings that are so much a part of the fabric of our cities and campuses, Gates is giving his money away. Tainted or not, the checks distributed by the Bill and Melinda Gates Foundation are clearly doing good in the world.

The Gates foundation not only supports more good causes than one knew existed, but it also supports a good Web site, as well. The site fits the image of a well-run and generous organization.

As far as branding the foundation and the site, the Gates name says it all. But Bill the philanthropist shares the marquee with his wife, Melinda, and father, William H. Gates Sr., the third principal of the $21 billion dollar fund.

Every page of the site includes the foundation's logotype, a straight-forward bit of elegance set in the Adobe Garamond typeface—the height of sophistication. The names use a mix of capital and small cap letters, while the ampersand uses an unusual alternate italic, and the word foundation is set in lowercase italic. The balance of the typesetting is not at first evident; it becomes apparent when the italic foundation is removed to reveal that the name Gates is centered under Bill & Melinda. This refined logotype is quite a contrast to the sturdy but rather commonplace Microsoft corporate logo. Interestingly, Microsoft Corporation is not mentioned within the foundation's site.

(THIS PAGE) The site is not an expensive one. Instead, it is a model of clarity and concision. The design is clean, the navigation highly functional, and the information timely.

EXPRESSING A MISSION HIERARCHICALLY

The foundation's home page clearly states both the mission of the foundation and the hierarchy of the site with three main links under the logotype: Global Health, Learning, and Pacific Northwest. These rollovers reveal the secondary navigation and are used consistently, though not identically, on every page.

The foundation is very clear about its goals, and these goals are reflected in the site's hierarchy. Information is arranged in strict order under the three main divisions. However, all other links on the home page are nonhierarchical, including two columns of featured stories and a horizontal strip of businesslike links across the top of the page.

Under the heading Recent Major Grants is a list of press releases in chronological order, with the dates providing the rollover links to the complete database of press releases. More featured items fall into a second column under the heading Highlights. This list includes a byline article, a newsletter as well as a PDF file, and a link to the Narrative Gallery, an archive of foundation success stories. It's not immediately apparent, but the photograph in the upper-left corner of this page represents a link to one of these narratives.

IMAGES OF HELPING

The corner photograph gives the home page its visual focus, and one of ten images appears at random each time the home page is loaded. The photos present the stark reality of needs met.

Clicking on one of the featured photos takes viewers directly to the story in the narrative gallery. The Gates Foundation logo is anchored to the upper left of every page. A short blue bar with three links, About Us, Press Room, and Site Map, overlaps the olive-colored background of the logo. These links represent the secondary hierarchy in contrast to the primary hierarchy, the foundation's tripartite focus on Health, Learning, and the Pacific Northwest.

The content fills most of the page. There is a nicely typeset headline topping the column and another sepia-toned photo with a caption giving the grant summary. The text, which wraps around the photo, is well written, succinct, and very readable. There are additional photos and captions, and the story finishes with a quotation from one of the grant's recipients.

The page is completely static but not simplistic. The photographs are not in color, yet they are particularly strong images. In fact, the palette is limited throughout, but the colors have been carefully chosen to direct the eye to links or more important elements without distracting from the overall feel of the page. The text has been confined to columns, and by interspersing images and breaking it up into narrative, captions, and quotations, the text too, takes on a serious, sophisticated air.

(LEFTMOST) This is a typical interior page with the focus on content reinforced by people photos.

(SECOND, THIRD, FOURTH) These images from the home page are all high-quality sepia-toned photographs of people, and you can infer that they are people or groups actually aided by the grants. Where sepia-toned images are often used to give a retro look, here, they lend a serious, no-nonsense quality. There is no shade of mawkishness nor do they romanticize the work of the foundation.

IMAGE YIELDS TO INFORMATION

On many other pages there are fewer images and the text is much more prominent. At this level, the hierarchy of the site begins to blur a little, but in a useful way. The expanded links in the navigation column lead down a level to articles about the work that is sup-ported by the Foundation. Each of these articles is full of links to additional information—material thoughtfully arranged and pre-sented. Some of the links cross over the site's hierarchy to the Narrative Gallery section, while others connect to outside sources, including the sites of specific grantees.

The lower you go in the hierarchy of this site, the fewer the number of images and the greater the reliance on HTML text. As a result, the pages load very quickly, but are not dull, and suit the intended audience well. The Gates Foundation does not need to attract viewers by offering a lot of needless fireworks. The fact that they give away huge sums of money is enough to attract plenty of attention.

EVALUATING GOOD

As a public-relations piece, this site is elegant and appropriately serious. The success stories are clearly written in a style refreshingly devoid of marketing hype. For those applying for grants, the information tells you exactly what you need to know and encourages nonfrivolous applications. The tone is warm and welcoming. And lest you forget, the Gates name, while it is never flaunted, is prominent throughout.

Most importantly from a branding perspective, the Gates name is used to further undeniably good causes. The association is overwhelmingly positive. Are you being asked to choose between the good Dr. Jekyll—also known as The Gates Foundation—or the evil Mr. Hyde—also known as the monopolistic Microsoft? It would be a mistake to take this approach. You must not presume to make psychological inferences about the duality of citizen Gates. Instead, the not-for-profit brand that is The Gates Foundation, including its works and its site, must be viewed on its own merit.

(THIS SPREAD) For instance, each of the three main divisional pages has only a single photo at the top. These photos are silhouetted against the page to emphasize the people in the pictures. The column of HTML text is broken up by red headings and links and sometimes offset against a yellow background.

LEADERS
for America's future

● GLOBAL HEALTH
● LEARNING
● PACIFIC NORTHWEST
● ABOUT US

Leadership and Staff
Grant Inquiries
Employment
Contact Us
Narrative Gallery
Special Projects
Grants

Grant Summary
Gates Millennium Scholars Program
$1 billion over 20 years

For more information, please visit www.gmsp.org. Additional information is also available through the United Negro College Fund (http://www.uncf.org), the American Indian College Fund (http://collegefund.org), and the Hispanic Scholarship Fund (http://www.hsf.net).

Family income and educational attainment go hand in hand. Historically, lower-income students who are also members of racial and ethnic communities have been underrepresented on college campuses. These students are even less likely to graduate. Even so, the pool of college-ready minorities has swelled in recent years, due in part to the growing number of high school graduates who have taken college prep coursework. Doing "what the preachers and teachers have told them," as William Gray says, these students have positioned themselves for the opportunities available in today's knowledge-based economy for Americans with advanced education. But financial barriers choke their dreams.

Over the next two decades, the Gates Millennium Scholars Program will commit $50 million per year to create 20,000 successful college graduates. The total commitment of $1 billion will fund scholarships for about 1,000 African-American, American Indian/Alaska Native, Asian Pacific American and Hispanic students each year. Minority students are eligible for full-tuition awards if they have a grade point average of 3.3 or better, have significant economic need, and demonstrate leadership in extracurricular or community activities. At the graduate level, individuals applying to, or currently enrolled in, science, mathematics, engineering, education or library science degree programs are eligible. Awards are renewable annually if scholars maintain a minimum 3.0 GPA. The United Negro College Fund administers the program in partnership with the Hispanic Scholarship Fund and the American Indian College Fund. For more information, visit www.gmsp.org or call 1-877-690-GMSP.

Opening the Doors to Higher Education

There is a gap between what college costs and what many American families can afford; and often, it is only partially covered by financial assistance from government, colleges and other sources. Poor students usually have larger unmet financial need than middle-class students. The funding gap not only deters many qualified students from pursuing college dreams, but it also forces others to choose a college based just on what they can afford -- not on their abilities and interests. Financial pressure is the primary reason that poor, minority students leave college. Those who stay often carry two or three part-time jobs to pay college expenses, leaving them overburdened and unable to perform up to their academic abilities.

"Ask the typical student why he or she attends college and they'll say they need a degree to make more money. But when you ask an Indian student, the answer is 'to help my people.'"

-- Richard Williams, Oglala Sioux, Executive Director, American Indian College Fund

Photo of American Indian wearing buffalo robes, Raymond Meeks, Wieden & Kennedy

< Previous Narrative | Next Narrative >

THE CHANGING AND YOUTHFUL FACE OF DESIGN

Try to imagine Lily Bart, the tragic nineteenth-century heroine of Edith Wharton's novel *The House of Mirth*, taking out an ad in the personals column of *New York* magazine." Most attractive, keenly intelligent, independent-minded, late 20s (but still youthful), seeks similarly qualified gentleman of wealth and influence." No, it couldn't happen. She had to rely on beauty and guile and keeping her reputation intact.

Now imagine a stately nineteenth-century institution, say Brown University, advertising in *USA Today* for bright, eager applicants. No, it won't happen, but well-established, first-tier universities can no longer rely on reputation alone to attract the most interesting students. There is serious competition to attract the next generation of Nobel laureates, millionaire entrepreneurs, and even future Edith Whartons.

SELLING REPUTATION

So along with lots of glossy brochures and attention to décor in admissions offices, schools of all sorts are investing in well-designed Web sites. You need only consider the wide range of interests served within a university—students, faculty, and staff—to realize that these sites serve a multiplicity of functions. The image of the institution is a combination of all of these, and it is this image that becomes the brand of a dot.edu Web site.

The perceived image of the institution is particularly evident with the Web site for the Rhode Island School of Design, RISD. Located next to Brown University in Providence, Rhode Island, RISD has the reputation for being the finest design school in the United States. It wouldn't do to have just any Web site, with such a reputation on the line.

First, RISD's site is student-oriented, and as such, it unabashedly aims at attracting design-oriented applicants. The home page loads a bit slowly; there's a lot going on in the background. But you can tell from the glimpses of images as they load that the page will be interesting. Art requires patience.

The browser window is resized to 800 x 620 pixels. The screen appears to be sliced horizontally by hairlines, and there are layers of images. In fact, a plug-in detect has checked to make sure you have Flash Player installed, and then a browser detect has checked your browser version to make sure it is JavaScript-enabled. While some might find these requirements for admission to the Web site annoyingly steep, it is reasonable to expect aspiring artists to expect nothing less.

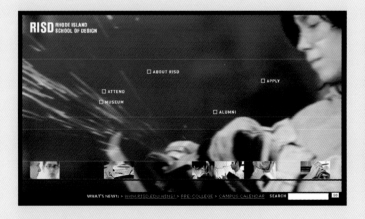
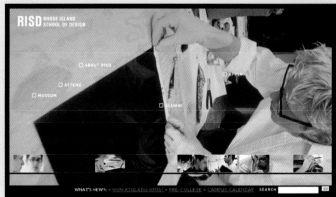

(THIS SPREAD) The Flash home page includes images of a student at work as the backdrop, bands of floating links and thumbnail images, and the RISD logotype in white fixed in the upper-left corner. Each of these element types resides in its own horizontal track over the background image and the background changes with each reload.

SELF-SELECTING THE AUDIENCE

The rather complex composition that is RISD's home page challenges the browser of the site to properly display it. There are actually three background images loaded at random, so that the page is not exactly the same with each visit. Each image shows a student at work, though camera angle and soft focus make it difficult to discern what the activity is at first. These images are as much about color as they are about subject. There is one each in red, yellow, and shades of blue.

Each image loads with a voice-over, a sound clip of a student talking about the life of the young artist on campus. Key words are "crit," "creative," "options."

There are eight layers of this home page composition: 1. black background; 2. three randomly loading background photographs; 3. sound byte attached to background image; 4. six horizontal contrast tracks; 5. white logotype; 6. floating links for hierarchical navigation; 7. thumbnail images; and 8. nonhierarchical navigation bar.

And there is more, because the navigational scheme adds another level of richness to the composition. It is clear from the five links—About RISD, Apply, Attend, Museum, and Alumni—that the floating text represents hierarchical links. What is interesting is how to catch them. Clicking on a link stops the action in one track while starting it in another.

One does not have to click on the link but simply stop one's pointer on it. The link is highlighted and fixed against the background. A secondary menu drops down and the thumbnail images animate along their track. Point to a secondary link, and an arrow follows the cursor indicating the current selection. Click to load the division or section within the division.

If you do not think this complexity is interesting, or if you find it confusing or off-putting, then you have failed the first qualification for admission. This is not meant to sound snobbish or to make RISD sound as though it is trying to be exclusive, but it is clear that this simple online challenge is engaging for prospective RISD students. It is certainly done with skill, taste, and as you are about to see, consistency.

INTEGRATING COMPLEXITY INTO A LOGICAL SITE PLAN

Each of the five divisional pages uses the same horizontal layout featuring pictures of artists, mostly students, and again, broken up by horizontal hairlines. The pages have a scratched-film look that gives the effect of a work in progress. The RISD logo has been anti-aliased into the background of each photo. The hierarchical navigation is clearly outlined under the photo along with a persistent Search link to the right. The secondary navigation within each division is listed in gray, and each page includes brief explanatory text.

The simple hierarchy becomes broader as one goes deeper into the layers. For instance, the museum division has nine sections, and each of these sections includes many pages. A step down is reflected in the headings, so the RISD: Museum heading at one level changes to Museum: Collection on the next. Moving down another level does not change the heading.

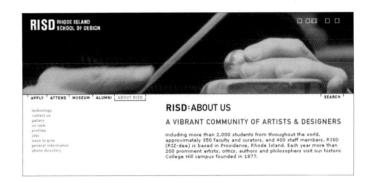

(THIS PAGE) Each divisional page is labeled with the bold RISD name along with the divisional heading. The HTML text is all set as sans serif, with GIF headlines set in a larger font. The Apply division page even gives the correct pronunciation for the RISD acronym, RIZ-dee, by which the school is most commonly known.

It is interesting how there is no hint of admissions within this section of the site. It would not be appropriate here. Yet the same elements are used to make and brand these RISD pages. This is indicative of the fact that while an effort has been made to emphasize the recruiting aspects of the site, the site serves a much larger community than just applicants.

Curiously, the site is full of detailed information for outsiders, people coming to the school for the first time or visiting the museum. There are calendars of public events, exhibitions, and alumni functions, lists of publications, lots of contact information, but little information for current students. No class lists or schedules, no daily announcements.

When you realize that the risd.edu site is separate from the messy exigencies of students inhabiting an urban campus, you may feel as though you have been cheated, that what you are seeing has a Disneylike patina of prettiness. On the other hand, what is this site trying to do? RISD has created a first-class marketing tool for the school. It is no less accurate than a glossy brochure and a lot more detailed and useful.

There is a sense that RISD is a wonderfully exciting place to study design, even if you aren't seeing the complete picture. It is as complete as it needs to be for the purpose it fulfills. Perhaps the public is being manipulated, but one is seeing what the artists at RISD wish us to see, as well as what aspiring artists wish to see. And that is the point.

(LEFT) Within the museum pages there is a fourth layer of hierarchical links and an additional navigational tool in the form of a three by five matrix of images.

(RIGHT) The section page for the museum's collections shows a tertiary hierarchy of links for the seven different areas of the collection.

ABOUT THE AUTHOR

Clay Andres, self-proclaimed Web architect, is the author of numerous best-selling and award-winning computer books, including *Great Web Architecture*. He has been a freelance computer journalist since the dawn of personal computing , and he is a Web columnist for CreativePro.com. In addition to writing about Web design, Andres has written technical marketing materials for corporate clients, including IBM, Apple, Xerox, and Adobe. Andres is also a Web designer and consultant with expertise in Web site architecture and branding. He lives in northwestern Connecticut.